"A remarkable achievement. Beth Porter has produced a clear, fascinating and provoking overview of the Net. In an overcrowded market, here is a book that really stands out for its authoritative mixture of knowledge, enthusiasm, clarity and insight.

Without relying on technical language, Beth Porter has produced an absolutely invaluable introduction to the Net and Web which also serves as a superb tool for those toe-dipping paddlers who might be considering a more whole hearted entry into the Internet world.

A book no one should be without. Her understanding of the wider commercial, social and political implications of the Net is combined with a practical and entirely sane feeling for it as an extension of the human spirit. "

Stephen Fry

the net effect

Beth Porter

This book is dedicated to the memory of
Douglas Adams [1952-2001]
- a true inspiration

intellect™
Bristol, UK
Portland OR, USA

First Published in Paperback in 2003 in Great Britain by
Intellect Books, PO Box 862, Bristol BS99 1DE, UK

First Published in Paperback in 2003 in USA by
Intellect Books, ISBS, 5804 N.E. Hassalo St, Portland, Oregon 97213-3644, USA

Published in Hardback in 2001 in Great Britain by Intellect Books, Bristol, UK
Published inHardback in 2001 in USA by Intellect Books, Portland, OR, USA

Consulting Editor:	Masoud Yazdani
Copy Editor:	Peter Young
Proofreading	Holly Spradling
Cover Design:	Bettina Newman

A catalogue record for this book is available from the British Library

ISBN 1-84150-849-7

FSC Mixed Sources
SA-COC-001695
FSC © 1996 FSC A.C.

Printed and bound in Great Britain by 4edge Ltd, Hockley. www.4edge.co.uk

Contents

acknowledgements **iii**

foreword **iv**

preamble **5**

Morphing From IT to ET 6

introduction: the Janus approach **8**

Connections 9
How They Brought the Good News from Ghent to Aix 11
The Importance of Nothing 14

section 1: the long & winding slip-road **15**

Anatomy of the Elegant Box 16
The War That Changed Everything 18
A Bodyguard of Lies 22
Tunny Turns the Tide 27
Swords Into MicroChips 30
A Decade of Secrets; Computers With Your Tea 34
Defense & the Big Bucks 37
Time of Transition 40
Racing to the Net 42

section 2: clear-eyed acumen & blind dreams **49**

Tooled-Up 50
Scaredy-Cats 52
Embracing the Beast 58
Who's Spinning the Web? 63
Gallimaufry 69
Information 70
Entertainment & Leisure 73
Commerce 76

section 3: the da Vinci syndrome **79**

 Under the Influence 80
 The Virtual Architect 82
 Not Crying Over Spilt Paint 83
 Fuzzy Boundaries 86
 The Book Unbound 89
 Digi Display 94
 POV 95
 Bending Reality 97
 Playtime 101
 Inviting the Viewer 105
 Fashioning Worlds 107
 Lights, Camera, Let-Down 109
 Reeling You In 112
 Tinkle, Tinkle Little NetStar 114
 Music to Your Ears 117
 Next Stages 122
 Buttressing the ThinkTank 125
 Reaping Rewards 128
 The Price of Talent 130

section 4: the internet experience **131**

 WWWwhat else is there? 132
 Here Be Dragons 137
 I Want IT and I Want It Now 138
 Worker Rights & Wrongs; Web Pros & Cons 141
 Power to the Net People 147
 Securing The Net 157
 Slipping Through the Net 163
 Learning CyberLessons 166
 Community Spirit 167

coda: quo vadis **169**

 Growing Like Topsy 170
 Asking Better Questions 171
 Okay, Wotcha Got Now? 173
 Tomorrow 177

index **180**

about the author **190**

acknowledgements

To Lord Puttnam and Stephen Fry I owe more than words can say.

I am grateful indeed to those who shared their expertise to enliven the various sections of this book. Without their generosity I could not have told the full Net story. For any errors or points of contention I claim sole responsibility.

Most particularly I would like to thank Alex Allan, Roy Ascott, Stephen Coleman, Maya Draisin, Leonard Kleinrock, Patrick Marber, and Tom O'Horgan for their insightful and delightful interviews. To Dr Kleinrock I owe a special debt for his generosity, assuring accuracy in the story of the ARPAnet, usually the subject of much mis-information. I'm also grateful for permission to quote and/or use illustrations from Tim Berners-Lee, Demis Hassabis, The Department of Computer Science at the University of North Carolina at Chapel Hill, Andrew Hodges, Joseph Jacobson Tim King, Mitch Mitchell, Pearson Television, Jeff Robinson of Scamper, Sony Entertainment, Andrew Wilson, and the editorial team at www.FaxYourMP.com/

A special thanks to Tom Gidden and especially to Ian Stevens for providing a salutary challenge to some of my technological gaps! I am grateful to my father Ralph Porter, not only for his loving support during the writing of the book, but for alerting me to some relevant historical information.

Thanks, also, to Peter Young for such a thorough and helpful job of proofreading, and to Bettina Newman for her invaluable contribution to the cover design and Rob Pepperell for suggestions of image manipulation. Last but definitely not least, my gratitude to Masoud, Robin, and Sally at Intellect for all the support a writer dreams of.

Requests to quote went out to various sources which received no reply. In those cases I have supplied full identification of the material used, and I apologise in advance if that is considered unsatisfactory in the future. All website addresses were valid as of mid-2001, but given the nature of the Net, some may no longer be accessible to the reader.

Perhaps to prove a point to myself as much as anyone, a great deal of the research for this book was done online. I am grateful to the many websites I visited, vital not only as primary sources but to verify and validate data acquired elsewhere. Several provided contact points for people who've since become electronic friends. Most of the illustrations used herein were downloaded from the Web. Since data compression sometimes affects image quality, I beg forgiveness if anyone feels aesthetically offended by the clarity of the pictures.

Beth Porter
Bristol
Spring 2001

foreword

by Lord Puttnam of Queensgate CBE

In *The Net Effect* Beth Porter does something that I honestly wouldn't have thought possible. She has written a totally accessible account of the history and effect of new technology, with enthusiasm and flair, and without a hint of the expected computer nerdiness that would, I confess, ordinarily scare me off. She makes you see that, in the future, the people she writes about will be historical figures as famous and revered as Crick and Watson, Alexander Fleming or Marie Curie, pioneers whose work really has changed the world for the better.

Christa McAuliff the American teacher and astronaut, shortly before she died in the tragic accident in the US spacecraft Challenger, said, "Every day of my life I touch the future – *I* teach."

Well, I don't teach, but I have spent the last four years visiting schools, teachers and pupils in my role as Chair of the General Teaching Council for England and, honestly, I watch the future touching education, and I marvel at its potential.

The internet has and will continue to revolutionise the way teachers teach and learners, of any age, will learn. Not just the internet either, interactivity and digital technology will enable creative thinkers and artists to find ever better ways of imparting knowledge.

In the same way that technology has made seemingly *anything* possible in the movies, digital educational content is set to make learning every bit as exciting as any computer game or Hollywood blockbuster. Of course there will always be basic skills to learn, but beyond that is a world in which learners will be set free by digital technology.

In the classroom of the future teachers will guide their pupils through the wealth of information and support available to them. They'll be helped to learn French by children in classrooms in France, their interest in physics will be stimulated by advice from Nobel prize winners, they'll experience human geography with children in the developing world. Teachers will find that, with their functionality pared down to the core task of teaching they will have a far greater opportunity to fulfil their own learning potential, advancing their profession and their pupils along with them.

These are exciting times, as I hope, will be the future for education. Whatever your interest in the age of technology, you cannot fail but be inspired by this book. Any belief that the internet is an alien force that will eventually engulf us is swept away, and its human and creative benefits are revealed and explored in a compelling fashion. I feel sure you'll enjoy Beth's book as much as I have.

preamble

It's exhilarating how quickly the general public has leapt from ignorance about the Internet to confusion and scepticism, to an uncomfortable yet determined feeling that it's something they ought to know more about. Only two or three years ago I was frequently asked by friends who'd heard I was working as a Website Producer: What is the Internet? [a question on the order of What is Life? only not so easy to answer.] Now, as an Internet Consultant, I'm more often asked how a website can produce business benefits.

For anyone who'd like some hand-holding about the structure of the Internet and how it works, please see Section Four. But in this book I want to step through the Net, pivoting around for a more comprehensive view. Not just how it evolved and what it does, but how it relates to the way we live. It's an especially satisfying story, since the journey has depended on contributions from such a wide selection of human cultures. It is still that cumulative contribution which quintessentially defines and redefines the Internet.

I confess. I'm a Nethead. An ageing CyberSurfer. A Nerdette. Having spent nearly three decades working in the film and television industry, I thought I was an old-fashioned girl, a parchment-and-quill kinda girl, a donkey-and-cart kinda girl. Turns out I'm a fully-fledged Net Junkie. If I can't visit the Internet every day, I experience withdrawal symptoms. I even changed careers so I can justify being online without a guilty conscience. Sad, but true.

It's not the Internet *per se* which fascinates and excites me, but the possibilities it offers. I'm not like those auto-freaks who spend endless hours taking cars apart, ooh-ing and aah-ing over classic solenoids and replacing head gaskets. To continue the vehicle analogy, I'm much more interested in where the Net can take me and what I get to see along the way.

There's a wonderful job title I've seen on various IT business cards: Internet Evangelist. I wish I'd thought of it first, because that's exactly what I've become. I realise not everyone shares my enthusiasm about this digital development. Some hide behind their own ignorance, others are wary of such techno-abuse as fraud, invasion of privacy, and loss of social interaction. I've tried to address such concerns as fairly and objectively as I can.

I'd like you to know why I'm so captivated by the Net, and why you already know more about it than you think. I also hope to allay any fears you may have about what is essentially a tool which you can use to enrich your life as and when you want to. Apologies in advance if anything herein rehearses what you already know. All I can suggest is you skip those bits and hope you discover something of interest.

There are still people who confuse the arena of the Internet with computers. In the way that someone learning I'm from Brooklyn asks if I happen to know their cousin in Manhattan – when they discover I work on the Internet they assume I must be a computer expert.

Sure, over the years I've learned a bit about that hardware 'box' through which I access the Internet just as I've discovered how to integrate various bits of software which ensure I can use offline what I've picked up online. But it's the cyber-journey which interests me. How I can use the Internet to enhance my life. That's what I'd like to share with you.

A brief word about terminology. The Internet is often referred to as the Net, and the World Wide Web is shortened to the Web or the WWW. Some people interchange the words Net and Web, though they are different [and there's a more comprehensive definition later on]. The Internet is a network of computerised connections unlimited by geography and which exchange or provide information, services and entertainment using a variety of encoded data transfers. The Internet encompasses eMail, the World Wide Web, and a handful of other platforms and protocols of this data exchange. In short, it's a system of connections which deliver and fulfil electronic requests. It's vital at the outset to remember that any such requests are meeting human rather than computer needs. Up to now!

Morphing From IT to ET

I'm fed up with industry conference speakers with all the imagination of a hangnail bemoaning that they still haven't figured out how the Net can make more money, as though that were its *raison d'être*.

As it offers us the mechanism to exploit IT [Information Technology], the Internet continually whets our appetite for ET – no, not Stephen Spielberg's creature, but Experience Technology. I start from the premise that the strength of the Net lies:

- ➢ in its anarchic construction and Hydra-headed focus within strict quantifiable parameters
- ➢ in its provision of both pre-determined and aleatory connections
- ➢ in its quintessential non-linear and interactive nature
- ➢ in its extreme resistance to regulation

Fundamental to the parallels drawn in this book, these components also fuel the creative process. And, as defined by the German philosopher Friedrich von Schelling, "the essence of humanity is free creative activity." It is upon such premises that I hope to highlight the relevance of the Internet to human socio-cultural development.

Following its inception as a discrete network developed by the post-war Advanced Research Project Agency [ARPA] of the US government, the Net, and more particularly the World Wide Web, has evolved from military-funded academic projects into a multifaceted delivery mechanism open to all and offering a global marketing, entertainment, and information resource. Yet websites have the potential to provide so much more than a combined super-duper shopping mall, leisure centre, and research library.

Without re-inventing the film & television, advertising, and publishing industries, the Web constructs a brand-new platform for global creativity, for the world of Imagination and Experience. In addition, and especially as accessibility improves, it is the logical forum for global participatory democracy, for a direct exchange of ideas, for self-appointed communities whose 'netizens' enjoy true equality.

A change of emphasis is needed as well as recognising that in this so-called Information Age the mere acquisition of data confers neither Knowledge nor Wisdom. I also contend that it is the convergence of Art and Technology which must drive the development of the Internet or it will fail to realise its potential as an exciting and complex tool for the whole of our species. Before we investigate these intricate aspects of the Net, I want to track its underlying origins.

introduction: the Janus approach

Most writing about the Net focuses on a particular aspect: its use for business or its driving technology. This book aims at a broader target. Yes, there will be some practical information about the How of the Internet, but I'm more concerned here with the Why of it. I want to highlight the connections between the various Net components and place them in the wider context of society, its development and continued evolution. Although I will concentrate on the so-called developed world, it's important to include all populations, since theoretically the Net is available to everyone and can affect the cultural future of our entire species.

Paradoxically, in order to help understand the effects and impacts of this remarkable technology on our present and future lives, we must take the Janus approach and not only look forward, but back.

Connections

We must peer far enough back in time to trace our species' approach to problem solving. Along the meandering evolutionary road leading up the socio-cultural ramp to the Internet SuperHighway we'll encounter significant milestones connecting the journey. We have to start tens of thousands of years from anything remotely resembling a computer.

Fundamental to the very concept of the Internet are strategies to conquer time and space. This challenge far predates The Electronic Age, the Mechanical Age, or even the Agricultural Age. Controlling time and space has been integral to our survival as a species, and something we inherited from our anthropoid ancestors. By assigning names to the concepts we have been able not only to address how we function in time and space, but also to transcend the utilitarian into a philosophical realm of meaning and existence. It is the synthesis of the pragmatic and the ideological which produces invention and expression.

The anthropoids we evolved from [much as modern ape groups and dwindling tribal communities in Africa, the Middle East, South America, and Australia still do] all relied on communication systems among a knowable group who shared time and space. Only rarely did individuals become separated from the rest, but when they did, special sorts of communications evolved to conquer this time/space barrier.

Shared time/space communications include sounds, gestures, facial expressions, the production of odours, body language, the positioning and shaping of objects, colour coding. Some are bold and unmistakable [the scream of terror, the hug of recognition]; others extremely subtle, like a quizzical raised eyebrow or passive open hand. Examples can be found throughout the animal world and have co-evolved with the physiological and anatomical means to produce and interpret such signs and signals.

Before humans developed technology, communications which transcended time/space barriers were primarily sound-based. Screams and screeches, whistles, bellows, claps, croaks, clicks, and throat booms became supplemented by interacting with objects, such as chimpanzees drumming on forest boles.

You could say these are examples of time-travel, since time will elapse between the production and hearing of sounds over distance. When those sounds carry messages of significance, that's telecommunication. When they are imbued with a devised and repeatable structure, it's language.[1]

von Schelling, in his *Philosophy of Art* [1807], declared, "Architecture is frozen music." Freezing time is another way to manipulate it. Which is exactly what happens in painting and sculpture, photographs and films.

[1] Without wading into a sticky patch of linguistic debate à la Chomsky *et al*, it's a moot point whether or not language *per se* is strictly a human activity. Nor does it necessitate sound, *eg* sign language. In news media interviews during July 2000 neuro-physiologists identified that the brain area responsible for language is allied to pattern recognition, whether embodied in sound, gesture, or touch.

9

Think of time-lapse photography which automatically records the same scene at precise intervals over time. Any stand-alone frame records an event, making it available forever. When the succession of images is played back in sequence, real-time is reconstructed as a series of frozen moments. At any point in the sequence a frame can be altered or even replaced with another, producing a manipulation of time and space. Images used in this narrative way become symbols of ideas, whether they are structured, randomly displayed, or deliberately manipulated.

The emerging use of language and graphic symbols catapulted human communication into a completely different realm. It also separated our species from all others in providing abstract tools to explore the control of time and space. Linguistic theorists reckon the Neanderthals developed proto-languages about 100,000 years ago, giving rise over the following 60–70,000 years to modern language. So began what I call the Era of the Three I's: Imitation, Imagination, Invention.

We heard the rhythm of the rain and the strangeness of hiccups. The whoosh of the wind and the ghostly whoop of the gibbon. Bird song and baby cries. We copied and we connected, forming words spiced with music. Over 30,000 years ago, we aped the tanager's scarlet and all the greens of the forest, using iron-oxide and mud to shape splodges of colour into cave paintings. At about the same time, in what today is Austria, someone carved a voluptuous female form from 4 inches of limestone. A piece of rock became the symbol for the concept of fertility.

We selected random hand gestures, the pounce of a cheetah, and the eagle's glide, combined and formalised them into a dance. We transformed our appearance with feathers and masks to create the characters of pre-theatre. And with language, that apotheosis of the abstract, we paved the path to the imagination, to the enrichment of experience. I believe it's no coincidence that this Era of the Three I's also witnessed a wave of global migration which resulted in the settlement of the non-polar continents. It also expanded the Three I's into Four – the I of the self, the Ego.

As a species we can't run the fastest, climb the highest, or dive the deepest. Nor do we have the most acute hearing or sight or sense of smell. There isn't much to recommend us except a highly convoluted brain and a remarkable ability to adapt, rendering us the most successful global species except for the indestructible cockroach. Over the next 25,000 years we moved into new habitats, colonised them, and adapted to an exceptional variety of survival challenges exploiting Imitation, Imagination, and Invention. One of our most innovative developments was a more permanent communication record than speech.

By some 5000 years ago, when Iraq was Sumeria, the people carved wedge-shaped symbols into clay or wax. They codified language as cuneiform writing whose earliest surviving records included social documents and handy medical information. We'd found a tool that would waft us far into the future.

Our evolving brains were already capable of differentiating quantity. Even blackbirds can tell if they have three eggs in their nest or four! Like other nomadic hunter-gatherer species, we remembered that although those trees over the hill may fruit every summer, this one skips a year. We gave significance to the daily sameness of sun-time and darkness, and noted recurring sky patterns of stars and moon-shape. Counting enabled us to measure. We could relay relational information: I saw as many wild boar in the woods as you have fingers on that hand. Language and symbols allowed us to define time and space – to remember precisely, to plan the future, and to pass on knowledge, not just to our offspring like other animals, but to generations we knew we'd never meet.

The ancient Babylonians measured time with a calendar of lunar months; the Egyptians replaced it with a solar year. In the 13th century Leonardo Fibonacci of Pisa, having been influenced both by Euclidean geometry and by Arabic calculation methods on his travels to Algeria, discovered a series of numbers in which each is the sum of adding the previous two. He devised a system to calculate any number in the series. By 1364 a computational clock was invented by Giovanni de' Dondi which identified the date of Easter using lengths of chains representing calendar cycles. We could quantify the external world. We could qualify our thoughts and feelings. And we could share with each other both process and results.

Millions of evolutionary years finally delivered humans to the point of representation. Of agreeing that something can mean something else. Of coding. Contemplating that dichotomy so wonderfully depicted by Magritte's painting of a pipe entitled *Ceci n'est pas un pipe,*[2] permits us [unique from any other species] to regard ourselves and all facets of our lives. It allows us to objectify ourselves and others. It allows us to wonder. To extrapolate. To make connections.

And that is what the Internet is all about. Connections.

How They Brought the Good News from Ghent to Aix

In his 1845 poem of that name, Robert Browning describes the 17th century overnight journey made by three horsemen to carry a vital military message from Ghent to Aix. It's imperative the message gets through in time to save the city. It does, although two horses die in the hard riding of 165 miles.

What's interesting is that the message itself is never revealed, nor any of the circumstances to which it refers. Only the delivery is described, conveying the sense of urgency, import, danger, and speed. In fact, Browning admits making up the event. There never was a message, nor any conflict to which it refers.

[2] Literally "this is not a pipe."

The Net Effect

As Marshall McLuhan would declare in a different context over a century later, "The medium is the message." In part, this is just as true of today's Internet as it was of McLuhan's television. So, before we examine how actual content is affected by the means of its delivery, let's trace how passing messages through time and space evolved into the Internet.

Our ancestors, too, realised that meaning can be conveyed solely by its delivery mechanism. The vehicle preferred for thousands of years was feathered. Records dating from before 3000 BC relate how homing pigeons released from incoming ships heralded the imminent arrival of important visitors into Egypt.

Several centuries later, Sargon, the Mesopotamian King of Akkad, equipped each messenger with a homing pigeon which flew back if any harm befell the man. The very appearance of the returning pigeon in a particular direction triggered a new message sent by a safer route. The birds reported up-to-date Olympic Games victories to 8th century BC Athenian sports fans. A 4th century BC Roman magistrate attending the theatre used his pigeon the way we use mobile phones, to let the family know he'd been detained.

Of course, the sight of a trained bird can only convey so much. We needed a way to report detail, subtlety, and the abstract. We've already seen how the Sumerians used carved symbols to leave written records for any who could interpret them. The cuneiform wedges were refined by successive civilisations including the Egyptians whose hieroglyphics as early as 4300 BC interlinked pictographs and phonograms to produce extensive texts. Two thousand years later, the Babylonians had evolved their cuneiforms to render the powerful *Gilgamesh Epic*, depicting man's vain striving for immortality. By 1400 BC, the Syrians realised that ideographic symbols could represent syllables rather than entire words or concepts, providing improved flexibility to the written language.

This syllabary system presaged the concept of an alphabet, which in turn represented the initial sounds of words, frequently using reductive symbols of those very words. Alphabets were evolved variously by the Palestinians and Syrians of about 1700 BC and fully exploited by the Greeks by about 800 BC. Some systems used consonants exclusively. Most settled at approximately 25 letters, though some functioned on fewer than a dozen alphabetic symbols, while others developed nearly 75.

Whatever the number, the importance of the alphabet was the way combinations of letters could form far more words than any previous recording system. Anyone who can read and write is an expert in interpreting code: writing is encoding and reading is deciphering. Moreover written language became capable of more than recording facts. It could document concepts, feelings, predictions, and precision: perfect for complex messages. Of course a stone tablet isn't the most portable medium. Besides, apart from the past few hundred years, the majority of human populations relied primarily on oral communication; all but the elite were illiterate. Ensuring delivery of a message meant someone had to convey it.

The Net Effect

If you were as rich and powerful as King Darius,[3] and you wanted to communicate quickly with the outer provinces of your realm, you might do what he did: thousands of men were ordered to stand within shouting distance of each other and pass information from one to the other over terrain that would have taken a month to cross. In his *Commentaries*, Julius Caesar remarks on a similar system used by the Gauls to amass an army in less than a week.

If time were not an issue a single runner could suffice. But what if, as in Browning's poem, delivery speed were essential, not to mention some assurance of the messenger's safety? The earliest message delivery systems involved runners and/or horsemen relaying to staging posts along the route. We know that's how the 12th Dynasty Egyptian King Sesostris I found out about his father's death. Similar relays were used in ancient China, and in 18th century BC Babylon, where runners travelled two days and nights from Larsa to bring messages to Hammurabi.[4] The Persians and the Romans in turn used and improved on these relay systems to assure that urgent news could be conveyed swiftly and safely.

By the 13th century, the Venetian adventurer Marco Polo described the sophisticated relay system used by Genghis Khan's grandson Kublai Khan. He ordered horse posts at 25 mile intervals on each road radiating from the capital city of Khan-balik[5] – at each post messengers could pick a new mount from 200 fresh horses. As the messenger drew near, he blasted out a note from a special horn, warning those at the post to harness a horse ready for instant transfer. This arrangement apparently doubled the best speeds of the Romans. According to Polo, "in extreme urgency, they can achieve 300 miles." Polo also reports that when Khan held court at Shang-tu, normally a ten-day ride from home, he used the system for a next-evening delivery of fruit picked in Khan-balik the previous morning.

600 years later, in a disconnected and emergent United States, before it was overtaken by the Iron Horse of the railways, the Pony Express relied on exactly the same principle with even more frequent changeovers to deliver news and mail between Missouri and California in about 10 days. Relay systems, albeit in an unrecognisable form, comprise one of the fundamentals of digital communication. The stage is almost set to introduce the computer phenomenon which spawned the Internet. Just one ingredient is missing, and it concerns the computer's original function.

[3] Ruler of Persia between 522-486 BC.

[4] Devisor of the first codified legal system, the Babylonian General-King had the code engraved on a stele of black basalt, accompanied by a depiction of his receiving the law from Shamash, the Sun God. Hammurabi may have been the model for the story of Moses and the Ten Commandments.

[5] Modern-day Beijing.

The Importance of Nothing

Although modern computers can process words, images, and sounds as well as numbers, the concept of computing, as its name suggests, developed from a desire to speed up various numeric calculations. We can trace its origins way back to the 4th century BC with the invention of the abacus, most probably in Babylon.

Hundreds of years later high in the Andes, the Inca civilisation recorded crop yields and census data by means of knots strategically placed on colour-coded ropes. The device was called a *quipu*, and those early statisticians *quipucamayoc*. Squads of specially trained relay runners called *chasquis*[6] carried the 'programmed' *quipus* between *tambos* [relay-stations] to spread the news. The Incas also decorated dried beans with painted symbols as counting devices.

As important as this concept of calculation was, something was missing. And that something was nothing. More precisely, zero. Which was finally tossed into the mix by the Mayans, another innovative South American culture developed from about 1500 BC until its demise by Spanish invaders in the 16th century. The civilisation reached its cultural zenith during the first eight or nine centuries of the last millennium. Mayans had already developed elaborate hieroglyphic records either etched into stone slabs or written on paper. By the 1st century AD their mathematicians became the first to posit the concept of zero, an absence of quantity. The Hindu language also contained a word for zero, which was adapted by their Arab trading partners. Europe had to wait until about 976 AD before Arabic numerals took over from the zero-less Roman system. Now advanced calculation processes could really begin.

[6] Literally "receive the message." Apparently the *chasquis* were so swift and reliable they could assure deliveries of fresh fish in a relay system from Cuzco at the heart of the empire to *tambos* high up in the Andes, and could cover the 265 kilometres between Lima and Cuzco in just three days.

section 1: the long & winding slip-road

Unlike the entrance to a real-life motorway, the slip-road to the Information SuperHighway meanders across surprising landscapes, accumulating helpful roadsigns along the way. Over the centuries systems of distance message relay were supplemented by smoke signals, drums, fire beacons, semaphore, the telegraph, Morse code, and the telephone. They all used symbolic means to send complex data transmitted as small sequential parcels, and not all served the purpose for which they were originally intended.[7] Add the elements of electricity, transistors, and miniaturisation, and it's easy to fit the development of modern computers into the evolving story of connecting our species. Navigation tip: keep a lookout for how often we hitch a lift with the Navy.

 As we begin the 21st century, most people recognise a computer in the form of a laptop or personal desk-top at home or at work. It sure didn't start like that!

[7] Alexander Graham Bell was convinced his invention would primarily be used to deliver recorded music across long distances.

Anatomy of the Elegant Box

The computer box contains a central processing unit [CPU] which connects to a display device [monitor], pointing device [mouse], various input devices [keyboard, scanner], and various output devices [printer, fax]. Let's trace how its origins as a calculating device resulted in this electronic box of delights. For that we have to re-visit Europe in the mid-17th century.

Various engineers and mathematicians had been developing analogue mechanisms allowing increasingly more comprehensive ranges of calculation. Notable among them was a gear-driven prototype for the first mechanical calculator built in 1623 by University of Tübingen Professor Wilhelm Schickard, who was a friend of the noted astronomer Johannes Kepler. The principles of Schickard's so-called 'calculating clock' [which automated addition and subtraction and provided hints for multiplication] would probably have speeded up the development of more sophisticated machines had not the plans been twice misplaced: once contemporaneously during the Thirty Years War from when they remained undiscovered until 1935, and again during WWII until they reappeared in 1956.

In the 1640s, Blaise Pascal, the French mathematical prodigy and philosopher, improved on Shickard's model using a system of rising and falling weights, but the gears on his 'Pascaline' tended to stick, affecting its accuracy. In 1654 Robert Bissaker invented the mechanical slide rule which was used extensively for hundreds of years as the key calculation device.

By 1674 Gottfried von Leibnitz, primarily remembered for inventing calculus, also devised the first semi-automated multiplication system called the 'Stepped Reckoner,' constructed for him by a Monsieur Oliver in Paris. It could handle up to 16 digits, though wasn't entirely reliable. During the following century, others improved somewhat on Leibnitz's design including the Third Earl of Stanhope in England, Mathieus Hahn, and J. H. Mueller, the latter two from Germany.

Then in 1820, a Frenchman Charles de Colmar completed the first mass-produced calculator, which he dubbed the 'Arithmometer.' A commercial success, it remained in use until the turn of the century. Of course it could add and subtract. It also improved on Leibnitz's multipliers and even allowed elementary division.

All these mathematical functions were incorporated into the early analogue computation systems of the late 19th century, first using elaborate rotating gears and shafts, then electronic and hydraulic systems rather than numerical input. They were put to a variety of civil and military uses. For example, British physicist Lord Kelvin devised such a mechanical system to predict tide times, and by WWI similar systems could variously foretell submarine torpedo courses or control aircraft bombsights.

It wasn't until the 1830s that Charles Babbage and the Countess of Lovelace theorised about automating the process with the Analytical Machine or Engine, which could theoretically handle up to 40 digits.

The idea was to devise a more automated mechanism than the slide rule, one which could solve any mathematical problem. They hoped to use thin boards punched through with holes in strategic places, similar to the pattern boards of the Jacquard loom, then employed in the weaving industry. These punch-boards stored data which could then be used in various mathematical calculations. Babbage estimated addition speeds of a few seconds, more complex calculations in under 5 minutes.

The Countess, whom Babbage referred to as "The Enchantress of Numbers," published an analysis of the Engine, declaring it would "weave algebraic patterns just as the Jacquard loom weaves flowers and leaves." She went on to theorise many of the basics still employed in computer programming, including memory storage, data analysis, sub-routines and looping [which she compared to a "snake biting its tail"]. The Countess, Augusta Ada King, was the daughter of the great Romantic poet Lord Byron, and it is after her that the computer language Ada is named. Sadly the Analytical Machine would have required the power of five steam engines and taken up an entire football pitch, so Babbage and the Countess never saw it built.

The principles, however, had been outlined, and it was left to the 29-year-old American Herman Hollerith to patent a mechanism in 1889 which calculated census data by passing a series of punch-cards through an electrical contact. Seven years later Hollerith founded the Deutsche Hollerith Maschinen Gesellschaft [Dehomag] which became the German subsidiary of the International Business Machine Company in 1924. IBM was born.[8]

Another vital contribution had already been introduced by British mathematician George Boole, who, in the 1850s, devised an algebraic system using only two digits: one and zero which is why it's known as the binary system. Reducing the number to two allows symbolic representation via switches in either the on or off position. Such switches can be connected to a variety of storage, transmission and/or recording devices.

However complex the combination of numbers, they're represented by ones and zeros, commanding the position of switches to relay the information. And, since the information can represent any kind of data [words, numbers, images, etc], this Boolean logic is what still drives data transfer in today's computers.

[8] In 2001 historian Edwin Black published *IBM and the Holocaust* [Crown] documenting the rise of Thomas Watson from Sales Manager at National Cash Register, to President of the Computing-Tabulating-Recording Company which became IBM in 1924. Watson, recipient of a medal from Hitler which he returned in 1941, and later lauded by President Eisenhower as "a truly fine American [and] a great humanitarian," entered into a strategic alliance with Hitler in 1933 not only in using the Hollerith cards to identify German Jews but in planning and executing the means of their destruction.

The millions of minute on/off switches mounted on a microchip are now called bits,[9] eight of which compose each byte. The speed of data transfer is measured in bytes per second. This forms the basis of representing and manipulating information in small groups or packets, much like the smoke signal or telegraph principle.

Complementary to the switching system was the invention in 1907 of the triode vacuum tube by Lee Deforest. The tube or valve was essentially an amplification device for radio, telegraphy, and telephony. All automated computing devices relied on such valves prior to transistors.

After serving in the US Navy as a research engineer during WWI, a scientist and educator named Vannevar Bush invented the differential analyser, a more sophisticated automated solution for complex maths problems. He later chaired the Defense Research Committee for the US government, which as we'll see contributed to the development of much more than a range of calculation systems.

So, given the long and cumulative evolution of its various functional components, instead of approaching the Net with trepidation as something alien and impenetrable, we can assign this electronic delivery system its place among all the other communications networks which our ancestors devised. Unlike all the others, however, this one allows us to engage in a multiplicity of simultaneous data transfer often referred to as multi-media, since it encompasses various combinations of text, speech, music, and both still and moving images. It's worth highlighting how it evolved to manage all that, if only to underline how far it's come from its original purpose.

The War That Changed Everything

As well as all the urgent and military-inspired technological advance documented below, World War II effected significant social change. This, more than any other organised conflict since pre-historical tribal clashes, saw merit, expertise and intellect valued more highly than rank, class and privilege. How people behaved and the results of assignments began to matter more than their ancestry, what school they'd attended, or their bank balance. Particularly for the Allies, though not universally, the axiom proved truer the longer the war raged. When peace finally came, these seeds of social change sprouted unexpectedly in the field of computer and Internet development.

In 1937 a brilliant maths professor at England's Cambridge University, Dr Alan Turing, as fascinated by the process of problem-solving as Vannevar Bush, published a paper setting out all the principles for a simplified computing language eponymously known as Turing's Universal Machine.

For his biographer Andrew Hodges, Turing's "total originality lay in seeing the relevance of mathematical logic to a problem originally seen as one of physics.

[9] The word bit is derived from Binary digIT

In this paper, as in so many aspects of his life, Turing made a bridge between the logical and the physical worlds, thought and action, which crossed conventional boundaries."[10] Both Bush and Turing figure prominently in our story. Each also illustrates the very different support systems of their respective countries.

As the conflict of 1939 escalated fatefully into World War II, communications over vast distances became vital to coordinate activities for both sides. A safer, more sophisticated system was required than had served during the previous War, when 80,000 homing pigeons became military messengers for the British Air Force. The new military command units required a method of closed communications between high level field reporting and the collective HQs. Capitalising on Marconi's production of wireless messages between Italy and the UK at the start of the century, both the Allies and the Axis set up closed telephone networks to allow such private conversations. In effect, this was the prototype for the principle of the Internet.

Though precise information about developments in relevant countries is still protected under Official Data legislation, we know several European military agencies had long been funding research on various forms of encryption devices, decoders, calculators, and processors. Particularly in America, much of the research was assigned to university departments, cementing a relationship between the military and academia which has stimulated decades of ethical debate tabulating the moral price of technological progress.

With the war in 1914 had come an imperative to create, intercept and interpret military coding systems. Instead of the *ad hoc* employment of espionage networks used by governments for centuries, Military Intelligence became official. Of course several European countries had already set-up top-secret codebreaking units, with a watchful eye on German re-armament after their WWI defeat. The British operation, established by Naval Intelligence in 1919, housed a cryptography team of over 50 personnel in Room 40 at the Admiralty. The unit went by the almost cosy-sounding title of the Government Code and Cypher School, or GCCS, which was rapidly given the sobriquet Golf, Cheese and Chess Society. Three years later the Foreign Office took control of its activities. We'll soon see how valuable it became.

The US State Department, too, established MI-8. Referred to as the Black Chamber, it was based in New York and headed by Herbert Yardley. The unit, under the aegis of the Army, successfully decrypted various foreign diplomatic codes, including the Japanese, until it was suspended in 1929. After Yardley's departure, William Friedman led the team of cryptanalysts; he is now honoured as the Father of American Cryptology.

Meanwhile, the US Navy had addressed similar problems since the 1920s. Cryptanalysts Laurance Safford and his civilian associate Agnes Driscoll focused on deciphering naval encryption systems, recruiting a support team to crack WWII

[10] The Alan Turing HomePage http://www.turing.org.uk/; quoted with permission by the author. The latest edition of Hodges' book *Alan Turing: the Enigma*, was published in May 2000, by Walker and Company, New York, ISBN 0-8027-7580-2.

Japanese naval codes.

For encryption purposes, the American Army had been working with the Choctaw tribe to produce secure voice communications on the battlefields of WWI.[11] By the time the US entered the Second World War, many native Americans were selected for similar purposes including Cherokees, Choctaws, Commanches, Hopis, Kiowas, Navahos, Seminoles, and Winnebagos.

The Army's sister-force the Marines also used what they called codetalkers, relying exclusively on members of the Navaho tribe. It's worth noting the record of these tribesmen was 100% in transmitting messages which were indecipherable to the enemy. Their invulnerability was primarily due to the Navahos' phenomenal ability to keep all the coding templates in their head – since nothing was written down, the Axis had no means of deciphering.

In 1922 Arthur Scherbius had developed a highly complex mechanical coding system called the Enigma Machine for use by banks and railways, which German Military Intelligence bought for the Navy in 1926. Its various stages of development are crucial to the story of how computers evolved into devices sophisticated enough to service the Internet.

The fundamental principle of the Enigma is a series of code letters, sequentially displayed on notched wheels called rotors. These are linked to another series of letter equivalents or cribs, with the proviso that no letter can ever equal itself. The greater the number of rotors, the greater the number of coding permutations. Once again, I want to concentrate on the inspirational process rather than the intricacies of the hardware.

With customary efficiency, extensive documentation was prepared to accompany Enigma, including set-up instructions and coding examples. Whether by fair means or foul, a set of these papers was obtained by an ambitious clerk in the German army. In 1931 he actually sold them to the French Secret Service, where their significance was totally ignored by the cryptography unit. When he later approached the GCCS, the clerk didn't even make a sale because the perceived wisdom in the UK was that Enigma simply couldn't be cracked. This was an error which added years onto the ensuing war.

Both civilian and military versions of Enigma were manufactured and some were sold abroad – in fact one was bought by the Polish government. One notable version the V1 [later renamed the Z1], was the brainchild of an engineer named Konrad Zuse and his assistant Helmut Schreyer, credited by many as the inventors of the first mechanical binary programmable calculator; it printed results on redundant 35mm celluloid.[12]

[11] Security was deemed guaranteed since the Choctaw language was so obscure.
[12] The V1 metamorphosed into the V2 and eventually the V3, all of which were re-assigned the identifier Z, perhaps to avoid confusion with the V2 rocket, developed by Wernher von Braun, coincidentally a friend of Zuse.

The Net Effect

In Poland [already in possession of a commercial Enigma machine] Marian Rejewski led a small decryption unit which broke the German code in 1932 with a system they called a Bomba, allegedly because it made a ticking sound. Though their contribution to the story cannot be underestimated, their success served only to encourage even more complexities of Enigma.

As war approached in 1939 the Poles, with ever increasing reasons to foil German efforts, passed on their deciphering work to the British during a secret meeting near Pyry. But the Allies had their work cut out.
Throughout WWII the Germans employed different versions of Enigma for each of their military services; each version depended on its own codes. Cracking any one code wouldn't get you very far because the decryption keys were changed every day. These keys depended on a manual intercept of which ciphers represented which, itself a complex and random process. Subsequent Enigma incarnations boasted even more intricate rotor and cable mechanisms. By 1941 Zuse, backed by the German Aeronautical Research Institute, improved on his previous civil prototype and applied to Enigma the same concepts of binary mathematics and Boolean logic to produce a programmable electronic calculator.

At its most complex, the Enigma produced 150 trillion coding permutations! The Axis Powers were thrilled – Hitler's war machine enjoyed every strategic advantage. Archived memos of the time reveal the German command was convinced that Enigma rendered them invincible. It certainly was an elegant system, albeit not in appearance.

The device looked like a deformed typewriter, featuring a keyboard topped by a series of visible windows. Pressing one of the lettered keys resulted in the production of a completely different and randomly chosen letter which appeared in one of the windows, set in place using the system of rotors. The random crib equivalents could be activated by manually plugging in a circuit wire to relevant connecting holes, rather resembling an old-fashioned telephone switchboard. Every day, German military command changed the wire-codes using a *TagSchluessel* or daily key, so that Enigma messages never used the same cipher equivalents two days running.

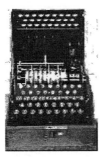

A version of Enigma

All the Allies tried to crack these impenetrable codes, but we know most about the British and American efforts. Both governments funded Military Intelligence units of mathematicians and theorists for this top-priority which became known as the Ultra Project because it was classified as Ultra Secret. Even with subsequent freedom of information legislation it has been virtually impossible to discover the precise degrees either of cooperation or competition between the Allies with respect to such higher-than-Top-Secret activities. We shouldn't forget that before 1989 in Britain the very existence of MI5 was officially denied, and that of MI6 until 1994. Rumours are legion of internecine competition not only between the different military divisions but between Allied countries.

A prime example of inter-Allied surveillance was the top-secret Venona Project, set in train at its headquarters in Arlington Hall, Virginia by the US Army's Signal Intelligence Service [SIS][13] in 1943 to monitor and procure the encryption codes being used by the Soviets to exchange diplomatic messages. An unanticipated result of Venona was the discovery that Soviet secret service operatives were working under cover in the US. It is only surmise by some analysts to assume the reverse was also true. Persistent monitoring of the Soviet Union continued after the war under the aegis of US Army Intelligence G-2, which intercepted messages exposing the Soviet Union's knowledge of the Manhattan Project and other sensitive military information.

Cracking the German codes occupied the greater wartime effort. There were two decryption priorities: 1] deciphering Enigma codes quickly enough to subvert their daily variations, and 2] the encrypted teleprinter transmissions based on cipher-codes,[14] which served as a closed communications network between Hitler and his generals. The latter, called *Schluesselzusatz* by the Germans, could encipher and transmit simultaneously, saving precious time. It was nicknamed Fish by the Allied decryption teams, and both the intercepted messages and decryption machines were known variously as Tunny and Shark. In all but name, Fish acts as an Internet.

A Bodyguard of Lies

In 1939, the year prior to his elevation as Prime Minister, First Lord of the Admiralty Winston Churchill authorised the relocation of the GCCS to a decryption facility at Bletchley Park in Buckinghamshire. It was under the overall supervision of Naval Commander Alastair Denniston and referred to in official documents as Station X, though its denizens called it BP.

[13] The SIS eventually became the National Security Agency, whose National Cryptologic Museum based at Fort George G. Meade near Washington DC houses an extensive collection of declassified wartime military intelligence records, including exhibits of Enigma and its successors.

[14] The codes were engineered by the Lorenz Company and actually based on an American system developed during WWI by Gilbert Vernam for what was then the National Cash Register Co. The company later focused on electronics, eventually becoming AT&T.

Behind a deceptively innocuous red-brick facade resembling a row of residential houses, the Intelligence Agency drafted in a bevy of predominantly male academics, cryptographers, and mathematicians, supported by a dedicated team of women information processors,[15] to decipher coded messages which had been intercepted by teams at Knockholt and other British listening posts, called Y-Stations. There were so many messages whizzing around, one Wren[16] reported the interceptors were getting chronic cramp in their fingers with so much writing.[17]

The role of the Bletchley female support team went largely unrecognised until a debate in the House of Lords in March 1997 to request government funding for a memorial was led by Baroness Trumpington, who had herself been posted to Bletchley when she was 18. After describing the sad process of totally dismantling the Bletchley equipment after the war on the orders of Churchill, she declared that she wanted to honour "the Wrens and civilians who did the actual donkey work for the brilliant mathematicians."[18]

Sometimes the Enigma operators used swear words in the code – one of the Bletchley Wrens considered herself an expert in such slang, and interviewed in *Station X* told how she decrypted a message from the German Command forbidding the use of bad language to protect the innocence of the young female decoders. Apparently this was one command which continued to be ignored.[19]

At its most industrious, Bletchley employed over 12,000 people, none of whom was permitted to tell even those closest to them exactly what it was they were doing every day. But, as the Baroness pointed out, "the two really major historical events of the 20th century that took place at Bletchley were the development during World War Two of the science of cryptology and the first digital electronic computer."[20]

In 1940 US President Roosevelt okayed the equivalent establishment of the euphemistic Communications Supplementary Activity – Washington [acronym CSAW, pronounced See-Saw], housed in a former girls school on Nebraska Avenue. The US team also comprised an *ad hoc* amalgam of military and civilian personnel with expertise in pattern recognition, including musicians, chess experts, and scientists from all disciplines. They enjoyed even greater protection than those on the Manhattan Project which eventually produced the Atomic Bomb.

[15] Interestingly, these processors were collectively known as "computers."

[16] Women's Royal Naval Service [WRNS].

[17] As depicted in the television series *Station X* broadcast first in the UK in 1999 by Channel 4 and subsequently on WGBH in the US.

[18] *Hansard*, 20 Mar 1997: Column 104. It is worth noting that the Liddell Hart Centre for Military Archives at Kings College London, contains personal documentation on the work of Edith Gordon Blagrove [later Lady Brind], who, as Superintendent in the WRNS, became an administrator at Bletchley Park.

[19] *op cit*

[20] *op cit*

Once the US officially entered the war, Allied information exchange escalated, albeit on a restrictive basis. Both Churchill and Roosevelt were aware that German Observation and Cryptanalysis Services [the *B-Dienst* and the *E-Dienst*] could intercept strategic messages. In some cases these were sourced not by military personnel but insurance underwriters.

Some US insurers for Allied military shipping were partnered by Swiss companies, who, wittingly or not, passed on vital information to their own German co-insurers. Though ostensibly neutral during the war, the Swiss establishment was rife with anti-Semitism. Even today information is being uncovered of services provided by Swiss financiers to the Germans, such as secret bank accounts and stores for looted art treasures. Given such a military advantage for Hitler, this upped the ante for the Allies to decrypt all versions of Enigma. And fast!

CSAW arranged for several teams to be stationed at Bletchley. In 1941 Station X received a small American delegation including naval personnel Lieutenant Robert H. Weeks and Ensign Prescott Currier accompanied by SIS representatives Captain Abraham Sinkov and Lieutenant Leo Rosen.

Significantly their official report contained no mention of Bletchley's success with Enigma. Of course the delegation was well aware of decryption progress but had sworn to pass on the restricted information only to the top command at G-2, SIS, and Friedman at MI-8. Debates still rage about whether or not Captain Safford's US Naval encryption unit, Op-20-Q, was also on this elite list, since he focused, as we've noted, on the Pacific war. Confusion is fueled by a memo Safford sent in 1942 to his unit command, pleading for more circumspection in releasing progress reports about codebreaking, claiming that the Allied chances of cracking Enigma remained "rather poor."[21]

Information-sharing among the Allies continued in various forms. For example, CSAW funded and administered so-called war-related courses, such as that at the University of Pennsylvania's Moore School, which were attended by various Bletchley personnel.

After working doggedly for years to analyse, deconstruct and address the complexity of the German codes, both the Americans and the British were working on systems of advanced circuitry combined with hundreds of vacuum tubes. In fact there were so many of these valves, and they emitted such heat, it's rumoured the cipher teams used them to dry their washing.

Trumpington's "brilliant mathematicians" were universally referred to as boffins. The various programs they devised at Bletchley in effect served as blueprints for the Wrens who used them to decrypt intercepted messages from the German code machine settings.

[21] Various explanations mooted for this include that Safford was being deliberately misleading to officers he didn't trust, or that he was referring to only one version of Enigma.

These Wrens included one Margaret Young, interviewed some 55 years later in January 2000 by Andrew Broom, a fellow retired archivist at the Scottish Record Office. She told him, "During the war when you were aged twenty, unless you were in a reserved occupation, you had to go into the war effort, and I had tried to get into the WRNS, but I was directed to Bletchley Park, which in those days was a very secret establishment. I wasn't one of the famous boffins, I'm afraid, I was just in charge of a roomful of teletext machines."[22] At the time, Margaret had no idea of the part she played in breaking the famous Enigma code.

"I knew it was highly secret, obviously ... but, I mean, nobody actually knew unless you were working on it. And when I was told that I was going to be allowed to leave once the Japanese war finished, I remember I was hauled up before a brigadier and warned with dire threats of being taken to the Tower if I ever opened my mouth about Bletchley."[23] Another of Margaret's colleagues relates in the fascinating Channel 4 series *Station X* how she only realised the urgency of what they were all really doing when she was handed a *Luftwaffe* codebook still wet with the captured aircrew's blood.[24]

Bletchley's undoubted star was Alan Turing, whom the British Intelligence Service had recruited in 1938 for the top-secret GCCS upon his return from completing a doctorate in number theory at Princeton University. The work he'd already accomplished with his Universal Machine [in all but name a computer program], had resulted in a computing device, jokingly nicknamed the Heath Robinson, which relied on an intricate series of electromagnetic relays to multiply binary numbers.

The Heath Robinson was in the charge of Max Newman and Wynn-Williams. Newman, whose expertise was in the topological study of geometrical properties and spatial relations, had been Turing's tutor at Cambridge and privy to his paper on Computable Numbers. Turing was placed in a decryption unit headed by Dillwyn 'Dilly' Knox, and set to work on a counter-Enigma system called Ultra.

He teamed up with fellow Cambridge mathematician Gordon Welchman, and improving on the effective but limited Polish Bomba, they developed the Turing-Welchman Bombe which was used to decipher *Luftwaffe* Enigma signals. Their first success averted an attack on the Derby Rolls Royce factory in June 1940, and was subsequently of vital importance in coordinating the evacuation of Allied troops at Dunkirk. This was the Ultra in action.

[22] *Celebrating Memory:* An oral history of the Society of Archivists and its members as transcribed on the Planned Environment Therapy Trust Archive and Study Centre website: http://www.pettarchiv.org.uk/
[23] *ibid*
[24] *op cit*

The Net Effect

The German Naval Enigma codes were proving much more insidious, and the *U-Bootwaffe*, Germany's submarine fleet, honed its so-called grey wolves into a devastating sea presence. They hunted down Allied vessels in underwater convoys called wolf-packs. Turing, universally referred to at Bletchley as 'Prof,' set up a special unit in Hut 8[25] solely to decrypt the U-Boat codes.

Meanwhile a CSAW Naval support group based in Ohio collaborated on a similar arrangement they also called a Bombe. Both systems depended on the speed of their automated calculation, eliminating incorrect parameters, to decipher in minutes what had been taking decryption teams hundreds of hours by hand. Here, too, and later in the US capital, women played a crucial but secret role. Decryption work was processed by units of WAVES,[26] whose full story only became known in 1995 when President Clinton ordered a partial lifting of the project's information ban.

Though the U-Boat codes still eluded them, both the British and Americans had achieved a far greater understanding of the Enigma problem. This was in no small part due to the capture of a German weather ship and its codebook by none other than 007 creator Ian Fleming, who'd also been part of the Bletchley team. However, an even greater prize fell into Allied laps in May of '41, when Kapitän Lieutenant Fritz-Julius Lemp, in command of the submarine U-110, fired torpedoes into a convoy of British ships in Icelandic waters.

In the ensuing battle, the German sub was damaged, convincing Commander A. J. Baker-Cresswell, of the destroyer *Bulldog* that he could capture the U-Boat. The whole incident happened so quickly that the U-110's Enigma operator Georg Hogel was ordered to evacuate, leaving behind his equipment, a consecutive series of the ever-changing codes, and the relevant position charts, all of which were salvaged by the British before they hooked up the sub to tow it back to Blighty.

But the U-Boat broke free and sank without trace. Admiral of the *U-Bootwaffe* Commodore Karl Dönitz [eventually to succeed Hitler as President of the Reich, Minister of War, and Supreme Commander], was mistakenly convinced the Enigma code was safe.[27] Sadly, just being able to correctly decrypt Enigma codes couldn't instantly compensate for the German's superior fighting power, though the incidence of successful Allied U-Boat sinkings rose during May and June. For Turing, capture of the codebook only reinforced his conviction that decryption must be made automatic to be effective.

[25] The legendary huts were a complex of fairly basic workshop outbuildings behind Bletchley Park's imposing red-brick structure; each served as home to different code-breaking teams from all branches of the armed forces.

[26] Women Accepted for Volunteer Emergency Service.

[27] In May 2000, Universal Pictures released *U-571* which is a fictionalisation of the U-110 incident, in which the Enigma codes are captured by an American boat with an American crew! British film director Michael Apted completed a feature adapted by Tom Stoppard from the Robert Harris thriller *Enigma*,due for release in 2002 by Manhattan Pictures International. Although this more accurately sets the codebreakers in the UK, the story's focus is on the key decryption boffin [played by Dougray Scott] suspecting his Bletchley paramour is a spy.

The enduring secrecy of Ultra [doled out to those on the front line on a need-to-know basis] actually resulted in some tragic sacrifices, raising the same kinds of moral dilemmas for the codebreakers as would later torture J. Robert Oppenheimer for his work on the Atom Bomb.

Accounts differ, but it is generally accepted that when a German operative, instead of the usual substitution *Korn*, accidentally sent a direct code for the word 'Coventry' in a message revealing a planned *Luftwaffe* attack on the city, British Intelligence let the air-raid proceed after putting the emergency services on alert. To have tried to forestall the bombing would have tipped off the Germans that their code had been broken, and the Allies wanted them to keep using it.[28]

Perhaps even more contentious has been the revelation that the Y-Stations were intercepting messages about atrocities in the death camps, which were also not acted on. Fierce pressure to end the war led Churchill to remark the following year, "In wartime, truth is so precious that she should always be attended by a bodyguard of lies." It is on the back of such impossible choices that pre-Internet technology was developed.

Tunny Turns the Tide

In 1942 Turing was secretly posted to America on a four-month consultation with the US top brass and research teams, not only to address U-Boat codes, but also to advise on an electronic encryption mechanism to carry speech signals between Roosevelt and Churchill. During Turing's absence his deputy, the former chess champion C. H. Alexander was put in charge of Hut 8.

By the time Turing returned in March 1943, the U-Boat code was broken, and he'd been reclassified as a roving consultant on all Bletchley projects. Despite victory with Enigma, the Fish still swam free. At first the Heath Robinson was set to hook the Fish, but there were problems. Then, as reported so eloquently in *Station X*, the decryption unit had a lucky break in 1941 when one of the German transmissions was sent twice using the same codes, allowing mathematician William Tutte to work out the logical structure of the Tunny codes. The unit now had an overview of their problem, but Heath Robinson still couldn't seem to crack it.

[28] In fact, to preserve the sanctity of Bletchley, the British sent out decoy messages to fool the German command into concluding that the Italians had betrayed them. The Italians avenged themselves by stealing an Allied codebook in Rome and passing it back to the Germans.

Never one to promote either his own ego or the old boy network, Turing sent Newman to the Dollis Hill Telephone Research Establishment for the Government Post Office.[29] There he was introduced to an amazingly self-motivated boffin called Tommy Flowers, who had put himself through night school and earned a degree in engineering from London University. Under its motto 'Research is the door to tomorrow,' Dollis Hill was an early prototype of the industrial R&D lab.

Flowers had been working on an electronic system which would eventually be incorporated into today's direct dialling and long-distance dialling facilities. When he first encountered the Heath Robinson, he proposed replacing its system of electromagnetic switches with valves, estimating the new device could be completed in under a year.

The Bletchley strategists were horrified at the thought of such a delay, surmising that with Hitler's military advantage, another year would see an Allied defeat. They decided to stick with Heath Robinson, hoping Turing would sort out the bugs. Besides, they argued, weren't valves unstable?

Undaunted and convinced of the reliability of his valved system, Flowers persuaded the Dollis Hill money-men to employ a team to work day and night on a prototype which they called Colossus. In December, just eight months later, they demonstrated its capabilities to an astonished crowd at Bletchley. The machine comprised 1500 vacuum tubes and filled an entire room. Until then the biggest machine ran on a mere 150 valves. Colossus could analyse Tunny's code wheel settings [and there were millions], recording on 5 paper-tape loop readers, each processing 5,000 characters per second. Best of all, it sacrificed not a jot of accuracy for its speed.

Quoted in the press years later Flowers called his effort "a string-and-sealing-wax affair." Bletchley immediately invited him to construct a larger Mark II version of Colossus, nearly doubling the number of valves – oh, yes, and it had to be operational by June 1944.

It was because Flowers' new one-ton version, [operating at five times the speed of the prototype] was delivered on time, that the D-Day landings at Normandy proceeded so effectively as the world's largest ever naval invasion.[30] By 1945 Bletchley was operating ten versions of Colossus, each in its own room and staffed around the clock in three shifts by specially trained Wrens.

[29] The GPO was later privatised into British Telecom, which coincidentally co-owned the Bletchley Park site with the Department of the Environment. As of winter 2000, BT was in negotiation with Chris Smith, Secretary of State for the Department of Culture, Media and Sport to codify a lease-back arrangement to the BP Trust for the remaining 30 acres. In early 2001 The Post Office changed its name to Consignia.

[30] The Allies had been allowing the Axis command to intercept phoney messages about the attack; Colossus verified that the Germans were fooled.

It's a tribute to the entire Bletchley team that although Colossus made swift work of Tunny codes for over two years until the very end of the war none of them had ever seen the Fish.[31] Military historians agree the achievements of the codebreakers turned the tide for an Allied victory.

These military cryptography teams were not only concerned with decoding German messages, they developed mechanical encryption systems of their own. These included one the Germans never deciphered called the Sigaba, which mirrored Enigma's typewriter-like keyboard. When pressed each key selected ciphers from over half-a-dozen geared wheels and printed them onto a rotating paper-tape. Very similar in appearance was the Typex machine whose added advantage enabled it to process joint communications between the British and American Command.

Little is known of the Soviet mechanical cipher transmission systems, except for German reports of capturing such devices during their Russian invasion. But it was on their post-war Russian successors that the surviving GCHQ Colossus machines were trained as Britain played its role in the Cold War. Back in Germany, Zuse himself continued to pursue encoding solutions, and in 1945 invented a programming language called *Plankalkul*. The company he founded was acquired by Siemens in 1969.

Of course the war was also being fought on another front in the Pacific. In 1940 Japan signed a treaty with Germany and Italy to form the Axis. The following year, to protect the borders of their Chinese occupation, they also signed a non-aggression pact with the USSR. [32]

During the war, the Japanese employed three highly complex coding machines, known by the Allies as Purple, Coral [or Red], and Jade, all designed around relay switches and plug-boards, with a series of semi-circular wipers wired to contact terminals instead of Enigma's rotors. The system itself was known as JN-25 by the Americans, and proved remarkably effective for transmitting wartime diplomatic information. These machines were the focus of Captain Safford's Navy decryption unit Op-20-Q. It has subsequently been noted that the US Naval Command considered the combined Allied code-breaking work so secret that at one point President Roosevelt was taken off the distribution list!

[31] It is entirely due to the determination of ex-MI5 operative and nerd-before-his-time Tony Sale that so much of the detail is known of the Bletchley Park and subsequent CSAW work. Sale painstakingly reconstructed Colossus, completed in 1997, and helped avert the proposed sale of the BP site for redevelopment, assuring its conversion to a museum of which he is now the curator. In May 2000, an Abwehr Enigma Machine, serial number G-312 was stolen from BP, prior to the installation of an upgraded security system. In mid-October, and minus its rotating wheels, it was sent with a demand for £_ million to Jeremy Paxman, a BBC broadcaster. In November Dennis Yates of Derbyshire was arrested on charges of theft and extortion. As of spring 2001, the missing parts had not yet been recovered.

[32] The Russians finally did declare war on Japan, but only after the Atomic Bomb was dropped on Hiroshima. Some analysts claim it was this conflict of Soviet interest more than anything that set in train the subsequent Cold War; though others cite the rabid anti-Soviet activities of an obsessed and ambitious J Edgar Hoover in the 1920s.

The SIS wanted a Pacific decryption presence closer to the actual fighting, and during the summer of '42 Sinkov, recently back from Bletchley, was posted to Melbourne [and later Brisbane] to head the unit, which also included a small Australian contingent. Their progress in conjunction with Op-20-Q allowed the US to capitalise on the decryption work at Bletchley and contributed to Japanese naval defeats in the Coral Sea and Midway battles. By this time, though, Roosevelt had become convinced that only the Atom Bomb could stop the war. As we'll see below, both CSAW and the early computers played a role in achieving this goal.

It will probably never be fully revealed the exact nature of how much was shared between the Allied forces of the decryption methods used in both theatres of war. Certainly both British and American Intelligence were determined to keep details from their USSR Allies.

The efforts of the Allied codebreakers were not only seminal in affecting the outcome of the war, but in setting out the blueprint for the development of all today's computer systems. And here's a salutary thought: the program code that steers the World Wide Web is more complex than all World War II codes put together!

Swords Into MicroChips

By the end of the war, both Britain and the United States possessed the technology and the talent for either nation to lead the digital development begun in the wartime cipher rooms. It's true that six years of conflict and deprivation left the UK in a far more fragile fiscal position than their US comrades in arms. Even before the war's end a nearly bankrupt Britain received millions of Lend Lease dollars for military equipment. British post-war efforts concentrated on establishing a Welfare State to serve all the people.

There was no rush by American industry to claim the territory. I believe it is the very hands-on involvement of the US military in the commercial sphere which assured America's dominant position in the evolution of computers and the Net. It's important to document this influence, not just for the record, but to put in context the reaction of governing bodies to some of the unanticipated uses of the Net today.

It's impossible to credit any one person with the application of computing technology to what we know as the Internet, but I'd like to highlight several *sine qua non*'s. Their work illustrates the segue from the military arena of the war years to the subsequent contributions from the academic and commercial spheres. We've already met two of them: Vannevar Bush and Alan Turing. Let's start with the former.

During the war, Bush, already straddling the worlds of defence and research, was put in charge of the Office of Scientific Research and Development, setting the agenda for all military research projects. He also became the Director of the Research and Development Board of the Army and Navy. In July 1945 Bush contributed an oft-quoted article to *The Atlantic Monthly* entitled *As We May Think*, in which he asked provocatively "What are the scientists to do next"? Bush's privileged knowledge regarding the R & D work of the 1940s, render his predictions, often inaccurate in detail, less startling to us than those of Nostradamus must have seemed to his 16th century contemporaries. His ruminations on the electronic computer however remain suitably prophetic.

Bush posited that of all scientific disciplines it was physics which had raised expectations for post-war scientific achievement. He also extrapolated these possibilities to civilian application. He predicted that the cumulative rate of scientific development and its prodigious output of data would paradoxically serve to lessen the overall knowledge of the individual, forcing greater and greater specialisation [and not inconsequentially, increasing the need for information management]. He declared the mass production of electronic components would result, not just technically, but economically in the viable realisation of the theoretical computing machines of the 19th century.

He also foresaw data compression for information storage and rapid retrieval, though he envisioned the *Encyclopaedia Britannica* on microfilm as opposed to digital disk. Bush wrote that typewriters would respond to the human voice rather than pressing lettered keys, a concept which he said would lead to mobile communication devices all connected to each other.

Moreover these machines could be programmed to process data automatically and more rapidly than anyone thought possible. They'd also be able to act in concert with other automated systems – he gives an example of a department store sale affecting simultaneous changes in inventory, sales staff identification, and customer debiting. Today we call this convergence technology.

Bush recognised that the essential contribution of the scientist and mathematician was not a facility to solve equations, but the ability to analyse, to assess, and to extrapolate. He valued logic and symbolic thought. Mere processing was the province of programmable machines. He warned against thinking of increasingly automated machines as comparable to the associative working of the human brain, but suggested that systems of information selection could attempt to mimic this process for each person. He called the mechanism memex, predicting it would contain books, records, and communication data. This information could be exchanged with other people, amended, and accessed when required. If all that sounds familiar, it's not far off what we know today as the personal computer.

As already noted, both during and after the war American military research into computing and establishing more reliable communication systems was being carried out at several US universities, including Pennsylvania and Stanford, under the Advanced Research Project Agency, which plays a vital role in our story. It's ironic that today's ubiquitous desktop and laptop computers contain more processing power than the massive machine funded by the military and developed during the war at the Maryland Ballistics Research Lab to calculate artillery tables, affecting such operations as angles and trajectories of cannons.

The machine was called the Electronic Numerical Integrator Analyser and Computer or ENIAC, and was finally built in 1945 at the University of Pennsylvania's Moore School of Electrical Engineering. It occupied 1500 square feet, weighed in at 30 tonnes, was the first fully electronic digital computer, and was undoubtedly known to Vannevar Bush.

Since it predated by two years Bell Laboratory's invention of the transistor, ENIAC still depended on nearly 17,500 vacuum tubes and had to be programmed manually. It remained in use until 1955, despite the early appearance of the microchip and microprocessor in the 1950s.

Chief engineers on ENIAC were a couple of guys named John: Eckert and Mauchly.[33] Mauchly, the elder by 12 years, had already received a doctorate in physics from the prestigious Johns Hopkins, a military-related institution in Maryland with a global reputation in medical science. Because he was intrigued by high-speed electronics, in 1941 Mauchly enrolled in a war-related course at the Moore School. Also based there was his wife Mary, who had joined the CSAW team of approximately 100 women [like those at Bletchley known collectively as 'computers,' because they worked with electric calculators to produce the artillery firing tables]. While at the Moore School Mauchly met Eckert, a University of Pennsylvania graduate in electronic engineering working in a unit led by Hungarian-American John von Neumann, who was for many years given credit for masterminding ENIAC.

Of the hundreds of female 'computers,' von Neumann chose six to join Mauchly and Eckert. These half-dozen women [Kathleen McNulty, Frances Bilas, Jean Jennings, Elizabeth Snyder, Ruth Lichterman, and Marilyn Wescoff] became the first people to be known as computer programmers. Several of these women have subsequently participated in television documentaries, revealing the true purpose of ENIAC. One of the women's roles was to 're-wire' the machine when a new problem needed calculating. The wiring was similar to the telephone switchboard-like plugs used on Ultra, and reset in conjunction with the manual on-off switches. They were used to the boffins asking them to help with various complex mathematical problems.

Near the end of the war, a delegation from Los Alamos paid the team a visit, given clearance to calculate a new problem. Weeks later, when the women 'computers' learned about the bombing of Hiroshima, they realised they'd actually played a part in the Manhattan Project, developing the Atom bomb.

[33] Eckert, however, was always referred to by his middle name Presper.

The ENIAC patent was challenged decades later in 1973. In a corporate patent lawsuit, University of Iowa Professor John Atanasoff claimed that back in 1937 he and his research assistant Cliff Berry had shown Mauchly their prototype for a device incredibly similar to ENIAC, even though they never followed through with its full production. Atanasoff won the case. In 1940 he and Berry devised the ABC[34] which solved simultaneous linear equations. It ran at a speed of 60 Hz, performed additions in under a second, was a serial, binary, electromechanical, digital, special purpose computer, and contained the first regenerative memory. Atanasoff was presented with the Pioneer Award in 1984 by the Computer Society.

However, the role of Eckert and Mauchly cannot be dismissed, and they were justly rewarded, too, with the American National Medal of Science among other honours. For they didn't stop with ENIAC, but set up their own company in 1946 to develop machines which superseded its storage and processing capabilities. First they worked on the BINAC [Binary Automatic Computer], designed for the US Air Force as an early in-flight computer and completed in 1949. It could process 3500 additions or 1000 multiplications per second. Even though the partners were far better at binaries than business, the Eckert-Mauchly Computer Company went on to develop EDVAC [Electronic Discrete Variable Computer] and then UNIVAC [Universal Automatic Computer], the first electronic computer to be used commercially.

One of their team was a highly inventive former Associate Professor of Mathematics from Vassar. Her name was Grace Murray Hopper and her contribution to the computer/Internet tale yet again bridged military and commercial research. She'd been inducted into the US Navy in 1943 as a Lieutenant [junior grade], and would eventually rise to the rank of Rear Admiral.

Her first assignment, though, was to Harvard University's computation laboratory headed by Howard Aiken, who employed her as a computer programmer on an IBM-backed project called the Automatic Sequence-Controlled Calculator. Back in the 1880s Aiken had been instrumental in keeping alive the principles formulated by Charles Babbage. He also predicted that one day all US business would be conducted on six electronic digital computers!

Hopper described for The Institute of Electrical and Electronics Engineers History archive her position as "the third programmer on the first large scale digital computer, [Harvard] Mark I,"[35] remaining to work with Aiken on the Mark II. She tells an amusing tale set on a hot summer day in 1945 when the Mark II suddenly stopped. After investigating the mechanism she discovered an unfortunate moth which had flown inside to its death. Carefully mounting the moth in her log-book, she noted she'd "debugged the computer."[36]

[34] Atanasoff-Berry Computer.
[35] IEEE *Annals of the History of Computing*, Vol 10. No. 4, pp. 341-342
[36] *ibid*

One of the projects for Eckert-Mauchly was her invention of a translation method from human-to-computer language, housed in a compiler device called the A-0, and arguably the first of its kind. On Hopper's team was one of the ENIAC programmers, Elizabeth Snyder Holberton, known as Betty. She was instrumental in developing Hopper's compiler with her work on a UNIVAC program which could generate subsequent programs. She also contributed to Hopper's development of various computer programming languages, most notably Flow-Matic and COBOL [common business-oriented language] for UNIVAC about which we'll learn more shortly.

A Decade of Secrets; Computers With Your Tea

In 1946 Alan Turing, freed from duties at Bletchley, was awarded the Order of the British Empire for his seminal albeit secret part in the Allied victory. Secrecy proved the keynote to the remainder of his life. Turing actually continued on with hush-hush government work relocated to The Government Communications HeadQuarters [GCHQ] in Gloucestershire in the West of England. Working with an assistant from MI6, Donald Bayley, he perfected his speech secrecy system.

Sadly, because of the Official Secrets Act, this brilliant but shy man was unable to receive public recognition for his encryption work. He needed a cover story which would secure his position for several years, and retreating to academia he continued his pre-war pursuits. As already noted, during the 1930s Turing had begun work on a 'universal machine'[37] giving rise to his theory of computability, which, as Hodges puts it so succinctly, among other insights assumes "that symbols representing instructions are no different in kind from symbols representing numbers."[38] It is for this, along with theories about artificial intelligence subsequently developed at Manchester University, that many regard Turing as the founder of computer science.

After the war, Turing was invited back to Cambridge, then housing the National Physical Laboratory [NPL], as Principal Scientific Officer on the British response to von Neumann's EDVAC [itself highly influenced by Turing's work]. He synthesised many ideas inherent in his universal machine, and, though he left NPL in 1948, the result was launched the following year as EDSAC [Electronic Delay Storage Automatic Computer].[39] What's particularly striking about EDSAC is who funded it.

No longer on every UK street corner, until well into the 1960s the ubiquitous Lyons Corner House cafés supplied the British public with hot drinks and cakes served by uniformed waitresses affectionately known as 'nippies.'

[37] In this case "machine" is actually a generic term for a formula or theory
[38] *op cit*
[39] Fifty years later Cambridge University funded a 50th Anniversary celebration for the EDSAC I at which three simulators were demonstrated, and Bill Gates announced funding for the William H Gates III Foundation for related research projects.

During the war at least one London Corner House on Soho's Coventry Street was open 24-hours a day, serving refreshment to a comradely mix of air-raid wardens and the musicians who'd finished their set at Ronnie Scott's nearby jazz club. But how many of its customers realised that J. Lyons & Company [very much still trading as a food producer], was not only providing pots of tea but pots of pounds sterling to the development of the burgeoning computer industry.

In fact, the Lyons team headed by T. Raymond Thompson and John Simmons, stayed on with the Cambridge Unit to work under Maurice Wilkes,[40] parlaying EDSAC into the first commercial computer which they eventually called LEO I on its completion in 1951 – LEO was an acronym for Lyons Electronic Office, which itself became an offshoot company. Could a computer really make a refreshing cuppa? No, Lyons wanted the machines to speed up the production and delivery of cakes to a sweet-starved nation. In 1963 LEO merged with the English Electric Company, which was eventually taken over by International Computers Limited [ICL], still a thriving British hardware conglomerate. With the profits they realised on the sale, no nippy ever received a sweeter tip.

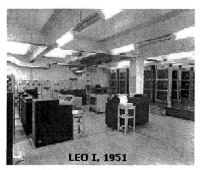
LEO I, 1951

As the photograph of LEO I shows, this early version of the computer still required massive floor space, and wasn't graced with monitors. It did, however, fulfil all five essential functions: input, data storage or memory, processing, control, and output. Raw data was fed in and stored until the internal processing mechanism, responding to a stored program, released its computational results onto printout paper. Stacks of it.

While the NPL team worked on EDSAC and until his departure, Turing was engaged on the Automatic Computing Engine, known as Pilot ACE. This sophisticated machine was designed primarily for processing speed. It boasted a main memory system plus backup and could perform numerical analysis, chess problems, and decryption. But Turing was frustrated by the delays in its actual construction. There is also speculation that he didn't get on with the NPL chiefs, or, more likely that they were uncomfortable with his open homosexuality.

[40] Wilkes had first-hand experience with EDVAC when he took a course at the Moore School. His subsequent Cambridge work included microprogramming, cache stores, time sharing and early computer networking. Now retired, he's currently on the Board of DEC, as well as a staff consultant with AT&T in Cambridge.

After spending a year's sabbatical working on a theory of neural nets, he left the Lab in 1948, accepting Max Newman's invitation to Manchester as Deputy Director of the University Computer Lab. ACE, and its follow-up Deuce, were completed without him in 1950 at the Lab's new headquarters in Teddington, a London suburb on the Thames which had been heavily bombed during the war. Turing's goal at Manchester was to construct the electronic embodiment of the Turing Machine which could be programmed to process all commands – essentially a digital computer. Newman had wangled a grant for this from the Royal Society, but had already assigned the project to F. C. Williams, a radar engineer who'd made it his own. Turing pursued other interests including theories focused on morphogenesis and artificial intelligence, culminating in his 1950 publication of *Computing Machinery and Intelligence* in *Mind*, the journal of philosophy.

He followed this with an exploration of the Fibonacci number series, applying it to the natural patterns in flora. His election the following year as a Fellow of the Royal Society couldn't compensate for the threat his sexuality was perceived to pose to his GCHQ security clearance. In the obsessive climate of the Cold War and with homosexuality still on the UK statute books as a crime, Turing was tried and convicted in 1952. Rather than deny his lifestyle, or spend time in prison, he accepted a course of psychoanalysis and a barbaric series of oestrogen injections, administered to suppress his libido. Tragically in 1954, this 42-year-old Allied hero of the war committed suicide rather than continue such demeaning 'curatives.' His incomparable contribution to the advancement of computing and the Internet is only recently being given the plaudits it deserves.

Tommy Flowers, too, was forbidden from revealing the details of his war work upon his return to Dollis Hill, where he was employed until 1964. In fact, he'd been ordered to destroy all but two of the Colossus machines, receiving a mere thousand pound reward for his decryption work, which didn't even cover the debts he'd incurred while developing the system. He was anxious to parlay the power of Colossus into an electronic phone system, but couldn't persuade the Post Office administration how effective the machines already were, nor that such systems had a part to play in national telephone advancement. Today, as British Telecom [BT], their investment in global electronic telecommunications is calculated in the billions. The two Colossus machines were eventually housed at the GCHQ in Cheltenham and remained in use until the 1960s. Their decryption algorithms are still classified information. GCHQ of course remains Britain's largest electronic monitoring station.

Flowers moved to International Telegraph and Telephone for the last five years before his retirement. Eventually he was honoured with an MBE [Member of the British Empire], though not even his family could know why until 1970, when certain information restrictions were lifted. When asked by the press about the part he played during the war in the development of computers, he said with characteristic modesty, "At the time I had no thought or knowledge of computers in the modern sense, and had never heard the term used except to describe somebody who did calculations." In 1977 honorary doctorates were awarded him by both Newcastle and De Montefort Universities.

✿✿✿✿✿

Defense & the Big Bucks

The decades following the war saw not only technological developments, but an interwoven series of commercial alliances which laid the groundwork for the establishment of many of today's most successful multinational companies. As before, keep your eye on the role of the Navy.

In 1950 the engineering firm Ferranti was working on its own Mark I computer at the University of Manchester. They called in UK expert Douglas Hartree to assess the cost-benefit of continuing the project commercially, given the competition. Hartree's conclusion indicated a typical lack of vision at the time: England's calculation requirements could be more than served by the three existing computer projects. He recommended Ferranti should offer something else to the mass market.

The firm ignored his advice, however, and developed the Mark I into the world's first commercial computer, released the following year as the Mabel or Madam. Total sales: eight. Until they closed down in 1993, Ferranti continued developing increasingly powerful computers including the Pegasus and Perseus series in the 1950s and Sirius and Orion in the following decade.

Meanwhile, across the pond, another commercial saga was brewing in CSAW. One of the unit's most innovative thinkers was an unprepossessing former Westinghouse X-ray equipment salesman named William Norris, whose approach to the Enigma challenge earned him a promotion to lieutenant commander. Fired by such intriguing occupation, he mused along with Howard Engstrom, CSAW's Head of Research, how they could carry it on in civvy street. Engstrom had no intention of returning to his Yale University post of maths professor, and the two also rejected careers in a government lab, which Norris agreed just plain didn't pay enough. The Navy didn't want to lose either of them – in fact they wanted to keep the entire CSAW team.

In the months after the war and having considered several commercial sponsorship and investment opportunities, Norris, Engstrom and a few like-minded colleagues devised a business investment plan to retain half-ownership of a technology development company, backed by the Navy [with the support of its Top Brass]. The clinching argument for the Navy was these trusted men would secretly continue their cyptanalytic work to the nation's advantage in the imminent Cold War, seeds for which had already been sown.

Priorities for Norris and Engstrom, however, were more concerned with applying the principles of their computing machines to industry rather than hunting Soviet baddies. They envisioned digitised versions of the coding machines for air traffic control and automated ticket reservation systems.

Such cash-hungry developments required private contracts. They targeted Western Union and American Airlines, hoping to convince postwar captains of industry of a digital future. Sadly, neither man had the ability to translate their babble of electronic data transfer into language mere mortals could understand. Nor, because of the secrecy agreements they'd signed, could they actually demonstrate the machines they knew already existed.

It is significant that when Norris and Engstrom couldn't find the required backing, they benefited from the direct intervention of James V. Forrestal, a former Wall Street mogul who also happened to be Secretary of the Navy. He brokered introductions to various investment bankers who unfortunately dismissed their ideas as having no commercial future. The Navy didn't allow such lack of vision to stymie their bigger plans. No less a figure than Admiral Nimitz, who'd commanded the Pacific Fleet during the war, personally made it known to one John Parker[41] that the US Navy needed his help.

Sensing a chance to secure jobs for his threatened workforce, Parker bought into a consortium with the Navy, each taking 100,000 shares in a company they named Engineering Research Associates [ERA], adding 40 CSAW staff to work with the now jubilant Northwestern Aeronautical team. One of the computing luminaries on the ERA computer design team was the young Seymour Cray, who even before his intelligence work in the Philippines as a teenager during the war, had been fascinated by electronics back in his hometown of Chippawa Falls. Before long ERA was acquired by Remington Rand, at the time a household name for manufacturing typewriters.

Eckert and Mauchly also needed a business angel. Hopper continued to play her part, and was particularly successful in allowing programmers and business managers to reach common ground. They even managed to win a contract from the US Census Bureau for UNIVAC. But the company lacked business savvy and, like ERA, was eventually taken over by Remington Rand. It was under their aegis that UNIVAC, the first commercial computer in America, was completed in 1951, a month after Ferranti's Mark I was up and running in Manchester. Cray was still on board.

With the Cold War in full chill, the US was literally freezing in Korea, supplying most of the personnel and equipment along with UN troops to stem the communist forces of the North.[42] Head of the UN Command was Douglas MacArthur [a staunch Republican who'd reluctantly shared the WWII Pacific command with Nimitz]. But President Truman recalled the General when he openly opposed the Democratic government's policy, convinced instead that the conflict should expand to an invasion of China.

And guess where MacArthur headed after the public façade of his triumphant return? To Chair the Board of Remington Rand. In the ensuing nine years prior to his death in 1964, he saw the company's UNIVAC unit set up its own division under a merger with Sperry, forming the Sperry-Rand Corporation, whose vice-president was Eckert, with Mauchly Director of Computer Applications. By the time UNIVAC and Burroughs merged to form Unisys about twenty years later, everybody knew the computer industry meant big bucks.

[41] A graduate of the Naval Academy and the wealthy but troubled owner of Northwestern Aeronautical, a failing glider company based in Chippawa Falls, Minnesota.

[42] In the inevitable evolution of history, in 2000 North Korea's hereditary leader Kim Jong Il signed a peace accord with South Korean President Kim Dae Jung, paving the way for re-unification and ending five decades of Cold War.

Meanwhile, Seymour Cray and Bill Norris, unwilling to divert their attention from the scientific to the increasingly commercial, left in 1957 to establish Control Data Systems, raising the capital from a pool of small private investors. The goal was to build the world's fastest transistor-based scientific computer. Its success provided the American academic community with the backbone of its subsequent computer network [leaving key competitor IBM to dominate the business market].[43]

According to the National Cryptography Museum website,[44] since its days as the SIS the National Security Agency was well aware of the benefits of computer development both for its own and commercial purposes. It entered various partnerships with private industry. Cited is the Harvest Project, jointly developed with IBM to come up with a "super high-speed memory and high-speed tape drives, beyond anything then in existence." Their tape-drive, known as Tractor, set the standard from the machine's introduction in the early 1960s. It remained on the market for over a decade.

We've already noted the invention of the transistor, which took over from the vacuum tube as a more efficient method of regulating electric and electronic signals. Not only were they tiny by comparison, they amplified and relayed signals over a much wider range with far less distortion. Then in 1958, Jack St. Clair Kilby, an employee of Texas Instruments, produced a silicon chip mounted with hundreds of transistors. This was the first integrated circuit and became the requisite for the microprocessor, allowing all the intricate functions of the main-frame to be printed on a circuit board. To give an idea of the size differential, a microprocessor containing millions of circuit elements can pass through the eye of a needle.

By the early 1960s the Fairchild Semiconductor company became one of the most successful manufacturers of these circuits. On the Fairchild team was Gordon Moore, who goes into computing history as the inventor of Moore's Law, which accurately predicts that computing power will double every 18 months.

Paradoxically, as they become more powerful, chips are constantly coming down in price. Which is why a modern PC that can fly you to the moon on NASA's website, costs only slightly more than the groundbreaking Altair 8800, launched in 1974 by Micro Instrumentation Telemetry Systems [MITS] as the first personal computer.

Back then for your 400 bucks you got a self-assembly panel of switches, with no keyboard or monitor, but driven by a circuit board. It sold in the thousands, pulling MITS back from bankruptcy. Twenty years later, the storage capacity of a personal computer had increased by 100-fold.

[43] Cray parlayed the company into Cray Research in 1972, exploiting the new integrated circuits and microprocessors to address such science-based problems as weather prediction. With Les Davis, another former ERA colleague, Cray Research has led the way in devising ever-smaller liquid-cooled digital mechanisms. Fascinating fact: the liquid is the same used as artificial blood for transfusions in those allergic to human blood.

[44] http://www.nsa.gov/museum/harvest.html/

Oh, yes, and three years before the Altair 8800 was released, a couple of nerdy Seattle teenagers formed a company called Traf-O-Data to sell computer-generated traffic data analysis. When the computer hit the streets, these whiz-kids convinced Altair to let them program it using BASIC[45]. The kids were Paul Allen and Bill Gates, and their new company was called Microsoft.[46]

Time of Transition

Vincent Cerf, one of the UCLA team led by Leonard Kleinrock which developed the Internet, declared in a 1995 article on networking, "A fertile mixture of high-risk ideas, stable research funding, visionary leadership, extraordinary grass-roots cooperation, and vigorous entrepreneurship has led to an emerging Global Information Infrastructure unlike anything that has ever existed."[47] He was talking about the 1950s and 60s.

The next phase of our journey coincided with an unprecedented change in the socio-cultural and economic climate of the West. I am convinced that this was the catalyst which allowed all the technological ingredients needed to complete our Internet journey to coalesce unhindered. Since the early years of the century successive Western generations had been hit Ka-Pow! by unspeakable horrors of two world wars, the Depression, the Holocaust, segregation, and a rabid hatred of the Eastern bloc fomented by political and commercial vested interests.

However, especially in the US, WWII had swelled the coffers of industry, resulting in the new phenomenon of the multi-nationals, companies whose sheer scale allowed them not merely to influence but to circumvent government regulation. Capitalism's trickle-down had never been more demonstrable. In sharp contrast to the more socially complex Vietnam War, when thousands of troops marched back into the civilian economy of the mid-1940s, both respect and jobs awaited them.[48] The booming economy further eroded social barriers, allowing a disposable income to more than just the elite. Many US servicemen and a few women, unable to afford higher education before the war, took advantage of the GI Bill to attain degrees.

[45] Beginner's All-Purpose Symbolic Instruction Code, a computing language developed in 1964.
[46] That same year two Southern California boys, Steve Jobs and Steve Wozniak, started building computers in blue boxes; six years later their Apple II was launched with 16K of RAM but no monitor. Cost: just under $1200. Two years later Apple bit into 50% of the personal computer market. Gates and Allen released Windows v1 in 1984 and the PC battle was in full swing.
[47] Cerf, Senior Vice President of the Data Services Division of MCI Telecommunications Corporation, has also served as President of the Internet Society since 1992. The article is available on the MCI website: http://www.mci.com/
[48] Sadly, though, this peacetime paradise seemed to be for whites only. And the wartime workforce of women virtually melted back into domesticity.

Technology had started to eliminate domestic, assembly line and office drudgery, leaving room for a fatter slice of leisure time. And to fill that time, the most popular new miracle of all – television. Certainly in America, that medium pretended to extend the sense of national cohesion born from war's many sacrifices. It also displayed its citizens to each other in a way Hollywood never could. Not only were their politicians and favourite stars speaking directly to them,[49] they met a national community of so-called real people just like them.

Despite a pervasive denigration of intellectuals as 'eggheads,' real people were seen not only to be as smart as professors, they could win thousands of dollars just by answering quiz questions.[50] Of course, guided by the advertising industry, the bulk of the images were carefully constructed with media trickery and even downright fraud to concentrate on the fast-growing aspirational middle class white majority, diverting attention from the very wealthy, the very poor, and any ethnic, religious, or political group which didn't conform.

More than any other cultural phenomenon, television helped America to put a price tag on every aspect of life. In the jargon of the time, it brought the world "right into your living room." Though families watched in isolation, somehow they felt connected to the entire nation.

Their children, the baby boomers, grew up in an unprecedented era of plenty. For the first time, kids could stay in school without having to rush into the responsibilities of adulthood. These were the first teenagers, and it was cool to 'just be, man'! They grew up expecting their share of daddy's bulging wallet. They also developed 'an attitude,' embodied in a growing sense of independence, a rejection of authority, the expectation they could change their destiny through upward mobility, and the cohesive and liberating power of rock and roll. By the time they were in a position to make their own decisions in the mid-1960s, something in society had changed, fundamentally and forever. The kids knew what it was, but as Bob Dylan put it so poignantly, Mr [and Mrs] Jones sure didn't![51]

This era of unlimited possibility witnessed the most rapid development of the proto-Internet, exemplified by the timeshare concept put into practice in the 1950s at MIT[52] when one single computer was linked up to several remote terminals, producing a network of users.

[49] A popular song of the era about one of America's TV superstars relates the thrill and tingle "when Liberace sings just for me."
[50] A popular put-down of the time taunted,"If you're so smart, why ain't you rich"?
[51] *Ballad of a Thin Man*, 1965 Warner Bros. Records Inc.
[52] Massachusetts Institute of Technology; much of this early research into multi-access computing was being funded by the Office of Naval Research and the Air Force Office of Scientific Research.

In 1957, however, something happened which literally launched a rocket to the Net. Sputnik I was sent into orbit around the Earth by a triumphant USSR. Literally meaning "travelling companion to the world," Sputnik rotated for 57 days, during which a shamed American government vowed to overtake their Cold War rivals as the leaders in science and technology.

That meant unlocking massive Treasury reserves – today we'd call it a peace dividend. I clearly remember as a 15-year-old the pervasive sense that the nation had somehow failed. It was exemplified in a political cartoon by Jules Feiffer [who specialised in satirising American pomposity] which depicted a man pointing a telescope at the sky and admitting "We have committed the worst of all possible sins – we were second."[53]

And, shame piled on shame for a nation which put God on its money, we'd come second to the Devil! It's true – in that ridiculous time of transition, large swathes of the American public actually believed that Soviet Premier Khrushchev's shoes covered cloven hooves and beneath his hat poked a pair of hellish horns. The first defensive step then-President Eisenhower took was to appoint MIT President James A. Killian as a Presidential Assistant for Science. As we'll see MIT has played a major role in developing all aspects of the Internet.

Racing to the Net

It was no coincidence that 1958 saw the official endorsement of the super-expensive NASA,[54] set up by an Act of government to coordinate all civil US aeronautics and space activities. It became an important customer of the booming computer industry. Of course, military R&D continued its own parallel pursuits, and it is that road which leads directly to the Internet. Even today the networking technology developed under The Advanced Research Project Agency[55] is what drives the US military command and control system.

As it had since the early days of the century, the tripartite effort of military, academic, and commercial hastened the journey. It's at this point that the balance begins to shift in favour of pure research rather than immediate profit. The irony, of course, is that such research has resulted in the most lucrative industry in commercial history.

I won't go into every nook and cranny, but we need to chart the role of ARPA. Given that we started this backward glance over 100,000 years ago, perhaps the most startling element of these final stages on the Internet timeline is the phenomenal speed of advance.

[53] Originally printed in *The Village Voice*, the cartoon subsequently appeared in Feiffer's collection *Sick, Sick, Sick*; McGraw Hill, 1958.
[54] National Aeronautics and Space Administration.
[55] ARPA was renamed DARPA [Defense Advanced Research Project Agency] in 1972.

As we've seen, that was partially due to the sense of national competition with the USSR in the space race, which was accelerated by President Kennedy before his assassination in 1962. Given the *realpolitik* of the time, this competitive driver could not be codified into an agency or its funding approved by Congress unless there were a defence-related justification. Which made perfect sense in a nation both mesmerised and scared-to-the-hilt by the prospect of a nuclear war. After Kennedy's untimely death, his successor Lyndon Johnson determined to continue and extend that initiative, if anything, emphasising the military aspect even more strongly.

In 1962 ARPA's Information Processing Techniques Office [IPTO] began funding a series of projects meted out to university departments around the country[56] in an effort to maximise the financial investment in the computer industry which both government and the military were continuing to make.

Under the overall supervision of Dr Joseph Licklider,[57] a former psychologist and researcher at the Cambridge Massachusetts information systems consultancy of Bolt, Beranek and Newman [BBN], one of IPTO's priorities was to find a better way to send data packets between computers on a time-share system or network. This came to be known as a Resource Sharing Computer Network.

Another surprise, considering the military funding source, is the climate of sharing and openness which has set the foundations for all subsequent Internet advance. As we'll see, this aspect of making research results available to all was instrumental in exactly which bodies were chosen as the proto-Internet's first points of connection.

IPTO's various research assignments emanated from the Command and Control Research unit [CCR] in Washington DC, headed from the outset by Licklider. In *Online Man Computer Communication*, one of a series of published papers, Licklider and a computer-savvy colleague Wesley Clark had recently introduced a concept they called a Galactic Network.

Licklider was already aware of the MIT timeshare network and a firm advocate of creating different sorts of communities with the new technology. He realised implicitly that computers were far more than number machines. Much more exciting than their facility to connect machines to each other was their potential to connect people. He influenced the research projects to contribute toward a series of connections and dubbed those working on it the Intergalatic Network.

[56] Theoretically the projects were awarded on open bidding; in practice they tended to be assigned via universities in California and Massachusetts to teams composed mostly of men with prior wartime or university association. More open to outrage was the pay differential in a workforce comprising 99% men and 1% of women, educated to similar qualifications.

[57] In 1960 Licklider had published *Man-Computer Symbiosis* which advocated that the computer science industry be vigilant about assuring it was there to serve society rather than the other way around. His interests remained aspects of interactivity and accessibility.

Universally regarded as a true inspiration, Licklider left IPTO in 1964, transferring first to IBM, then assisting with MIT's work on multi-access computers, which became known as Project MAC. As his IPTO replacement, he invited the 20-something prodigy, Ivan Sutherland,[58] who in turn brought in Robert Taylor from NASA research as his assistant and successor.

At the time, MIT's Lincoln Lab[59] was bristling with engineering and mathematical genius. New Yorker Leonard Kleinrock [since dubbed the Father of Data Networking, and the Inventor of Internet Technology] was one of them, working there between semesters as a PhD student at MIT on a full graduate fellowship in the Electrical Engineering Department. "My entire graduate education was fully funded by the MIT Lincoln Laboratory through their staff associate program – they were very generous."[60]

Kleinrock had already devised visionary theories about packet-switching by the start of the decade, though others have since claimed credit. He is resigned to what he calls the "land-grab for credit" in the early days of the Net. "I have to admit there were some people, some powerful people in some powerful companies who wanted to claim the territory, and they wound up getting more credit than they actually deserved. Which tended to put people's noses out of joint. As for my own contributions, I always thought the facts would speak for themselves; history would eventually record the truth."[61]

The record was finally set straight in February 2001, when his peers at the US National Academy of Engineering honoured him [along with Cerf, Kahn and Roberts] with the Charles Stark Draper Prize "for contributions to the development of technologies that are the foundation of the Internet, a stunning engineering achievement that profoundly influences people, commerce, communications, productivity, and interpersonal relationships throughout the world."

Kleinrock's groundbreaking 1962 thesis on *Message Delay in Communication Nets With Storage* was later published by McGraw Hill in 1964 as *Communication Nets*, a year after he'd relocated to take up a professorship at UCLA's Computer Science Department, where he still teaches. As we'll see, his UCLA team was seminal in realising the early version of the Internet. MIT colleagues of Kleinrock included Lawrence Roberts, Frank Heart and Robert Kahn. Roberts, familiar with Kleinrock's work, invited him to Washington DC to help formulate a plan for ARPA.

[58] Sutherland, currently Vice-President of Sun Microsystems, was one of the first people to conceptualise the Graphical User Interface [GUI] which is what makes possible the whole notion of a web-browser; he also pioneered concepts of Virtual Reality.
[59] Established in Lexington, Massachusetts in 1953 under the administration of MIT, the top-secret laboratory was dedicated to defence research.
[60] Quoted with permission from an interview with Charles Petrie, Editor in Chief of Internet Computing at the 1996 Pittsburgh Supercomputing Conference at which Kleinrock received the Computer Society's Harry Goode Memorial Award for "fundamental contributions to packet switching and queuing theory, two of the principal technologies that led to the Internet, empowering the global community to participate in worldwide economic, political, and cultural processes."
[61] Personal communication.

In conjunction with Thomas Merrill, Roberts established the first Wide Area Network [WAN] between the Lincoln Lab and the System Development Corporation in Santa Monica, operating on a dedicated phone-line but without packet-switching.[62] Heart and Kahn both worked at BBN. Taylor hired Roberts as overall manager on the ARPAnet project.

It's unlikely anything so blatant or conscious a policy as nepotism guided project assignments. Far more likely is the tendency to trust people with whom one has already established a working relationship.

By 1965 The Department of Defense gave ARPA control of a budget exclusively to develop the network. The DoD was responding to President Johnson's recent memo demanding that government agencies support the nation's universities in research to establish "creative centers of excellence – to contribute to basic knowledge needed for solving problems in national defense." When IPTO subsequently authorised discrete research on networking projects its budget was 18.6 million dollars. That had increased to 31.5 million by the time the network was in full use.

There is some debate about how proscriptive ARPA was in assuring that any of the research projects would result in a military application. Kleinrock [whose UCLA work focused on a mathematical understanding of how groups of things, people, or information move forward, and create and unblock bottlenecks] recalls having to provide a military justification for his project proposals – though he admits that the justification may have been addressed only after a request for project funding. "Yes, the funding came from the military, but the way they work, they want the commercial world to develop products and processes they can use."[63]

Testifying before a Senate committee to explain why universities were benefiting more from DoD contracts than research grants from the National Science Foundation, Dr John Foster, the DoD's head of Defense Research and Engineering explained the research would directly contribute to national security and that "No one in the DoD does research just for the sake of doing research."

By 1966 not only was the research well underway in America, the UK's National Physical Laboratory had begun a similar project in Cambridge. We can only surmise the contribution Turing might have made to such seminal work. Research was also in train in Japan, and most likely in the Soviet Union, though precise details are scarce.

[62] In fact this project was part of a larger US air defence system, called SAGE [Semi-Automatic Ground Environment] funded by the US Air Force as a rapid-response mechanism to counter nuclear attack. While the Lincoln Lab was commissioned to devise its software in conjunction with the SDC, MIT and IBM began construction on a hardware system called the IBM AN/FSQ-7. The prototype was so big it had to be delivered in 18 vanloads and when assembled weighed in at 300 tons.

[63] Personal communication.

A proportion of the ARPA money was allocated to a prime agency target, identified at an evaluation meeting in 1967: to develop a system of protocols based on Kleinrock's theory which would allow computers with completely different specifications to connect to each other through sub-networks. The protocols would triply ensure that each computer was primed and ready to receive any information sent, that it could interpret the information, and that it could request the information again if it had been interrupted in transit. Clark presented an idea for specific networking hardware which eventually was called an Interface Message Processor [IMP].

The Defense Department had a surprise in store when such companies as AT&T and IBM increasingly refused to respond to ARPA's Requests for Quotations [RFQs]. With no common enemy, post-war profits had replaced any corporate desire to assist the military in what was seen as pure research with no short-term return on investment.

The guiding commercial imperative dictated that companies protect their market-sensitive bespoke technology [computers, protocols, etc] to assure their slice of the market cake. The ARPA projects, however, were predicated on open standards, and the whole initiative depended precisely on the kind of accumulated shared knowledge that had broken the war codes. So the big business fish wouldn't bite, leaving the research crumbs to the little fish and the universities.[64]

When big business drew up the battle-lines, it triggered a reaction entirely in tune with the growing anti-authoritarian mood of the times. If that was the game the establishment wanted, the ARPA boys were ready and willing to play. The idea of electronically connected communities built on openly available source codes established early-on the ethos of the Net which continues to this day.

Licklider's former colleagues at BBN won the tender to create the first network infrastructure. They had one year and a million bucks to deliver an IMP-to-IMP subnetwork connecting four designated nodes or sites at two campuses of the University of California [Los Angeles and Santa Barbara], Stanford Research Institute, and the University of Utah. Each node was responsible for developing software to service its own linked equipment.

Kleinrock and his team of graduate researchers[65] at UCLA had established a time-shared computer facility in the Computer Science Department. Because they were concentrating both on the design of a putative network and on aspects of its performance and measurement, ARPA decreed they would become the first recipients of the IMP, making UCLA the first ARPAnet node, and establishing an official Measurement Center for the project.

[64] It's true that ARPA's research budget dwarfed that of the National Science Foundation; however it was peanuts in comparison with the DoD's total budget, a proportion of which was already going to the multinationals for strictly commercial development.
[65] This innovative and talented team included Ivan Sutherland and Vincent Cerf, referred to above, and Steve Crocker.

Two months before the ARPAnet came to life in Kleinrock's laboratory, UCLA put out a press release in which he is quoted as follows [predicting much of the Internet as we know it today]: "As of now, computer networks are still in their infancy. But as they grow up and become more sophisticated, we will probably see the spread of 'computer utilities,' which, like present electric and telephone utilities, will service individual homes and offices across the country."[66]

The IMP was installed less than 6 weeks after Neil Armstrong took that small step onto the surface of the moon. Flower-power bloomed throughout America and Europe, and the Beatles sang *Here Comes the Sun*, reflecting the intense optimism of the time.

At UCLA, Steve Crocker set up the Network Working Group which established a knowledge-sharing procedure called Request for Comment [RFC]. If any one ingredient at this early stage set the tone for all subsequent Internet development it was this totally open accumulation of comments, suggestions, and research results.

On a more technical level, any knowledge or data shared needed to be transmitted by packet switching. As noted above, the data is broken down into units, sometimes called datagrams, and each data packet is assigned a header indicating where the data came from, where it's going, and the route it will take to get there. Such information is known generically as meta-data: it assures any lost data can be easily identified and re-sent. No true computer network can function without this facility.

Another vital aspect made possible by the underlying principles of the Net is that of interactivity and contribution. Probably more than anyone involved in setting up the ARPAnet, Licklider saw this most clearly.

His article co-authored with Taylor for *Science and Technology* asserted, "We believe that communicators have to do something nontrivial with the information they send and receive … to interact with the richness of living information – not merely in the passive way that we have become accustomed to using books and libraries, but as active participants in an ongoing process, bringing something to it through our interaction with it, and not simply receiving by our connection to it. We want to emphasize … the increasing significance of the jointly constructive, the mutually reinforcing aspect of communication. When minds interact, new ideas emerge."[67]

It was 1969, the four initial nodes were connected, and the ARPAnet was born.

[66] *"UCLA To Be First Station in Nationwide Computer Network"* 3 July 1969 UCLA Office of Public Information.

[67] *The Computer as a Communication Device*, issue #76, April'68, pp. 21-31

After including BBN in the loop the next year, by 1971 the network had grown to 15, processing over 70,000 data packets a day. A year later, ARPAnet was successfully demonstrated between 40 machines at the International Conference on Computer Communications. Though it still wasn't clear exactly how they might be used, now connections could be made between communities, and they didn't need to scrap their existing equipment to participate.

In the ensuing years various other networks were established, military [MilNet], academic [the UKs JANET], community based [UseNet, eGroups] and commercial [Commercial Internet eXchange (CIX), CompuServe]. With the simultaneous evolution of additional data-transfer protocols, the technology existed to connect the networks to each other. In 1972 BBN computer programmer Ray Tomlinson devised an eMail protocol, but never foresaw how popular it would become as a means of global communication. When your own PC dials up to the network hosted by your internet service provider [ISP], you, too, are plugged into their network and can access any other open-data standard network. This network of networks is the Internet.[68]

[68] It's inevitable in a book of this nature that many details of the story have been omitted. Happily, the Web is the repository of testimonies from the very people who contributed to the Net's development, as well as countless interpretations from others.

section 2: clear-eyed acumen & blind dreams

If you encountered someone reluctant to use a washing machine, preferring to cart their dirty clothing to the river and beat it against the rocks, you might pity them, ridicule them, or try to help them use the machine. Yet, with no more justification, millions of people today regard the Internet as an object of anxiety. Partly to allay such fears, and partly to relate the societal effect of the Net to that of other fundamental technologies, this section will explore the socio-cultural gap between the introduction of the new and its acceptance. I hope it will also reveal the richness of the World Wide Web, which [like young Maggie Tulliver in George Eliot's *Mill on the Floss*] reflects the "clear-eyed acumen and blind dreams" through a mix of social, economic, academic, and artistic contributions which make it an important shaper of our culture.

Was technophobia around from the earliest days of our tool-making ancestors? Just what is technology, how did its introduction affect our cultural development, and why are we so afraid of it?

Tooled-Up

It's no wonder so many of us are baffled by technology, considering we apply it to some of our most confounding pragmatic problems. As an adjunct to pure logic and abstract thought, the fashioning of objects and their subsequent application to problems in the material world is at the heart of every technology. This process involves either the use of existing tools, or their manufacture. A few decades ago it was assumed only humans could accomplish this – indeed some anthropologists partially defined our species by this ability. We now know that several other animals consciously employ and even alter twigs and stones etc to produce various problem-solving tools.

Sea otters off the California coast love nothing more than a gourmet abalone dinner. Catching the critters is no problem for such accomplished divers – the harder task is cracking open the shell to suck up the sweet meat inside. Once upon a time, some clever otter discovered that if it floated on its back using its stomach as a kind of anvil for the crustacean, and hammered the shell with just the right size of rock, it would be rewarded with abalone *al fresco*. This is a cultural evolution, a learned behaviour passed down the generations, since baby otters are not born with a tool-using instinct.

The patience of Jane Goodall observing generations of Gombe Stream Reserve chimpanzees resulted in the first record of a primate actually making tools. In this case 'making' requires some manipulation of the raw implement. Three quick examples:

➤ For a refreshing drink, chimps ball up fibrous plant matter into sponges, sopping up the water collected in bowl-like hollows between branches, and wringing out the liquid directly into their mouths.

➤ Chimps adore a snack of termites or stinging ants, an important source of dietary protein. The problem: how to snare the insects without getting bitten. The apes have learned to strip the leaves off just the right size and weight of stalk to make a highly effective fishing-rod. This is then carefully inserted into the termite hole where the insects, instinctively reacting to the intruder, clamp onto it. Before the ants know what's hit them, the chimps pop the wriggling treat into their mouths and munch away.[69]

➤ Rainforest apes hate getting wet. They've learned to pick suitably sized broad leaves and hold them like umbrellas till the rain stops.

Other species, including male bower birds, use whatever adornments they can find to decorate an enticing nest for their chosen mate. Those near human civilisation often supplant pebbles and twigs with discarded candy wrappers and bits of coloured glass. But that's an instinctive behaviour, whereas otters and apes need to learn.

[69] Harder than it sounds, several Gombe researchers have tried and failed to fashion precisely the right tool and use it properly; baby chimps can be seen learning to fish correctly through play.

Mammals are born with fewer instincts than other animal classes, sacrificing such genetic programming for greater flexibility in the face of the unexpected. Discounting the autonomic nervous system,[70] humans are born with very few instincts indeed: a new born baby will automatically grasp anything put into its hand, we all have an innate fear of falling, and if an object heads straight for our eyes they instinctively close. Genetics predisposes us to a variety of options, but we can consciously change much of this destiny. Those inheriting a genetic tendency for buck-teeth can have dental braces fitted to correct the problem. We can overcome physical barriers to cultural development: we're not born with wings, yet we fly in machines. We still thrive in the Era of the Three I's.

The highly creative process of invention requires three stages:

1. Analysis: perception of the problem and possible solutions
2. Abstraction: visualisation of each solution and subsequent choice
3. Implementation: choice or manufacture of requisite tool and/or process and its application

Stage two provides two options, either an instant understanding of what's required [the Eureka moment], or a series of trial and error. Stage three can involve tools or not. To soothe a crying baby you can construct a cradle or pick up the child and rock it in your arms. The solution depends on the same fundamental process: a process of making connections. It's the same used by artists to write, choreograph, or paint, by scientists to formulate equations and conceive experiments, and by philosophers to extrapolate ideas.

When the process implies a solution which involves tools we call it technology. Another facet of technology, as opposed to science [with which it has mistakenly become almost synonymous], is that it does not provide eternal truths. The orbit of the earth can be measured, as can the length of an hour, and these are virtually immutable. But a technological solution can be superseded by something more-effective, rendering the first not invalid but obsolete.

Technology is founded on scientific principles, primarily from mathematics and physics. It may be used by scientists but it is not their sole province. The laws of science exist whether or not we're aware of them. No matter how many people believe the Earth is flat, it remains an oblate spheroid. Technology, however, requires some degree of intervention.

This all seems perfectly straightforward and reasonable. So what perceived monsters lurk within the very concept of technology to produce such fear in some of us?

[70] Which controls such involuntary reflex actions as pupil dilation and shivering.

Scaredy-Cats

I don't believe there is anything inherently frightening in the technological. For survival reasons, our species is understandably wary of the new, the unexpected, the unexplained.

When the evolving hominids in the opening sequence of Stanley Kubrick's *2001: A Space Odyssey* first encounter the towering monolith [a metaphor for knowledge as powerful as Eden's apple tree], they approach the alien structure with extreme caution before accepting its benignity and celebrating it with exhilaration. Think how warily you first regard someone who isn't behaving within your range of social propriety. Then, objectively, if you judge that such a person seems harmless, was, say, only putting on an act, your fear evaporates. If we appreciate that an external tool can do a job more effectively, make our lives easier or enrich it, we have nothing to lose by embracing it. Or do we?

I contend that technophobia transcends the matter of understanding, nor is it overcome by a cause-effect analysis. What's more, I'm not convinced it was an issue for most of our history as a species. First of all, this so-called phobia is not a psycho-medical condition like agoraphobia. It's a socio-cultural aversion, which I believe is the unintended consequence of two related factors: increasing populations and the collective acquisition of an increasing body of knowledge.

We will never be able to credit any particular person with the invention of our first seminal technologies such as the wheel, the grinding stone, the sharpened flint, the production of fire. What we do know is that everyone in those early hunter-gatherer societies benefited.[71]

Because of the circular way such groups were structured, each of their 20-30 members was very well known to the others. They shared a sense of trust and responsibility. They had to. Their lives depended on it. They roamed loosely-bounded territories, following herds and harvesting ripened vegetation. They didn't own those territories, and more often than not boundaries overlapped with similar groups who visited them at different times.

[71] Recent anthropological evidence indicates there was less role division than we've assumed, either in status or gender. Various pre-historic societies such as the Javanese have left traces of female as well as male warriors and administrators; artefacts discovered with Palaeolithic remains suggest that women hunted alongside men; many tribal groups rotated leadership rather than imbuing any one individual with the powers of the divine.

Very rarely did they encounter each other, and then more likely for socio-sexual benefit than aggressive confrontation.[72] Such unpoliced pacific existence is only possible when resources amply serve population size. Within these nomadic groups, any technological lifestyle improvements were applied to common problems.[73] Their immediate benefit was clear, and they could be adopted and further adapted without threatening egos or social cohesion.

Between 10-12,000 years ago there followed a transitional period from a primarily hunter-gatherer to a pre-agrarian and finally an agrarian *modus vivendi*. For the first time people settled. Near fresh water and wild-growing eatables, they awaited protein on the hoof in the form of migrating herds. Eventually, they learned how to better control time and space by breeding animals for food, leather, and useful bone and sinew. They didn't have to mentally map territories or remember when wild trees would fruit. They could plant and reap tasty rewards.

Inherent in the agrarian is the technological, primarily because if a group of people don't have to travel to survive, they need more permanent shelter. And they must address such accommodation issues of sanitation, food preparation, childcare, etc. Caves, of course, had been used, but they didn't always occur in optimal sites for settlement. Shelter had to be constructed.

To build dwellings today we devolve responsibility to a variety of offices: town planner, surveyor, architect, bricklayer, carpenter, glazier, plasterer, electrician, plumber, decorator. In earlier times, everyone was a do-it-yourself-er, constructing yurts, hogans, or igloos, using materials to hand-shaped by appropriate tools. Some early structures so successfully solved various issues of domestic comfort, they equal or surpass modern dwellings.

For example the brilliant ventilation system of temperature control used in 1st century Middle Eastern desert buildings is still as efficient as any modern mechanism – it could even produce ice! Various societies BC enjoyed efficient bathing and sanitation. For centuries specialist engineers worked with and improved upon traditional solutions. Construction, along with a host of other technology-related occupations, continued to be carried out by the untrained, too. As late as the 19th century, when European immigrants trekked westward through North America, whole communities pitched in to build barns and houses for each-other.

[72] Simplistic theories of a genetic imperative for aggression propounded by Desmond Morris and Robert Ardrey have been blown away by more plausible interpretations of archeological and anthropological evidence by such ethologists as Julian Steward, James Anderson and above all Ashley Montagu.

[73] Not only in humans, but other primates, too, often it is the young who stumble upon "the better way." Various primatologists cite the example of a colony of macaques in Japan in which youngsters first ventured into hot springs to better face the winter; the adults soon followed suit. And when one young monkey learned to wash sand off sweet potatoes at the shore, not only did the behaviour soon spread throughout the colony, successive generations now prefer their sweet potatoes salted! This mirrors the way Internet technology has been adopted within the wider community.

Not just building but the processes of agriculture itself fueled even greater technological development. Digging holes with fingers is efficient enough on a small scale, but farming requires more proficient tools. Since technology stimulates improvement as we've already noted, proficient tools suggest even better ones to intelligent minds.

One of the inevitable social consequences of staying put as opposed to moving around for your living, is the need for a larger labour force. Organised agriculture requires more hands than gathering nature's bounty. The process expands to include preparation, planting, weeding, harvesting, processing, distributing, and eventually packaging and marketing crossing the line from farming to agribusiness.

Animal husbandry implies nurturing and protection in addition to slaughter. Hunter-gatherer childbirth was regulated by breast-feeding, itself a reasonable contraceptive.[74] It served no survival purpose to produce children more than every three to four years, which is the length of time an infant remained in close body-contact with its mother. By contrast, the bigger the agrarian family the more dedicated hands are available to tackle the chores, daily and repetitive. Babies were weaned more quickly so others could be conceived. There is, of course, a cultural and emotional trade-off.

The bigger families grew, the more room they needed. Small groups of adults spread further and further apart, staking out their own land, defining their own territory. For the first time came notions of mine and yours. Us and them. Ownership. With this threat to simple social cohesion, prioritising family over group loyalty, came a greater need to defend one's territory against strangers.

The concept of a stranger or alien was itself unknown until this seminal social change. In fact the word for human in many languages is the same as the word those societies use to describe their ethnicity. A stranger, in effect, wasn't considered human. It was during this era that territorial defence adapted technologies developed for hunting. There's not much transition from shaping tools which kill and cut for the pot to those which eliminate threatening strangers.

Settlements evolved into villages and towns. Seats of power and dominion resulted from division of labour. A ruling class, a soldiering class, a labouring class, a service and artisan class, a domestic class. Gradually, the shape of society changed from the circular [within which equality is implicit] to the pyramidal hierarchy, topped by an elite. The Yangshao is documented as such a transitional society between 2-5,000 years ago in Western China.

[74] It still is, for the Mbuti Pygmies, the Khoi-San of the Kalahari, Inuit Eskimos and tribes in South American, Indonesia, Siberia, Australia, and the Philippines.

When societies are thus polarised, it can no longer be assumed that any technological developments will automatically be recognised as beneficial for all. Not only are others regarded as strange, so are their way of life, their customs, language, and tools. For example, when European settlers to the North American plains brought with them farming techniques involving the plough and other devices, they couldn't understand why such tribes as the nomadic Blackfoot reacted with disgust. The indigenous people equated land with Mother, and ploughing it into furrows was perceived as brutal desecration. The ensuing conflicts were based on the immigrants' assumption that any economic benefit resulting from their imported technology took precedence over the Native's belief system.

Interaction between strangers [or even within groups] wasn't always conflict driven. As societies became more structurally complex, further specialisms developed. The more we rely on the experts produced by division of labour, the more unprepared we are to enter their territory, participate and take responsibility. There's a recognition that someone else can do something or make something better than you can, and you're reluctant to reveal the depth of your ignorance. Of course, perhaps you can provide equally unique services or commodities. Convenient options: trade and exchange. Nobody's ego is compromised.

Ensuing eras witnessed both more conflict and more trade between groups. Different lifestyles, different solutions to common problems were evaluated accordingly, then incorporated, exchanged or supplanted. This increase of the knowledge base, and its distribution among proto-experts was a direct result of population increase and dispersal. Today the Internet speeds such data transfer to every corner of the globe at a rate that barely allows for its understanding.

Over the centuries, the rate of absorption by various societies to the accumulating body of technological knowledge and expertise rose inexorably, reaching undreamed of rapidity in the mid-19th century. By that time, it was no longer possible for anyone to claim proficiency in every technological discipline. The chasm between the fruits of invention and their understanding by the very population they were meant to serve was nearly unbridgeable. Sociologists call it the technological gap.

Alvin Toffler, who wrote so eloquently of these subjects in his book *Future Shock*, further defined the phenomenon to the press as a "shattering stress and disorientation" when change is introduced too rapidly. Remember Vannevar Bush's 1945 warning: the greater the overall accumulation of knowledge the less any one individual can absorb. It's by no means certain that all the implications of every technological advance *can* be understood by everyone. Even people who grasp that an increasingly complex tool could be of benefit to their lives, tend to feel that they'll never be able to keep up with more and more of its improvements.

This is particularly true of electronic as opposed to mechanical advance. Western society has had about 250 years to accept as normal machines with moving parts. We may not all be mechanics, but we see machines in every sphere of our lives. Electronic advance, on the other hand, was evolved under a cloud of secrecy. It gave rise to specialists branded with such derogatory epithets as nerd and geek. And, too, the manifestations of electronics remain largely unseen.

A car with or without electronic improvements looks pretty similar to the public. Now we're told such familiar appliances as ovens and washing machines and central heating boilers are governed by electronics, and are vulnerable to viral disease! We thought we knew these handy devices; now we're not so sure. This ethos engenders an undefined sense of failure or ignorance, of not quite coming-to-terms-with. Rather than any notion of terror or distaste implied by technophobia, I believe it is this other sensation which more precisely defines it today.

Nor must we ignore the economic dimension. The phenomenon of technophobia is usually linked by cultural analysts to the early 19th century Luddites, textile workers in the North of England who destroyed the machines which automated weaving, and which they reckoned would ruin their lives.

When, for similar reasons, French workers threw their wooden clogs or sabots into the gears of newly introduced machines, the word sabotage was coined. The understandable anger of those workers, particularly against the background of the European economic depression caused by the Napoleonic Wars, is rooted in financial reality rather than a fear of technology. Hey, this machine will replace me – why should I learn how it works?!

From that time on the popular perception of technological progress was tinged with suspicion. Even if the fruits of technology were widely adapted and notions of inevitable progress accepted, nagging questions remained. Progress for whom? Was progress the real driver – or profit? And what was the social cost?[75]

I believe modern-era technophobia began in the West during the 1980s with the proliferation of video recorders [actually introduced in the late 1950s], further exacerbated by the subsequent introduction of the remote control. Both technologies were developed to simplify the process of viewing films and television programs. A certain section of the public felt it was just too complicated a journey getting the equipment set up before they felt the benefits of simplicity.

Nor does the technology industry help itself here. Like any sub-strata of specialist endeavour, it's evolved its own jargon. Ostensibly this makes communication between participants more precise.

All jargon is divisive and polarises those in the know from outsiders. Depending on how exclusive any sub-culture conspires to be, layers of jargon can be constructed not just for efficient communication but as a protective barrier. The consequences include: a sense of smugness for those *au fait* with the terminology, feelings of inadequacy in those unfamiliar with it, an opportunity for the former to bamboozle the latter, to cover their own ignorance, and even engage in financial exploitation. Just how thin is the linguistic line between the expert and the con-artist?

[75] Sometimes the longer-term effects of technology are not always clear. Witness the current debate about how harmful the microwave output from mobile telephones may be.

Another industry-specific phenomenon serves further to ripple these already muddied waters: the instruction manual. Which of us hasn't at some time returned home with a new gadget or appliance, bravely opened the box and proceeded to assemble, connect, or otherwise enable it using the enclosed instructions. Suddenly we're teleported into a Kafka play of absurd grammar, translated perhaps from the Martian, and accompanied by illustrations which might as well refer to ballroom dancing. This is definitely a phenomenon of technology. A fig, for instance, needs no such instructions. Nor does a fantasy, a frog or a friend.

Much Internet technology is promoted as plug-and-play – just plug it in and the computer will sort out its own internal instructions. We who have spent hours of frustration as the computer's processor fails to recognise new equipment or software, know this can be a cruel deception, though, to be fair, the situation's improving rapidly. But no one, not even the nerdiest nerd is born with technological expertise. People are willing to learn, but when they're misled by the false promises of careless manufacturers who want to rush out their not-quite-ready wares for a fast profit, frustration undermines confidence.

True, failure to deliver is sometimes the result of user ignorance overwhelming all reason. Computer and Internet technical support lines daily deal with stories which are as hilarious as they are pathetic.

> A Cautionary Tale
> A man attempting to set up his new printer rang the dealer's technical support number, complaining about the error message: 'Can't find the printer.' The man said he'd even held the printer up to the screen, but the computer still couldn't find it.
>
> Not a million miles from the apocryphal Missouri woman in 1910 who wanted to send a cake to her son in California via telegraph!

Despite this, many people new to the Net want to discover what it's all about. A small proportion jump right in with both feet and paddle along nicely. If things go wrong, as they inevitably do, well, it's just a machine, it can be fixed. They're excited by the novelty, by the challenge, by the fun.

Another section of the population has a completely illogical attitude toward the Net. Some won't go online because they're afraid they'd become hooked and never go out. It would sap freewill like a vampire.

One young woman I know is adamant she doesn't want to go online because she prefers going to the library. "There's something about leafing through books, they way the feel," she says. Though I try to explain that I, too, still enjoy the library, and that libraries and the Internet are not mutually exclusive, she remains obstinate. It reminds me of trying to get a child to eat something new. "Yum," you encourage. "I don't like it!" resists the child. "But you've never tried it," you reason. "Because I don't like it!" counters the kid. I give up at this point; life's too short.

Because the Net is currently accessed through a computer,[76] when I ask if they're online many people respond saying they're afraid of computers, or find them 'too complicated.' I usually then ask whether they drive a car [or use any major appliance], and the answer is inevitably yes. When I further inquire whether they understand how the car or whatever works, could they take it apart and put it back together, just as inevitably the answer is no. That hasn't stopped you driving, has it? Pause while penny drops – clunk!

Given so many preparatory barriers just getting online, when it comes to actually surfing the Web some people are so intimidated that a real fear does emerge. On analysis, it's not a fear of the technology, but one that stems from a mistrust of themselves. They're afraid of accidentally destroying the expensive equipment by the merest press on the keyboard or click of the mouse. They've fully accepted they are not now nor have they ever been capable of understanding this Net thing. To save face [and possible repair bills], they simply leave it alone. Which is a great shame, considering how much it has to offer.

Embracing the Beast

In 1532 political philosopher Niccolo Machiavelli wrote "Nothing is more difficult to arrange, more dangerous to manage or less certain to succeed than the introduction of new things. For this introduction will be vigorously opposed by everyone who is doing well under the present arrangements, and given but weak support by those who would do well under the new."[77]

Take-up of any new technology not only depends on a willingness to use it, but a variety of other socio-economic factors. Much international attention is currently directed at issues of online accessibility, the digital divide as it's known. Who has and who has not.

We'll explore this in greater detail below, but now I want to contrast public acceptance of the Net with other modern data transmission technologies which partly parallel its development, as shown in the following graph.

[76] Though, increasingly, this will expand to include a variety of devices further explored below.
[77] *Il Principe* chapter VI

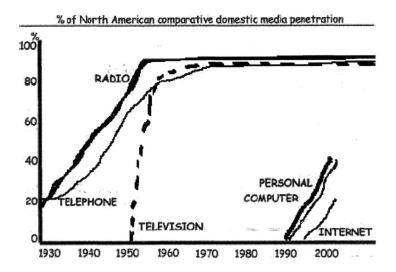

% of North American comparative domestic media penetration

These media all involve processes which at first appear mysterious to the general public. Radio, for example, baffles those who don't really understand wave modulation, amplification, and the process of transmitting and receiving sound-waves. It's common for children and even unsophisticated adults to believe that something [or someone!] is actually inside the radio set producing the speech and music.

Radio had similar origins to the Internet as a tool of private rather than mass communication with a user base which evolved from the military communications station to the nerd's workshop to the heart of the home. Its hardware and mechanics improved with contributions from many sources over a hundred year period, producing sets which were smaller, cheaper and easier to operate. To fill air time an entire content industry was spawned, following different commercial models in various countries.

By the mid-1920s, US radio manufacture had overtaken the automobile industry; ten years later everyone but the most destitute could afford one. Nor has the industry suffered with the introduction of competing leisure and information services. Radio is available in portable form, in cars, and over the Internet. Digital audio broadcasting [DAB] combines technically flawless programme delivery with interactive services such as ticket ordering. The wind-up radio, recently invented by Englishman Trevor Bayliss, has brought wireless broadcasting deep into the bush country bypassing the need for electricity. Its full cultural effect has yet to be appreciated.

According to A. Michael Noll, what we know as television began its earliest existence in the USSR with the principles of image scanning discovered in the 1890s by Paul Nipkow, and refined by fellow Soviets Boris Rosing and his student Vladimir Zworykin who exploited it commercially in America.[78]

In his 1998 paper presented to the Advertising Research Foundation,[79] Barry Kiefl, Canadian Broadcasting Corporation's Director of Research, provides an interesting analysis of domestic television penetration and early national English-language viewing behaviour in his fascinating prediction of Canadian viewing habits.

Even before Canada launched its own network in 1952, border cities sold TV sets in their thousands, since residents could receive US programs. In less than ten years domestic penetration had reached 50%. Twenty years later more than 50% of Canadian homes subscribed to cable services in order to pick up US network shows. And, as Kiefl notes, "this was at a time when cable was still in its infancy in the US and elsewhere."

That phenomenon of virtually borrowing another nation's broadcast services depended on the shared language and cultural similarities between Canada and the US. It factors strongly in both content and scheduling policies for CBC and Canadian cable companies.

"By contrast," continues Kiefl comparing media penetration, "the other two 'universal' household communications media, radio and the telephone, took several decades to reach full maturity. The telephone, albeit more dependent on the existence of a power-grid infrastructure, took the longest, almost five decades, to become a universal household communications appliance and at one point in history actually lagged behind TV adoption. Radio took about two decades to reach full household penetration and, surprisingly, grew quite dramatically during the Great Depression."

Just over 100 years after its initial introduction, US domestic penetration of television sets is estimated at 98%, though it is much less in the developing nations. That said, the latter's take-up of television beats that of the telephone by more than two to one. It's probably telephone installation which most closely relates to the Internet.

Not only is domestic take-up comparable, but both the Net and the phone rely on sending and receiving data packets in an interactive fashion. For both, too, content is of more importance than delivery systems. Users of both media put up with more than their fair share of interference to service in order to get the message across. Users access the experience on a one-to-one basis, despite the fact that online the 'other one' is a computer. As we'll see later, convergence technology is rendering such comparisons obsolete.

Domestic acceptance of the telephone also points up the disparity between rich and poor nations. At just over 95% penetration, there are more phones than people in US households, with separate lines devoted to voice and data; the take-up of cellular and car phones increases the figures. By late 2000, UK cellular take-up seemed unstoppable according to the *London Times*.

[78] *The Future of Communication: An Essay for the Year 2000* Camford Journal Vol 1 #2 4/99
[79] Reproduced at http://www.cbc.ca/

"The four big mobile phone companies are expected to report this week that 30 million Britons – or about 52 per cent of the population, including children and old people – own mobiles. By the end of the year, analysts expect that number to increase to more than 60 per cent."

But in South America, India, Africa and parts of Asia average telephone usage is 1 per hundred of the population, with less than 1% take-up of fax or the Net. That said, when India deregulated its ISP market in November 1998, the government never expected the subsequent rush to bid for licenses.

In his paper for African Telephone Indicators published in June 1993, Jean Jipguep, Deputy Secretary-General of the International Telecommunication Union noted "It is no coincidence that dictatorships and totalitarian systems have only ever existed in societies where the penetration of telephone sets is low and where access to information is restricted to a ruling elite."

Which only emphasises how much more pertinent is the principle when the Internet factors into the equation. Jipguep strengthens his theory with the observation that although sub-Saharan Africa contains about an eighth of the world's population, it uses a mere 1% of the global total of landlines. "That's just ten percent of the telephone density of Asia and less than one percent of the telephone density of the rich industrialized nations that comprise the Organization for Economic Cooperation and Development."

According to a 1997 China Telecom overview of the Hong Kong telecommunications industry, the then colony saw rapid growth between 1992 to 1996, fueled by an investment of over 271 billion Hong Kong dollars[80] in the infrastructure. During the five-year period, there was an increase in landline subscribers from about 11.5 million to some 54.9 million.[81]

In recent years, mainland China, too, has addressed international communications. Dr Tim King, who visited Beijing in 1998, related day-to-day economic conditions to Internet take-up. "If you want a hole dug, just get 40 people with long-handed shovels – certainly not a JCB. And a recent report in the local English-language paper extols the work of some northern farmers who helped clear some drainage ditches and thus alleviate flooding – all 192,000 of them. Mind you, with the average wage being around $US 800 per year you can see why human labour is used rather than expensive foreign equipment.

[80] about $35 billion US.
[81] http://www.cthk.com/

"That doesn't apply to the IT industry, of course, but as many PCs are made in China there's a surprising number of them in use. There are games-playing cafés with rented PCs and multi-player games, and there were 13 million PCs sold to industry and individuals last year – with 20 million estimated this year – there are over 1 million Chinese net users, using the four main networks – two academic, one called Golden Bridge [after a national IT initiative] and one called ChinaNet."

Out of a population of some 1.2 billion people, only 100 million have a landline telephone connection, with a further 20 million mobile phone users. Echoing Jean Jipguep's caveat, King also points out that "Chinese people need a [government-granted] licence to access the Net."[82] Since the licence fee is kept at an artificially high level, it's become the government's most effective tool in restricting Net access.

More heavy-handed methods include the recent jailing of Lin Hai for two years on a charge of treason after he passed on 30,000 eMail addresses to an American magazine. Huan Chi currently faces a ten-year sentence for plotting to overthrow the government because his website published an account of the Tiananmen Square incident. And Sichuan Internet Café owner Jiang Shihua was arrested and charged with subversion for posting criticisms of the Party on his website.

Media watchdogs such as the Paris-based Reporters Without Borders identify a network of Chinese 'web police units' searching out fraud and pornography, but their remit seems to include the recent closure of the New Culture Forum site which sponsored political debate.

It is less than a decade since the Internet has been used by a wider public than its post-ARPA ancestors. As we've seen, its take-up closely parallels that of the telephone. In early 2001 industry analysts estimate global Internet usage at 405 million people. In July 2000, the UK Office of National Statistics released figures to the news media indicating 25% of UK homes [6.5 million households] have an Internet connection as of first quarter 2000, an astounding doubling of the previous year.[83]

More impressive than take-up is the incredible amount of websites available for browsing. A study by Cyveillance[84] in the summer of 2000 found that the Web contains more than 2.1 billion documents housed on an estimated 2-300 million webpages, and it's growing at the rate of 7 million pages per day.

[82] An expert in relational database systems, Dr King founded Perihelion Distributed Software Ltd in 1986 and ISP UKOnline in 1994, now part of the EasyNet Group. His article was contributed as a Member of the Board of SWIM [South West Interactive Media] appearing in its industry newsletter SWIMming, Issue Six, 2 October 1998, archived online at http://www.swim.org.uk/ Quoted with permission of the author.

[83] The figures indicate penetration is lowest in Scotland, Ireland, and the North of England, highest in London and the SouthEast. Though only 3% of the poorest homes are connected, nearly 1 in 2 of the wealthiest homes have Net access, which puts the UK ahead of mainland Europe but below the US. The UK Government has committed itself to assure Net access for all by 2005.

[84] http://www.cyveillance.com/resources/Webstudy.pdf/

While information about precise numbers of WebPages is difficult to pin down, it's easier to quantify Web Hosts, systems registered with an Internet Protocol [IP] address, any of which may contain multiple sites. From its base in December 1969 of 3900 such hosts, the figure had risen to 36,739,000 by July 1998.

The Net is already being accessed in an estimated 50 million locations worldwide. In particular, its application to business, particularly the growth of eCommerce, continues apace. A guest lecturer at Manchester Business School reports the rise of UK business websites, from a 1997 base of 16,000, growing to 30,000 the following year, more than doubling to 70,000 in 1999, and reaching a phenomenal 7 million by January 2000.[85] This is the basis upon which industry projections of Internet acceptance refer to near global penetration by about 2025.

In a very real sense, the Internet is a tool, though you cannot hold it in your hand. It's a cyber-tool. A tool of enrichment. We've already witnessed how it developed into the complex mechanism it is today. Now let's explore the contributing aspects that make it able to serve so many agendas. It's time to talk Web. World Wide Web.

Who's Spinning the Web?

One of the remarkable things about the Web is that it has no centralised structure, no one owns it, no one is in charge of its management – yet it works. Remarkably well. This refreshing *status quo* is largely due to one man, Tim Berners-Lee.[86] Born in London in 1955, both his parents were mathematicians who worked on the Ferranti Mark I computer at Manchester University.[87]

Growing up in such an atmosphere of invention young Tim became intrigued by how computers could link up to disseminate information, and how various bits of the information itself could connect to other associated bits much in the way the human brain can.

[85] Personal communication.
[86] In addition to his post as the director of the World Wide Web Consortium, the coordinating body for Web development, Berners-Lee currently works at the MIT Laboratory for Computer Science where he occupies the 3Com Founders chair. Among numerous international awards, in 1998 he received the distinguished MacArthur Fellowship, commonly known as the "genius" grant to continue his work with the World Wide Web Consortium in setting technological standards for the future of the Web.
[87] See p37.

After graduating with a physics degree from Queens College at Oxford University [where he built himself a working computer], Berners-Lee joined Plessey Telecommunications in Dorset as principal engineer. He moved to D.G Nash Ltd for whom he wrote a multitasking operating system, before fulfilling a short-term contract in 1980 as a consultant software engineer at CERN, the European Particle Physics Laboratory based in Geneva. While there he wrote a computer program called Enquire to organise information, making it accessible to other computers within CERN. It served as an early model for the Web.

After accepting a position with Image Computer Systems [where he sharpened his skills in system design for real-time communications and text processing software development], at the age of 29 he was invited back to CERN on a fellowship to work on distributed real-time systems for scientific data acquisition and system control. It was during the ensuing few years that he re-designed Enquire and parlayed it into what became the World Wide Web.

In various interviews he's admitted it was because he was given the freedom to work on projects which interested him that he was able to join forces with another CERN colleague, Belgian engineer Robert Cailliau, who helped finesse the idea into an official project. They were finally given the green light in 1989 to create Berners-Lee's global hypertext system.

What interested them was how to organise and access information over the Internet – "human communication though shared knowledge,"[88] as Berners-Lee later described it. He envisioned "a universal space of information" in order "to work together better,"[89] with subsequent developments enabling computers to take eventual responsibility for managing information, freeing up humans for more creative endeavour, whether in a business, science, or leisure discipline. Licklider would have approved! But where was this so-called virtual or cyber-space? How do you make real something which can't exist?

In order to create such a paradox Berners-Lee and Cailliau began writing a set of internet protocols which would enable input text to be transmitted and re-assembled in a computer screen lay-out display [through a browser]. Because the text can be accessed by any computer connecting to the server which hosts the document, it instantly becomes available worldwide. The two sought the assistance of technical student Nicola Pellow [who helped create a line-mode browser for the project][90] and CERN programmer Bernd Pollermann [who programmed a distribution server].[91]

[88] From the talk entitled *Realising the Full Potential of the Web*, presented in London at a W3C meeting in December, 1997, quoted with permission of the author.
[89] *ibid*
[90] This was prior to today's familiar window-like browsers.
[91] A server is like a staging post storing web files and allowing access to them; programmers can write code to enable virtual servers.

Berners-Lee foresaw that such a facility could address the ever-increasing problem of information overload. Because of the specialisations described above, people need a simple way to access information outwith their immediate spheres of interest. The various protocols devised by him and his colleagues could achieve this with a combination of hypertext and the Internet.

Hypertext is the means by which a word or image is connected to another merely by clicking on it with a mouse – it literally jumps you from one place to another.[92] That place can either be contained within the same document or to a completely different one, even one on another website. It's made possible by embedding a particular code into the document, which is written in hyper-text markup language or html. Berners-Lee invented the terms http [hypertext transfer protocol] and html. And, of course, he named the whole system.

Before Berners-Lee settled on the name World Wide Web, he'd rejected Information Mesh, Mine of Information [MOI], and TIM [The Information Mine], which he thought too egocentric. Interviewed by the Seattle Times in 1999 to promote the excellent book he co-authored with Mark Fischetti, entitled *Weaving the Web*,[93] tracing its genesis and ongoing development, Berners-Lee revealed "there was no Eureka! moment where the Web just came to me – it really was an evolutionary process."[94] As he explains in Chapter Ten, "the Web is a work in progress."[95]

A website consists of one or more electronic pages displaying digitised text, graphics and/or sound. Unlike any physical page it needn't be constrained by length; the scrollbars built into the browser allow you to navigate its contents. Since cyberspace is infinite, theoretically there's no limit to how many websites can be made available online. The challenge was to provide a unique identification for each page or site, and a means of instantly connecting any of them. The system launched to a largely indifferent world in 1991.

Berners-Lee came up with the concept of a Uniform Resource Locator [URL][96] which assigns a unique identification for each webpage. This is the web address which is displayed in the appropriate window of your web browser, and usually begins with the letters http.[97] It allows those associative links mentioned above. The concept of association was vital for Berners-Lee, attempting to approximate the way human brains make lateral connections.

[92] The term hyper-text itself and the concept behind it had actually been devised in 1965 by Ted Nelson for his ill-fated Xanadu project, with a separate and early implementation three years later by researcher Doug Engelbart at SRI, who devised a shared workspace called oNLineSystem or NLS. Englebart invented a rudimentary mouse to help manipulate the hypertext.
[93] Published by Harper in the US, Orion in the UK, and already translated into five languages including Chinese.
[94] Quoted with permission of the author.
[95] *op cit*
[96] Though he originally called it a Universal Resource Identifier or URI.
[97] URLs can also begin with a selection of other letters which indicate various other protocols for transferring data. For example: ftp [file transfer protocol], or news [which accesses a variety of Newsgroups, publicly accessible forums about limitless subjects].

Equal in importance to the Web itself is Berners-Lee's insistence that no one owns it and that the code which makes it possible [all the protocols, etc] be open and shared.[98] If you have the means to call up a webpage on your PC monitor, you can see an example for yourself of openly available coding. Just click the right-hand button on your mouse on any webpage. A pop-up menu will appear and one of the choices will read 'view source.' Choosing that option calls up another window in which you can see the html code which instructs your web browser how to display whatever is on that webpage. Try it!

In addition to his scientific far-sightedness Berners-Lee possesses an all-too-rare socio-cultural responsibility which baffles those of a more exploitative nature. "The vision I have for the Web," he explains in his book, "is about anything being potentially connected with anything. It is a vision that provides us with new freedom, and allows us to grow faster than we ever could when we were fettered by the hierarchical classification systems into which we bound ourselves."[99] His vision was codified on April 30, 1993, when CERN announced that anyone could use WWW technology without any payment of fees to CERN.

Because the Web was conceived as such a free-for-all phenomenon and cannot be under any single control, it invites global participation. Clearly it cannot function without it – what's the good of being able to gain access to file storage depots if there aren't any files in them? The WWW is not only a mass medium in the sense of reaching a mass audience [like television], but unlike broadcasting and more significantly in that anyone can create a website which is instantly available to everyone else with an Internet connection.

By contrast, an individual simply cannot send a taped programme to a broadcaster with any hope of its being aired. True, with the proliferation of cable channels in conurbations like New York, almost anyone can buy airtime for home-made programs, but the analogy is not complete. Because not only does that pre-suppose a commercial transaction, but the show is available only to those having cable access within a circumscribed range of transmission.

None of this means that websites cannot be commercial, nor does it proscribe any aspect of a site's function or content. What it does allow is exactly the same web access to a multinational corporation as to a teenager in Singapore. Each of their websites can serve whatever function is required and [unless it is protected by a password] is accessible to anyone who knows the URL.

[98] An uncomfortable situation developed in the early days of the Web when the National Center for Supercomputing Applications [NCSA] based at the University of Illinois publicly claimed proprietary status because of their developmental work on the Mosaic browser. Leading the Mosaic Project was graduate student Marc Andreesen, who left NCSA to join with businessman Jim Clark in what became the Netscape Corporation.

[99] *op cit*

From its earliest days, the Web has been an example of the technological gap. Berners-Lee was always mindful of that, convinced those involved with developing the Web have a responsibility to its effects on society which "can find itself left behind, trying to catch up on ethical, legal and social implications." As he said in a speech to the first International WWW Conference hosted at CERN in May 1994, "technologists cannot simply leave the social and ethical questions to other people, because the technology directly affects these matters."[100]

It was as a result of the conference that an alliance was formed between CERN and MIT's Laboratory for Computer Science [LCS] to establish, co-host, and administer an international membership body which would monitor the freedom of the Web and ensure open global standards for its technological development. Seed funding was provided by DARPA. Berners-Lee relocated to Massachusetts on the staff of LCS to head the consortium.

The body took the name of the World Wide Web Consortium, which is usually shortened to W3C. In addition to its host base at LCS, there are also teams at the French National Information Research Institute and Keio University in Japan. The project was announced to the world in July 1994 by Martin Bangemann, then a Commisioner at the European Commission, who had championed the inclusion of CERN in W3C and obtained support from the EC membership at government level.[101]

In his book, Berners-Lee describes the purpose of the consortium: "to lead the Web to its full potential."[102] He's since expounded on that to address W3C's "mandate to keep an eye on architectural integrity and simplicity," assuring that the rate of improvement of and addition to Web technology doesn't fragment the industry into developing standards which cannot be harmonised for global accessibility.[103]

[100] Quoted with permission of the author.
[101] Bangemann was subsequently disgraced, accused of corruption and resigned from his post. Prior to that, however, he gave his name to a prestigious annual international Awards Ceremony called the Bangemann Challenge, which rewarded non-commercial Web projects at a lavish ceremony held in the Stockholm Town Hall with cash prizes presented by the King of Sweden, followed by a banquet recreating the menu served to winners of the Nobel Prize.
[102] *op cit*
[103] Quoted with permission of the author.

Full membership in W3C was solicited from a range of commercial companies, government departments, academic institutions, and any other profit or non-profit body which could afford the $50,000 annual subscription; affiliate members could join for $5,000. In 2000 W3C's 424 members included: ABN-AMRO, America Online, AT&T, the BBC, Boeing, CitiBank NA, Daewoo Electronics, Electricité de France, GCHQ, Japanese Society for Rehabilitation of Persons with Disabilities, London's Metropolitan Police, Microsoft, The National Security Agency, Nato's Command and Control Agency, The Nippon Telephone and Telegraph Company, Phillips Electronic NV, Sony, Toyota, the UK National Health Service, Universities of Brunel, Bristol, and Bologna, VeriSign, and Xerox.[104]

If the Consortium members represent a wide range of interests, the hundreds of millions of websites reach even further. There's a false perception that merely because the Web displays such an unregulated range of experience, any particular contribution is diminished. 'How can you trust what's there'? is a frequent caveat.

That is not an Internet issue, it's one of cultural accountability. You might ask the same question about the millions of books contained in the British Museum Library. The library itself cannot be equated with the quality of content in any volume given shelf room. Nor can the Web be dismissed as a source of information or amusement because a percentage of websites have been prepared by the untutored, the unimaginative or the unqualified.

Hard copy publication is no more reliable. Nor is the quality of local cable narrowcasting. Or the standard of painting in a neighbourhood art show, or journalism on a school paper. Yet no one's suggesting heavy-handed regulation or distrust of these media. There have been precious few Mozarts throughout history, but would anyone suggest that musical composition be taboo to the untalented? Just because you're no Kurosawa should that mean you're forbidden to use your camcorder?

Who's to decide anyway? One person's political or religious, cultural or economic so-called truth is another's propaganda. And, apart from the efforts of Ralph Nader and various regional consumer watchdogs, the emblem of commercial accountability reads *caveat emptor*.

The Web provides a space for everyone and anyone. What you do within your space is up to you. It may have to comply with the laws of the land of its progenitor.[105] But it doesn't have to be accurate. Or literate. Or aesthetic. This makes it the most democratising medium there's ever been. It also bursts the bubbles of pomposity by that sector of society used to being granted respect and authority whether they deserve it or not. No wonder in a world largely dominated by hierarchical control of politics, business, and the military, that such an unregulated platform has set off the loudest tocsin in our collective history.

[104] The full list is available on the website: http://www.w3.org/Consortium/
[105] The legal aspects of Web content are sorely testing international bodies, particularly with regard to issues of jurisdiction, libel and copyright.

What Web Jeremiahs actually object to is the universal facility to access content that doesn't please them. They cite the availability of instructions to manufacture bombs or of pornography or racial hatred, as though similar documents aren't obtainable elsewhere. To use the library analogy again, it's like blaming the building for providing books which don't meet a particular group's worldview.

There may be a valid debate about what technological protection can be integrated to ensure such items aren't available to children, but that's a completely separate issue involving uncomfortable implications of parental and social responsibility versus state mandate.[106] Any other justification for castigating the Internet treads with jackboots on the toes of free speech. The Web helps prove that the best defence against the malicious and the salacious is sufficient information to stimulate informed debate and redress the balance.

I believe we should be celebrating the Web as a cornucopia in which anyone can rummage. It's as exciting as exploring an attic full of beckoning boxes, intriguingly labelled and fulfilling at the very least their promise of variety.

Gallimaufry

This strange word, derived from the French and meaning a medley or jumble, pretty accurately describes the World Wide Web, which is an amalgamation of professional and amateur virtual doorways leading to a plethora of special interests.

We call these doorways websites, and there are currently an estimated 800 million or them, give or take a few. They're being born and dying all the time. And they're being used for everything under the sun.

Berners-Lee may originally have conceived his "universal information space" as a global document storage and retrieval system. In the interim, however, the Web has opened out to include the widest possible range of content, a significant proportion of which focuses laser-like on degrees of the commercial.

Sites can also be passports to amusement, open-house to social welfare, or dedications to the electronic ego. Whatever people find interesting, amusing, exploitative or vital is represented on the Web. The best sites are guided not only by different presentations of the online versus the offline experience, but the different ways that experience is perceived. It should be noted that though the Web is used on every continent, and content is displayed in a variety of languages, its *lingua franca* is English.[107]

[106] Unsurprisingly, computer technology has produced filtering solutions which bar access to certain websites, with flexible parameters allowing entry to authorised people. Once again, this presupposes individual choice over group or state tyranny.

[107] This contrasts with the wider Net whose data transfer reflects increasing access by non-English speaking people sending messages in their own languages.

Because of the way the Web is constructed no two people will ever negotiate it in the same way. It recapitulates the way we amass those experiences which render each of us unique while paradoxically remaining an infinitesimal portion of the entire species. In short, the web experience is interactive and non-linear. Which takes a bit of psychological adjustment.

Certainly this is a baby industry and its rules are still being written. We're all learning on the job, and that includes web visitors as well as site creators. As with any media industry ultimately dependent on its public, there are more and less useful questions to ask. We ain't gonna get nowhere unless we all acknowledge that this is NOT a we-tell-you industry like radio, broadcast telly and cinema. It's a gimme-what-I-ask-for kinda thing. It invites dialogue and participation. After all who, except for some sad, sad people, would choose a site that merely screamed commercial messages, whether in boring plain text or souped up with fancy dancing fonts and pix? That's like watching a telly channel which only shows adverts instead of programmes. A kind of parallel universe BBC TV.

Most real-world experiences of learning and leisure are presented *a priori* in a one-way direction. Proactive Seat of Expertise Passive, Ignorant Audience. What I call the 'we-tell-you tyranny.' Now that doesn't sound quite so offensive if you substitute for the word 'tyranny' the more sanguine concept 'vision.' It is, after all, the *modus operandi* of most creative artists and disseminators of facts, as well as of the dictator.

The Internet, however, requires a series of actions and reactions which generate further actions until the cycle is terminated by either side. Often the 'other' is a website, but that doesn't negate the sense of control and participation of the user. There's no one place to start online. As a result of hypertext, you don't experience the Net in a linear fashion, progressively according to someone else's pattern. You always have choices, the ultimate being to access another site or log off entirely. With all that webpage content, there's a lot to choose from. For now I want to explore the diversity of the online experience. We'll examine particular examples in more detail elsewhere.

✿✿✿✿✿

Information

As we've seen, transmitting information was the initial use for both Internet and Web. Some people assume that's still its sole function. Although they're mistaken, whether military, scientific, political, social, historic, cultural or commercial, the Web's information cup brimmeth over. It's most often provided for free and available to anyone who lands on a particular website. There's an amazing variety of sites devoted to pure data, others to an interpretation of it. Although some pages are merely electronic repros of paper originals, many more are made interactive by the magic of hypertext and more complex programming.

You can find online news mirroring the lay-out of offline publications with electronic text in columns. Many such ePages are composed and maintained by the same journalists, others by writers who've grasped the subtle differences in writing and preparing online text. They understand the aesthetic of how content is accessed by web-users; most don't, convinced the content alone is sufficient. Some deliberately present information for downloading and perusing offline.

Prior to the Internet, widely disseminated editorial comment has been solely available either in a printed organ which published whatever factual story deserved it, or radio talk shows whose agenda is manipulated by the broadcaster. Adding volume to every iota of information online are the comments posted by a variety of interested parties, analysed and re-analysed.

This facility is open to anyone who takes advantage of the millions of what are called Newsgroups, or to those who can obtain webspace, which usually comes free as part of the package when you sign up with an Internet Service Provider [ISP] to 'go online.'[108]

Which raises something of a dilemma. It can certainly be argued that everyone's entitled to their own opinion, and that anyone's view is as valid as anyone else's. On the other hand [and given the observations above about specialisation, information overload, and expertise], the comments of those with more experience about a subject either as practitioners or analysts may intrinsically hold more merit. Could it really be that as democracy increases its currency decreases? Encountering the roar of online comment should the response be to take in as much as possible for fear of missing something, or a curt 'who asked you anyway?!'

Not just news and comment, but reference materials and encyclopaedias, too, have found cyber shelf-room, jostling for attention. Pursuant to the first release of multi-media tomes such as Groliers and Encarta [which not only provided on a CD-ROM all the material which previously occupied over 25 printed volumes, but enlivened them with hypertext, moving images, and sound], their massive content is now available on various websites. A tidal-wave of information, yes – but there's an ocean more.

This glut of data is fattened by: dictionaries for every language and discipline, searchable maps and interactive route planners, instant translators for nearly every language, currency converters, the thesaurus, hourly updated weather reports, digi-cams recording the behaviour of zoo animals or window-shoppers, song lyrics, current and archived articles from newspapers and journals around the world, medical diagnosis forms, airline and rail timetables, monthly mortgage repayment calculators, pages of quotations, almanacs, the progress of marmosets at the Pacific Primate Sanctuary, current bank rates, comparative house prices, museum collections, local and national voting records, stock quotations, school league tables, verbatim Parliamentary debates, technical repair and maintenance manuals, the periodic table, the history of just about everything – I could go on.

As an information resource the Web surpasses any previous material collection primarily because cyberspace has no size limit, and publication is easy and cheap or

[108] This process will be explained more fully below, as will the concept of Newsgroups.

free.

By comparison, the US Library of Congress [started in 1800 as its name suggests to house government-related documents] has expanded to fulfil a more general research function. It contains an estimated 28 million books and pamphlets, thousands of original manuscripts and personal political papers, maps, newspapers, music scores, microfilms, films, photographs, recordings, prints, and drawings. It houses 35 information databases of 26 million records, available to researchers and academics using computer networks linking over 20 million computer users in more than 100 countries. This astounding volume of physical data is rivalled by the British Museum's National Library boasting over 190 million items of equal diversity, with an additional annual increment of a further 1.5 million and Web resources leading to millions more.

No-one is suggesting the cyberworld will replace the real world. For the access of information alone, clearly there will be a need for libraries for many years to come. But even physical collections are relying more extensively on the Web. Not just, as we've seen, to provide an online database of resources, but also to display fragile books and manuscripts which are in danger of decay because of their age. While the originals are kept hermetically sealed, each cyber-page can be accessed online, making the works available to far more people than otherwise could view them.

However many pages of hard-copy a library can amass, the Web will always dwarf it. Project Gutenberg,[109] for example, launched in 1971 by Michael Hart, provides access to searchable eTexts for every book out-of-copyright which a growing battalion of volunteers feel should be included under Hart's categories of Light Literature, Heavy Literature, and Reference Works. Hart understood at that early point that any item [text, images, sound or any combination] which can be contained on a computer connected to the Internet can be reproduced and distributed infinitely, a phenomenon Hart dubbed Replicator Technology.

Further, he insisted that these eTexts be prepared in what's known as Plain Vanilla ASCII [American Standard Code for Information Interchange], as opposed to the page lay-out coding embedded in any wordprocessing program or html editor. Since ASCII displays text as it would appear in hard-copy without such coding, it ensures that any platform of computer can reproduce it legibly to anyone with Web access. Hart's also insistent that until online display graphics become standardised in the same way, his eTexts won't contain illustrations. However, he encourages individual display of the eTexts on personal websites, which can enliven them with any digital options available. With the help of its unpaid volunteers and public donations to offset text preparation and scanning, the project aims to have 10,000 volumes online by 2001. Though Project Gutenberg shows its American bias, nothing is stopping similar projects in other languages to expand the concept and better represent the wealth of global literature.

[109] Available online at http://promo.net/pg/ the project began when Hart was given $100,000 of computer time by his brother and other computer operators on the Xerox Sigma V mainframe at the Materials Research Lab at the University of Illinois.

Entertainment & Leisure

Every civilisation records its needs and desires to have fun, to be delighted, to interleave work and survival activities with leisure time, humour, fun. Smiles and laughter exist in every human society. Young apes, too, love being tickled and will even form a 'laugh' face in anticipation of the activity.[110]

Like the young of many mammal species, human kids create and learn games and other play activities which mimic adult concerns. It's part of the way we learn to make sense of the world and our own place within it.
No more graphic example exists than setting children loose to dress up in their parents' clothing. Adults have developed a cultural response of benignity and downright amusement when toddling tots assume such inappropriate grown-up mantles.

I believe these responses have generated a desire in adults to reproduce the sense of fun, of being young, of being amused, of being engaged and taken over by something other than tasks of survival. Down the centuries we've invented all manner of means to fill that desire. Paintings, carvings, music, dance, storytelling, jokes, boardgames, dolls and puppets, quizzes, poetry, sports, hula-hoops, peek-a-boo, happenings, frisbies, cartoons, rollerblades, computer games. Some are interactive, others received passively. [Of course we must remember that for those who actually produce such entertainments, they are not leisure activities but work, however enjoyable.]

Because many of these amusements have been commercialised, it's possible to measure participation. Once again, the Web reflects and expands the range of possibility. As an example, let's explore how Western film-going behaviour has been affected by the electronic revolution.

In the 1930s and 40s, at the height of movie popularity [and with competition only from live theatre, radio, and non-narrative leisure diversions], US film-goers attended changing double bills an average of twice a week. Twenty years ago, average UK per capita film-going had dwindled to approximately twice a year. However, despite new media, worldwide populations have never tired of their fascination with the movies, from the trivial 'gossip about the stars' level to intensive semiotic analyses.

Today, adult leisure time devoted to film-related activities [cinema-going, video rentals, cable and terrestrial television film viewing, etc] is fast approaching top levels of film attendance in the late 1920s to early 50s. This is despite higher costs per ticket in real terms, the almost complete absence of double bills, and greater pressure on film distribution companies to earn back production costs within the first weekend of release.

[110] Unpublished account of personal experience with young orangutans at the Los Angeles Zoo, 1976.

The Net Effect

At the convergence of millennia, Hollywood is funding its own digital convergence. Every aspect of filmmaking is undergoing digitisation from sound capture to online distribution. While some tinseltown moguls still think all chips come ready-salted, such innovative companies as George Lucas's Industrial Light & Magic, Sony's Imageworks and Digital Domain have been changing the movie landscape forever.

With an eye on a future Net delivery of eMovies, Carlton Communications' subsidiary Technicolor splurged 23 million bucks acquiring 49% of Real Image Technology. Instead of the time-consuming processing and developing an average of 35,000 release prints for every Disney, Warner and DreamWorks film, Real Image will allow Technicolor to compress, encrypt and store movies for electronic delivery and projection in a high-quality, copyright-tight format. In Europe various cyber-cinema projects are in development, including prototypes by mammoth German film-studio Babelsberg, involving simultaneous digital projection of films via satellite.

Keeping pace with the increasing pattern of film viewing worldwide is the explosion of film-related books and publications, feeding the public demand for news and views about every aspect of the movie business.

The Web has reflected this universal cinema obsession since its inception. Information and 'webchat' about movie-related subjects forms one of the heaviest areas of Internet use. Thousands of sites, both commercial and private, provide invitations to write reviews of current and past films, to rate them, question stars and directors, deconstruct scripts, download clips, muse about meaning, get tangled in trivia. Some sites actively encourage production. Absolut Panushka is a sponsored site which until recently featured an ongoing digital animation festival, soliciting new micro films and making them freely available for online viewing.

Fragmentation of media leisure choices during the past twenty years is reflected in a current Internet penetration of 5% of all media leisure time. The figure is growing exponentially.

Of course the Web offers far more engagement than commercialised and/or traditional entertainment sources. The Net is a vast repository of jokes and cartoons on all subjects. Some sites deliver chuckles in text form, some combine text and images, still others use streamed sound.

Many people use the Web as a free gallery to disseminate their poetry, paintings, photographs, short fiction. They've learned how to incorporate interactive or animated display, enhancing the experience of their work to viewers. There are plenty of sites which allow you to download copyright-free animated images with which you can enliven your own website. Of course these add-ons can be aesthetically abused, but the point is they're available.

Online games can be played singly, between two people, or, as in the various *Quake* tournaments, among a battalion united only in cyberspace. Innovative quizzes like *You Don't Know Jack* require the download of a coded engine which drives the online game, capturing your desktop.[111] It's sponsored by top brand names which interrupt the quiz in an amusing way, allowing free play for Web users.

Board games such as scrabble, chess and checkers are also available online, as are crossword puzzles, word games, tetris puzzles, adventure games, and every variety of card game ever invented – plus some you can design yourself. Most of these are freely downloadable; some are played online. Many serve as *hors d'oeuvres* for purchased fun.

There are also interactive games which are only available online. Usually aimed at a more, shall we say, adolescent level of humour, they include throwing eCustardPies at prominent figures such as Bill Gates or Whitney Houston or making the Pope's eyes pop out. The Web allows more sophisticated amusements, too, such as interactive storytelling and global music jam sessions.

We'll examine convergence technology later, but it's worth noting the improvements to streamed audio and video, which, with the addition of sound and vid cards to your computer, make it possible to tune in radio and television programmes around the world whenever you wish. Freely downloadable players acting as virtual radio stations allow you to pre-select stations dedicated to jazz, talk, news, classical, rock, even Parliamentary coverage. The latest of these also mimic juke boxes, allowing you to record and store tracks on your hard drive.

Speaking of music, with the development of audio compression programs [eg MP3],[112] the Web offers the ability not only to listen to tracks and samples online, but to download them and even to manipulate them, turning everyone into a potential composer.[113] We'll learn more about this in the next section.

And, of course, there's porn. I'm not going to address the moral arguments pro or con, but online pornography has to be assessed in the context of its availability offline. Only the naïve haven't noticed that the pornography industry is one of the most lucrative in the world. The Internet as a delivery mechanism for porn is not responsible for what's clearly an insatiable demand.

[111] Such a hybrid technology, which combines the Net with the resident program on your hard-drive, negates the need for a browser for the course of the quiz. This online version of the best-selling CD-ROM series can be found at http://www.won.net/channels/beserk/jack/jack-play.html/

[112] A means of compressing data for fast and easy transfer from an Internet server to a personal computer.

[113] In the first quarter of 2001, Napster, the website featuring MP3 tracks, has lost its appeal in the US Courts, and has been forced to close down. The collective sigh of relief breathed by a plethora of musicians, their agents and record companies could be heard around the world. But I bet a similar version will be back!

Since every country has its own legal standards of acceptability, and given the Internet transcends national boundaries, the responsibility for access to porn websites needs to be as individual as it is for printed or video material.

As already noted, there are computer programs to prevent browsers from displaying such material. Where there are no legal constraints, various degrees of porn are as available on websites as offline. There are two categories: the highly organised pay-per-view operations which supplement magazines, the club, rental and cinema scene, and the amateur postings of individuals of every sexual persuasion, using themselves as online displays.

In fact porn is not the only category appealing to individual expression. Digital cameras and easily created web software have made possible all kinds of exhibition portals revealing glimpses of people's beds, showers, teddy bear collections, shoes, sculpture, refrigerators, pets, and diaries.

Personal diaries, often called blogs, have become one of the hottest web cults, some attracting a huge fanbase who eagerly await daily instalments. Indeed this obsessive digital peering into the private lives of others [perhaps coincidental to the rise in real-life television shows such as *Castaway* and *Big Brother*], was fused with an exhibition in winter 2000 at the Watermans Art Centre in London, supplemented online at http://www.dido.uk.net/ The exhibit, called *Day In Day Out* or *DIDO* was mounted by Furtherfield.org, a collective of artists, writers, and critics who specialise in creative projects that straddle the Net and the material world.

Commerce

The Web wasn't designed for commercial transactions, but the business world was quick to infer its potential. It hasn't been that ready to address inherent problems.

There are two online business issues:

> Corporate investment
> Direct transactions

Corporate investment involves the market aiding, abetting, and acquiring web businesses [or dot com companies as they've come to be called] for greater profit. This attempt to follow traditional business models [wherein a flurry of new companies morphs into a big fish gobble little fish scenario] results in a constriction of the marketplace, with fewer consumer benefits.

The big question is whether the Web could possibly be the industry to re-write traditional patterns of capitalist development within business sectors. At least one challenge comes from the Internet labour force of project managers, designers, and tekkies in whom resides the skillbase.

Direct transactions include all websites which offer products and/or services for purchase by end users, customers, consumers. Current jargon dubs this process b2c [business-to-consumer]. Given the ease and flexibility of putting up websites, this tends to diversify the marketplace and has resulted in what's called disintermediation, or cutting out the middle man. Consumers normally benefit from greater competition and lower prices.

The development of the Web was undoubtedly technology-led. Since then it's largely followed a marketing-led agenda. Which isn't so surprising considering that America has most influenced the field. The US is a country dedicated to selling, its cultural value system predicated on assigning a dollar-worth to every aspect of life. This has been particularly true since the post-war years.

Measured quantitatively, the world of advertising and marketing annually turns over more than $20 billion in the US and nearly as much in the UK. According to all financial projections, not only are profits rising year on year, so are profit margins.

In such a cultural climate it almost doesn't matter what the product is. Selling becomes an end in itself. The global reach of Western goods and services has had profound effects on cultural development, the phenomenon called cultural imperialism. Undoubtedly the Internet offers an irresistible market.

According to the New Media Knowledge website, "the value of business on the Internet will reach $1 trillion by 2002. Online sales are growing 40 times faster than world GDP – even faster in Europe. At 2 per cent of the world economy, the Internet is set to become the biggest industrial market place in the world."[114] In 2000, the Finns were making most commercial use of the Net per capita, while Germany registered 42% use of online banking, compared with a more cautious 7% in the UK.[115]

As we've seen above, this focus ignores much of the Net's intrinsic value and potential. We're hit by the daily tidal wave of advertisements beckoning us to buy online. A new stock market, the Nasdaq, is dedicated to trading and reporting IT shares. News reports increasingly refer to the commercial aspect of the Internet – whether it's Judge Thomas Penfield Jackson's verdict on Microsoft or the demise of online sportswear eTailer Boo.com, powerful corporate forces dominate our perception of Internet activity, providing the impression that the Web is nothing more than an endless shopping mall.

Don't get me wrong – I welcome the opportunity to buy online. It's quick, it's far less hassle, I can make informed purchasing decisions and find astoundingly great deals. I definitely feel in control of my choices. There are perishable products I'd probably resist buying online, such as lettuce or strawberries. But I'd rather buy goods from a website offering me lower prices and free delivery at the click of a mouse than tromp around the shops. And if a wrinkly like me feels that way, I'm convinced the next generation will turn first to the Net to buy stuff, before even thinking about alternatives.

[114] http://www.nmk.com/
[115] BBC Radio 4

To emphasise the range of available online transactions at the beginning of the 21st century, here's a list of the variety of goods and services I've purchased over the past few months, several of which offered generous discounts.

For me: 28″ television, portable radio, mini cassette recorder, hairdryer, foreign and domestic airline tickets, car hire, pre-booked long-term carparking, foreign and domestic hotel and guest-house reservations, vitamins, organic coffee beans, books, annual fee for ISP, software registration, membership fees, paid all utility bills.

As gifts: soap, jewellery, flowers, plants, books, audio-tapes, food hampers, hand-painted scarf, speciality teas, hand-dipped chocolates, charity donations.

My past and current business clients offer an additional range including: antiquities, pet supplies, organic food, feature film and television programme spin-off merchandise, computer equipment and peripherals, literature and products for children with enuresis problems, online university and further education courses, zoo gifts, healthcare and beauty products, landscaping services and plant delivery.

That's a mere taster! Part of my job as an Internet consultant is assessing the effectiveness of websites, especially those for business. Sadly, most are drastically under-performing. The reasons have a lot to do with a misconception of what a website is for, what it can do, and the ways it can attract attention.

While industry is wealthy enough occasionally to fund both the technological and artistic innovation which can help them, the goals seem always to be shorter-term. Marketing sets the agenda for the majority of corporate websites, and when they do address innovation online it's more likely to refer to new selling techniques. Yet another example of the we-tell-you approach borrowed so inappropriately from traditional business paradigms.

Statistics from top Web analysts prove repeatedly that people don't go online to shop. They may well spend money once they're there, but that's not why they go. Since the Net at its best produces such a rich experience, a strictly utilitarian approach to content misses the point. Therefore the challenge for eTrading, and particularly for smaller eBusinesses which can't rely on brands, is how to keep the site sticky. It's up to the imagination of any individual website to lure first-time users back again on a regular basis. What variety of eye-candy will entice users to stick there long enough to reach for their credit cards?

Presentation has a lot to do with the answer, and the growing synthesis between the aesthetic and the technological has introduced a brand-new range of cyber-possibilities. It is the amalgamation between digital design and program coding which is spawning a vision of the future of communication. In the next section I want to set this exciting tool in its cultural context.

section 3: the da Vinci syndrome

Is this a wonderful drawing or an industrial blueprint? Both! It's Leonardo da Vinci's parachute, designed in 1485. The drawing joins a canon of his inventions including a military tank, a helicopter, centrifugal pump, and crossbow. None was able to be constructed during his lifetime because of the limitations of available materials. All the drawings were products of da Vinci's imagination, albeit based on sound principles of physics and engineering. All epitomise the synthesis between the Arts and Technology which has enriched so much of our lives, up to and including the Internet. With his fascination by and expertise in so many disciplines, da Vinci truly was Renaissance Man.

Today

we live in an Age of Specialisation for reasons discussed above. Neither life nor the Internet can be so neatly categorised, often fuzzing the boundaries between Art and Technology à la da Vinci. I believe the increasingly ubiquitous digital experience is one of the most important cultural drivers our species has ever encountered. Since it's not often given the attention it merits, I have used this section to explore in detail the enrichment which results from that fusion, and how the Net profits from it.

Under the Influence

Here's a true tale. In 1974 I was in Paris acting the part of Woody Allen's sister-in-law in his film *Love and Death*. On a break from shooting, another crew member and I attended a sculpture exhibit at the Orangerie Gallery in the Tuileries which proved to be the most bizarre, the most mesmerising art show I've seen before or since. Of course filmmaking itself is only possible because of the synergy between Technology and the Arts. However, so unexpected was this unusual sculpture exhibit, I believe it serves as a paradigm.

I wish I could remember the name of the sculptor; I do know he was Russian and that he worked in hydroponics.[116] The Parisian gallery was filled not with plants, but with microscopes and magnifying glasses on pedestals. The sculptures themselves were so small they could only be seen using magnification.

Under the microscopes blossomed a miniature world. Not only had the artist sculpted these wee wonders, he'd also fashioned the tiny tools required to make them. On each page of a book which measured a mere fraction of an inch, was a verse written in the Cyrillic alphabet. Another exhibit featured a bust of Lenin in bas relief, sculpted from an apple seed. A flea had been immortalised, shod in six perfect golden shoes. And a tiny working steam engine chugged back and forth lifting a lever. For perhaps the most amazing piece, the sculptor had hollowed out a human hair, which he polished to crystal clarity. Then he sculpted a microscopic blood-red rose, and nestled its green stem in the crystal hair-vase.

We tend to associate the concept of technology with science or with the mechanistic world as it relates to industry. But technological influence on the Arts has been just as crucial. The two interact in a variety of ways, helping to shape the creation of content and its delivery online. Subject matter is perhaps the most obvious, long pre-dating the Net.

Decades before modern movie audiences thrilled to special effects produced by animatronics[117] and computer animation, writers, painters, choreographers *et al* have long been inspired by the technological world, including:

> Any of Jules Verne's 19th century science fantasies featuring rocket ships, submarines and helicopters

> Igor Stravinsky's 1911 ballet *Petrushka*, about a mechanical doll who comes to life

> Karel Capek's 1921 play *RUR*[118] which coined the word robot and featured dehumanised mechanistic beings

> Fritz Lang's 1926 introduction to silent cinema of the narrative science fiction genre with *Metropolis*, depicting a mechanical dystopia set in the year 2000

[116] Growing plants in a soil-less medium.
[117] A system of remotely controlled movement of stand-alone creatures or portions of anatomy, mostly for film effects such as close-ups of the whale in *Free Willy* [1993].
[118] Rossum's Universal Robots.

> ➢ Salvador Dali's 1931 painting of droopy clocks *The Persistence of Memory*
> ➢ Pablo Picasso's 1943 metamorphosis of a bicycle seat and handlebars into a bull's head

Not by any means a new concept, our species has been combining Art and Technology since the cave-dwellers over 15,000 years ago. Imagine yourself sheltering from a violent storm. When it's over you creep out carefully to survey the devastated landscape. A tree has fallen, its branches ripped and raw; you pick up a twig, splayed at the end. As you tread, you stir up mud and clay, coloured from iron oxide. The twig falls and when you retrieve it, red clay clings to its proto-bristles. You wipe the twig against a boulder and the clay sticks. This brush tool proves far easier to control than the marks you've made before with your hand. You've invented the paintbrush!

What are musical instruments if not tools? Who first blew through the slit in a blade of grass producing musical tones? Over the centuries an ever more complex musical technology allowed composers greater flexibility. By the time Mozart was born in 1756, both the clavichord and harpsichord had been the keyboard instruments of choice for three hundred years. Then during Mozart's life a new instrument called the pianoforte [first seen in the 1680s] was refined by Johann Andreas Stein of Augsburg.

Called the Viennese piano, it enabled the internal hammers to return quickly to their original position as soon as a note was struck. Not only did Mozart recognise the benefit to pianists, this greater freedom affected the very concepts of his composition. Of course, Mozart would have continued to compose works of genius whether or not Stein had revised the keyboard. Nor were Stein's efforts specifically directed at Mozart. But because their separate efforts were connected, we all benefit from the musical legacy.

Though the Arts occasionally depict tools and inventions, they all rely on them to some extent in the process of creation and/or dissemination. Consider the striking photographs of molecular patterns comprising penicillin mould or skin cells taken under high resolution electron microscopes or the unexpectedly gorgeous colours and shapes of distant galaxies recorded by the Hubble Telescope. When what is normally invisible to the naked eye reveals itself to be so aesthetically astonishing, it truly challenges the very nature of Art and Technology.

Technicians extending the da Vinci example employ graphics to better communicate their ideas. We can label them industrial drawings, but if they approach da Vinci's artistic quality surely they straddle two disciplines. Whether Isaac Asimov[119] addresses the structure of DNA or the battle for galactic rule, it's literature.

[119] The prolific Asimov [1920-92] was Associate Professor of Biochemistry at Boston University and, apart from his classic science fiction works, wrote on a range of science matters from the complexities of the atom to the origins of life.

As already noted, one of our assets as a species is our creative ability – the capacity of our brains to conceptualise and synthesise. Too often and for whatever reason, adults neglect the creative process, strongly evident in the game-playing of childhood. So alien does the process become that it's wrongly identified as 'having an idea,' as though that were the end of it. In some circles the very word creative is used inappropriately, taking on a pejorative meaning as in 'creative accounting.'

Those whose vocations depend entirely on the process [most notably Artists and Scientists] know that the idea is merely the beginning. Sometimes it's the start of quite a painful and tortuous journey to embody that idea into a poem, a proven theory, a vaccine or an opera. Scientists primarily follow quantitative signposts, while Artists choose qualitative ones.

Over the centuries, technology has helped smooth the path for both. Along with this technological evolution, it's clear there's an underlying philosophical aesthetic which is guiding digital art, whatever form it may take. Several pioneers have steadily been evolving both their concepts and consequent manifestations since the 1960s.

The Virtual Architect

Victoria Vesna is a multi-media artist with a background in film, video and computer animation. She's working with electronic technology focusing on developing architectures for online communities "using time and space as the primary building blocks."[120] She has exhibited internationally at a number of shows including the Venice Biennale in 1986, the Ernst Museum of Budapest in 1994, the San Francisco Art Institute in 1997. More recently she worked with a team of digital artists and programmers led by Robert Wilson on *Bodies@Incorporated*, a networked project exhibited at the Arthouse in Dublin.

Visitors are invited to use a variety of building elements including "ASCII text, simple geometric forms, TEXTures, and low resolution sound" in order to construct virtual human bodies. "Bodies built become your personal property, operating in and circulating through public space, free to be downloaded into your private hard drive/communication system at any time."

Vesna is co-principal investigator on a research project *Online Public Spaces: Multidisciplinary Explorations of Multiuser Environments*, and serves as North American editor of the journal *Artificial Intelligence & Society*. She is also an Associate Professor at University of California at Santa Barbara where she directs the EAT lab.

[120] An abstract of Vesna's work can be accessed at
http://www.screenarts.net.au/beingconnected/f_abstracts/11.html/ and her UC Santa Barbara page is at http://www.arts.ucsb.edu/~vesna/ from which all quotes are taken.

She collaborated with Stephen Hawking to produce the CD-ROM *Life in the Universe*, and recently wrote both book and CD-ROM for *Terminals*, an online exhibition/conference distributed across UC campuses dealing with the cultural production of death. She is an artist fellow in an online PhD programme at the Centre for Advanced Inquiry in Interactive Arts at the University of Wales. Vesna has published her investigation of building communities without time, which questions "our relationship to time, the evolving attention economy and principles of intellectual capital, in relation to multiuser spaces."[121]

Its springboard is the irony that the Internet, like many other technologies, has partly been developed to save time yet "has amplified the pressure and demand of our attention. As telepresence expands our sphere of communication and influence, so too it has made us rethink our ideas of community."

Vesna's mission is to build a virtual infrastructure in which a different kind of community can flourish, bypassing reliance on sharing time or geography. She recognises that online commercial interests have embodied a variation of this theme in the online shopping mall, with the caveat that it's driven by purely economic rather than aesthetic motives. Her vision ranges more widely, introducing concepts which are not always understood, let alone eagerly adopted by the Arts establishment. Nor is she alone.

Not Crying Over Spilt Paint

An occasional colleague of Vesna is Roy Ascott who studied under Richard Hamilton and Victor Passmore, then guardians of an *avant garde* Basic Design Course which Ascott regards with hindsight as 'reductivist.' He was hungry for a greater dialogue between artist and viewer, and determined to incorporate such ideas when the Ealing School of Art invited him to devise a new course.

One of the artists he invited to lecture was Harold Cohen, devisor of Aaron the drawing robot.[122] When he came across the work of Ross Ashby and read Norbert Viner's *Cybernetics* Ascott "had one of those Eureka moments – it blew my mind. I could see two main things:

1. How it could provide a theory of art, which lay in the process or system not the object
2. The viewer had to be part of the system

[121] *op cit*
[122] The late 1960s and early 70s witnessed several variations of interactive and robotic art; in 1968 I attended Jean Tinguely's exhibit *Meta-Matic Number 8* at the Moderna Museet in Stockholm. The device, featuring mechanical arms clutching coloured magic markers, invited visitors to alter the speed and direction of the arms so that lines and forms were recorded onto a postcard which they could keep.

"I also saw that cybernetics could be used as the core discipline for an art school. Cybernetics is control and communication in animals and machines, therefore it involves dynamic relationships. What was essential for me was that interaction generates meaning."[123]

Ascott was convinced that any art course should depend on the application of cybernetics and computers to art. "All my work is based on that, including my current project *The Planetary Collegium*." The conviction has not always endeared him to the establishment. He was fired as President of the Ontario College of Art in the 1970s when he dared to challenge the very structure of the curriculum. "I devised a programme giving students the facility to design their own curriculum by combining classes which reflected various categories of approach, conceptualising, and application."

This unexpected liberty led to Ascott's appointment in 1975 as Dean of the San Francisco Art Institute, which is where he was introduced to concepts of electronic networking. "At SRI [Sanford Research Institute] I met Jacques Vallée of Infomedia and Brendan O'Reagan. Vallée was working with Johannsen at the Institute for the Future in Palo Alto developing ideas of computer conferencing.

"Just before I left England I'd been working on interactive tabletops which featured a grid and a variety of readymade kitchenware, which I called behavioural instruments – funnels, clothes pegs. Artists were invited to sit at the table and position these instruments. It was conceptual art. We recorded the sessions, but the art was in the doing. So when networking and computer conferencing came along, I was ready.

"In '78 I applied for a project grant called *Terminal Art*. The project was ready in 1980 and was the first online interactive asynchronic piece. The asynchronicity was the whole hook, real-time didn't interest me. Participating artists included Douglas Davies [former Art Editor of *Newsweek* and a practitioner of electronic art] and Jim Pomeroy."

As we've discovered above, computers at this time were rudimentary. Users couldn't access graphical monitors, but were connected by phone lines. Ascott consulted colleagues to realise his aim of opening the project to more artists.

"I cut a deal with Texas Instruments using portable dumb terminals. A keyboard connected to a main computer. The keyboard had two rubber caps onto which you placed the phone receiver which connected you to the computer. Vallée gave me three weeks of time, and Texas Instruments supplied eight terminals. I distributed these to eight conceptual artists, who knew nothing about computers. Together they produced a collective work via their individual keyboards."

[123] Direct quotes are from an interview generously given by Roy Ascott for this book.

Ascott wanted to extend the concept globally. After all, the technology would allow it; would the artists respond? Ascott had faith. "There are a bunch of artists out there looking for ways to defeat the keyboard, to be unencumbered." He decided to focus on a collective creation of storytelling. Influenced by electronic art historian Frank Popper, in 1983 Ascott took part in an exhibition at the Museum of Modern Art in Paris. Called *Electra*, it covered "the entire canvas of electric and electronic art.

"In the winter of '83/4 I did a piece of non-linear storytelling called *La Plissure du Texte* [The pleating or weaving of text], which was a pun on Roland Barthe's *Plaisir du Texte*. The subtitle was *A Planetary Fairy Tale*.

"I identified 14 nodes throughout Europe, North America and Australia and assigned fairytale characters to each node. Paris was The Wizard, Sydney the Wicked Witch, Hawaii was The Prince. IP Sharp and Infomedia donated computer time, which was used by groups of artists at each node. The main display screen was in Paris, a huge screen. Each artist would himself add or invite someone else to add to the story in the character assigned to his node. Even basic images were produced using ASCII code.

"In '86 I was invited to be a Professor at the University of Applied Arts in Vienna to set up the Department of Communications Theory. I was also a commissioner for the Venice Biennale. There I took over a massive empty building called the Rope Factory to mount a network exhibition which was organised remotely via portable dumb terminals. This was state-of-the-art equipment at the time. The piece was called the *Laboratorio Ubiquo* [The Ubiquitous Laboratory] and contained four massive screens to capture online material from a group of artists who were feeding in their versions of daily news stories."

In the intervening years Ascott has further evolved his fundamental concepts into a fusion of Arts and Science. His current project is called *Art-ID/Cyb-ID*, for which 15 artists have been invited to look at 84 keywords chosen by Ascott for "their mix of the metaphysical, the biological, etc, to maximise the variety of what I see as the most potent concepts in art and science.

"Each artist chooses nine keywords they feel best represent themselves, then they submit nine thumbnail images to complement the words. These can be still images, mpg movies, some include sound. I have a programmer in Barcelona who then generates a logo for each artist. The system driving the project searches for keyword commonality between artists, and displays what I call a cyb[124] which pairs up artists with two or more keywords in common. Each of these is displayed within a matrix of nine squares."

[124] Pronounced sibe.

The entire project is thus not merely a collective interactive creation, but because of the unpredictable value of combinations it can never be experienced the same way twice. This kind of random experience has underpinned the work of performance art since the days of the 1960s Happenings in Greenwich Village and even earlier by Parisian Dadaists. What's different about today's installation and conceptual artists is the digital demand that the viewer become an active participant in the work.

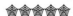

Fuzzy Boundaries

There's no doubt the Art/Technology partnership was substantially strengthened with the introduction of electronics. Indeed, the quintessence of interactivity unique to the post-modern artistic output is that very relationship. The importance of such evolving principles in the context of this book is the way these pioneering artists have cleared the way for the online realisations which are rapidly maturing into the Art of the Future.

The boundaries between Art and Technology are fuzzing. Mathematically plotted programming codes produce virtual reality imagery or fractals from Mandelbrot sets. Are they Art? At the 1970 Tokyo Exposition the Wabot-2 was programmed to play a keyboard duet. Was it music? Indeed the very concept of Art with regard to interactive media is the subject of much debate.

Is logo design on a corporate website considered Art? What about the layout of a webpage? If someone uses an animation software package to enliven a borrowed graphic, can you call him or her an artist? Insofar as one of the key components of any work of art is the quality of choices made, there's a valid argument.

And just what is the creative contribution of the programmers, those boffins who write computer code which enables interactivity? Internet programmer Tracy Gardner vigorously defends that aspect of her work, describing it as "artistic." She's convinced that programming requires a great deal of intuitive understanding of what a good program is and an appreciation of aesthetics.

"It is extremely creative. One creative thought can save you days of unenlightened programming. Software development is definitely a creative process for the experts. Unfortunately," she notes, "such skills are in short supply."[125]

[125] Personal communication.

Digital designers, too, find an increasing need to amalgamate skills. Web designer Ping Tang believes that "Internet Design will become a specialism of Graphic Design such as Animation has become. Thus it will be vital that the Internet Designer has a skill set that includes programming skills and a thorough knowledge of what more complex programmers can achieve, as well being able to use all the latest authoring tools the industry has."[126]

Since the component tools for experimental digital projects cost far more than most freelance artists can afford, much of the work emanates in the research and media labs of universities and large corporations. Some remarkable partnerships have been forged, such as that between Viennese botanist-turned-artist Christa Sommerer and French painter-turned-computer programmer Laurent Mignonneau.[127]

The pair were co-artists-in-residence at the Beckman Institute's National Center for Supercomputing Application in Illinois, and are currently based at the Advanced Telecommunications Research labs in Kyoto. Their book *Art @ Science* introduces contributing authors from all over the world expounding on work which conforms to their own philosophy, expressed in the introduction:

"The Arts and Sciences have long been regarded as separated disciplines. In this era of rapidly developing computer technologies a novel interdisciplinary spirit has emerged that promises a new collaboration between research and art. Computer Graphics, Interactive Arts, Scientific Visualization, Artificial Life, Chaos and Complexity, newly emerging Media Museums and Media Centers as well as Telecommunications are areas where artistic thinking influences science and where scientific methodology reaches into the arts."

Described on the website as "an interaction and communication space, where remotely located visitors can interact with each other through evolutionary forms and images … [*Life Spacies*] enables visitors to integrate themselves into a 3-dimensional complex virtual world of artificial life organisms that react to … body movement, motion and gestures.

The artificial life creatures also communicate with each other and so create an artificial universe, where real and artificial life are closely interrelated through interaction and exchange. A web page allows people all over the world to interact with the system as well. Simply by sending an eMail message to the website, one can create one's own artificial creature. The creature will then start to live in the … environment at the ICC's museum, where the onsite visitors directly will interact with it."[128]

[126] *ibid*

[127] Their exhibits include *Images and Signs of the 21st Century* in Berlin; *If – Imaginary Worlds of Communication* at the Museum of Communication in Bern, Switzerland; the Play Zone at London's Millennium Dome; and the ambitious *Life Spacies*, on permanent exhibition at the ICC-NTT Museum Tokyo. http://www.ntticc.or.jp/~lifespacies/

[128] This is the underlying principle of avatars discussed more fully below.

Future projects from Sommerer and Mignonneau will be on view throughout 2001 in Kiev, Seoul, Taiwan, Spain and France. It's apparent that one of the prime interests for such artists is the interactivity between them and their viewers to co-create an evolving environment. Not only are viewers active in helping to populate that environment, they can also affect the behaviour of the creatures by their own behaviour. Results can simply involve changing locations or more complex behaviour such as mating. In fact, the whole concept of passive viewer is forced to evolve into that of active user.

This brave coalition enjoyed by the visual arts world has not escaped the notice of other research institutions traditionally more focused on business and telecommunication. Under its Research Supervisor, Glorianna Davenport, the MIT MediaLab provides a safe developmental environment for teams of artists and technologists to create similar electronic systems to those of Sommerer and Mignonneau, aimed at a variety of both commercial and experimental goals.

The computational basis for the projects described in this section is one of a number of programming languages such as Java[129] or VRML[130] which respond to various commands issued by computer and/or Internet users. The impression of direct response is maximised because the programming code builds in a wide range of parameters: responses can either be randomly generated or called up according to a pre-determined sequence. They can also include text, graphics, and sounds.

For example, if the user clicks on an image of a keyboard, it might elicit a randomly programmed response such as the sound of a rocket, piano music, or a thunderstorm. These might accompany the image of the piano morphing into a dinosaur, or a text instruction to the user to click another image, triggering yet another programmed sequence.

The whole experience is thus driven by an if-then construction: if you perform this action, then it will result in this subsequent action, but if you perform that action, then it will result in that subsequent action. The results of such cause-effect instructions can either fulfil or subvert user intentions, which is stimulating indeed from an artist's point-of-view. The vital ingredients, though, are the randomness and the interactivity, which assure that no two users will have the same experience.

[129] A computer programming language devised by Sun MicroSystems, enabling both graphical animation and interactivity. The Gamelan website: http://www.gamelan.com/ is a virtual community of Java experts and features demonstrations of many applets [small applications] such as games, the Internet version of special effects, discussion forums, etc. Some result in spectacularly beautiful effects, such as David Griffiths' popular Lake Applet which calculates mathematical coordinates of a given image causing it to appear as a rippling reflection in water. More of Griffiths' applets are available on his website: http://www.spigots.com/
[130] Virtual Reality Markup Language invented by Mark Pesce.

The Book Unbound

For those who believe such digital proliferation presages the death of the written word, hold on. Reading isn't about to disappear, though books themselves may change. Books are so familiar in our society we don't often remember how short a time they've actually been available.

Johann Gutenberg may have invented movable type in 1454, but it really wasn't until the end of the 19th century that increasing literacy rates and affordable prices made every home a potential library. Today we take books for granted. We also assume [from that traditional we-tell-you approach to information and entertainment] that we must start reading at a certain point and follow a story in a linear progression.

The introduction of stream-of-consciousness by such literary giants as Virginia Woolf and James Joyce to reveal subjective as well as objective reality challenged the concept of linear storytelling. The path was duly paved for such contemporary exponents as JG Ballard to parallel in his "condensed novels" the fragmentary nature of society and the individual psyche with the structure of the story, told in thematically-linked short segments.

Pushing the concept further, his *Notes Towards a Mental Breakdown* consists of a single sentence. Each word refers to an extensive footnote each of which contains the story's narrative. This is probably as close as it's possible to come to a paper version of hyper-text.

Masquerade, a children's book by ex-Royal Navy electronics wizard Kit Williams,[131] is constructed very like a digital game offering various choices to the reader; the narrative's progress depends on which clue the reader follows. The plot involves a fictional treasure hunt to find a be-jewelled hare, but the clues planted within the story did [for a limited time] lead to an actual buried treasure.

With the advent of digital technology such paper-based works inspired authors to achieve similar narrative challenges through hypertext and program code, any rewards being virtual. In the context of Art and Technology, you'd expect a book's most creative element to reside in its contents, the skill of the author to use language with aesthetic merit, whatever the genre. Surely technology impinges little if at all on the process of writing.

Yet with the development of hypertext, literature is forced to redefine itself, and that has already begun to effect the creative process. There's no doubt that the world of hyper-fiction has yet to find its Shakespeares, but a few pioneering authors have taken the first steps on the journey to excellence. Stuart Moulthrop's *Victory Garden*[132] is one of the few online illustrations of the interactive, non-linear nature of the new fiction. Moulthrop invites a number of possible entry points to the story. Each choice reveals some of the story; various words are hyperlinked to related story elements.

[131] Published in the UK by Tom Maschler; in the US by Random House subsidiary Schocken, 1981.
[132] Samples can be accessed online at http://www.eastgate.com/VG/VGStart.html/

These can refer to plot, characters, or dialogue. Whichever routes through the overall text you follow, each path retains its own internal logic. No matter how each reader plans the journey, eventually everyone winds up with the same totality of story. Not only is this a different way to read, and one which involves the reader in the discovery of the story, but it affects fundamentally how the story is constructed so that it can accommodate all the parameters of choice. Conceptually it emulates sculpture.

In the case of *Victory Garden*, the reductive linear story is summarised online: "Jude Bush, an aggressive undergraduate student with something of a crazy past is ferociously seducing a reluctant graduate student named Victor Gardner.

"It is the winter of 1991, and Victor, we have learned, has just received a Dear John letter from the woman he loves, Emily Runbird, who is now serving with the American forces in the Gulf War. Emily has made it clear in a letter from the front that her true love is Victor's middle-aging and possibly deranged thesis advisor, Boris Urquhart."[133] By fragmenting this simple construction, each reader becomes part of the narrative in an individual re-assembly.

Various other websites boast examples of interactive fiction, but they turn out to mean something else. Some are primarily concerned with an electronic version of the round-robin story – one person begins a tale, posts it online, and anyone is free to append the next stage of the story patchworking together a collection of text.

Usually the person who started the story takes an editorial role, choosing which pieces to include and in which order. Technology in this case has allowed a group of disparate people to contribute, and a means of sharing the result with each other and the rest of the world. But it hasn't significantly altered the creative process of writing.

Other so-called interactive fiction sites apply the concept solely to the creation of text-based adventure games. In these, the story element is subservient to the game. Players [not, you'll note, readers] are required to enter commands to determine in which direction the game will continue. Usually the goal is to acquire objects, discover routes, and defeat enemies. Admittedly this simplistic plot structure could become more sophisticated, but so far there are few examples of real story-telling. And the various competitions for Interactive Fiction concentrate on the complexity of coding rather than any literary merit.

Such sites frequently refer to authors, but what they mean are programmers who can use authoring-tools[134] to create a matrix for the games. Such tools can also produce interactive learning programs which are based on similar principles. It's clear that creative content influenced by new technology lags far behind the possibilities for its display. What, though, of the very construction of books themselves?

[133] *op cit* Further websites offering examples are available from
http://www.iua.upf.es/literatura-interactiva/eng/p1.htm/
[134] Software packages providing narrative templates that can be hyperlinked.

Traditionally a book has come to mean a number of sheets of paper bound together in a proscribed order and upon which are printed sequences of words, sentences, and chapters. In Western society, crowded bookshelves have for centuries been a mark of civilisation, of culture, and/or of ostentatious wealth.

Now imagine an equally erudite household which contains only one book. From this single volume the people derive all their literary needs, whether reference, research, or leisure. It would, you'd think, have to be some enormous tome, far too heavy to lift, but this new book is portable as well as versatile. In fact books are in the process of being unbound before our very eyes, into a completely novel container of text, if you'll forgive the pun.

Not only has the MIT MediaLab encouraged artists to work with technologists to create innovative content, it also supported a team led by Assistant Professor Dr Joseph Jacobson[135] in their aim to completely revolutionise reading. In 1997 the team published *The Last Book* describing in detail their "electronic book comprised of hundreds of electronically addressable display pages printed on real paper substrates. Such pages may be typeset *in situ*, thus giving such a book the capability to be any book."

In effect, this integrates the concept of book with that of computer and display monitor. But it's hard to curl up with a good screen. So how to get paper pages to behave as a sequential series of electronic displays?

In order to achieve such a complex entity, the team analysed the fundamental difference between books and computer screens and how each stimulates different neural pathways to make sense of information contained within them. Books, they noted, are "a physical embodiment of a large number of simultaneous high-resolution displays. When we turn the page, we do not lose the previous page. Through evolution the brain has developed a highly sophisticated spatial map. Persons familiar with a manual or textbook can find information that they are seeking with high specificity, as evidenced by their ability to remember whether something that was seen only briefly was on the right side or left side of a page ...

"Another aspect of embodying information on multiple, simultaneous pages is that of serendipity and comparison. We may leaf through a large volume of text and graphics, inserting a finger bookmark into those areas of greatest interest. Similarly, we may assemble a large body of similar matter in order to view elements in contrast to one another, such as might be done to determine which of a particular set of graphical designs is most satisfying.

[135] The project team: Barrett Comiskey, Chris Turner, Jonathan Albert, and Perry Tsao. Jacobson is a Doctor of Physics and carried out a postdoctoral fellowship in nonlinear quantum systems at Stanford University. All quotes are used with permission.

"The problem, of course, with traditional books is that they are not changeable. The goal of the electronic book project is to construct a compelling version of the book updated for modern use."

The team eventually integrated the concept of a book and a computer. Their electronic book feels familiar: it has paper pages and the text seems to be printed in ink. However, the book itself has been programmed so the reader can select from a menu on its spine of several thousand titles.

When one is chosen, the book's pages display the entire text of that title. Select another title and the very same pages display the new work. The challenge to realise such a concept is enormous. The team modestly declares, "we need to completely reinvent the electronic display before considering such an endeavor."

Several obstacles stood in their way, namely the size of transistor storage chips, the price of LCDs, power consumption, and the weight of the electronic book. Oh, yes, and the development of electronic ink. eInk "is an ink-like material that may be printed by screen print or other standard printing processes, but which undergoes a reversible bistable color change under the influence of an electric field."

It's the interaction between the microparticles comprising the ink and the outer shell which contains it which provides the required bistability. This highly stable ink [which won't fall off on contact with a surface] can adhere to pages not only made of paper but a range of materials, such as very thin plastic.

As well as addressing issues of high-quality print display, including the possibility of incorporating video illustrations or compiling your own eBook contents from available excerpts, the team came up with an ideal display thickness about 2_ times that of paper, and costing somewhere between 1-10 dollars per sheet. Even if the eBook contained 1500 pages, that's still a lot cheaper than buying all the books it could display.

The team is also working on more effective ways to speed the data transfer to the pages, as well as a means of resizing text and even allowing the reader to record comments in the margin! With the evolution of computer memory cards, the team predict a data capacity which could make available the entire 20 million volumes of the Library of Congress. They also foresee a system of encoded royalty payments over a wireless Internet.

Collecting royalties online can also be problematic, whereas direct sales appear easier to control – something best-selling author Stephen King attempted with a revolutionary Internet publishing option. During the summer of 2000 King took the unusual step of releasing his latest horror chiller *The Plant* directly onto the Web[136] one chapter at a time. He cut out his agents and offline publishers, offering free downloads of individual sequential chapters. To continue reading you're on the honour system to pay on a chapter-by-chapter basis.

[136] http://www.stephenking.com/

Popular novelists of past eras, notably Charles Dickens, also released works piecemeal, usually in monthly magazines. But technology has made it possible for the writer to keep greater control over distribution and revenue. The snag for King was that after a promising start, not enough revenue was coming in to compete with his more traditionally distributed works. The temptation for readers to cheat was too great to resist, with payments dropping by 50% after episode 4.

By December 2000 it was still possible to download *The Plant* but King has put the project into what he calls "hibernation," until he meets other commitments. He halted at a satisfying story point and considers the experiment a success. Proving he understands the real difference between online and offline behaviour, King recently answered a largely uninformed critique in the *NY Times*, not of King's book but of his bucking the system. They refused to publish his rebuttal.[137]

What he considers "the most dismaying is the profound misunderstanding most business people seem to have concerning how entertainment – which is mostly produced by talented goofballs – interfaces with the business potential they see [or think they see] in the web. One thing seems clear to me: what works on TV, in the movies, and in popular fiction doesn't work in the same way on the Net." In other words, and please forgive the pun, content is King!

Technology has even affected the traditional means of purchasing paper-bound books. The largest bookstore in the known universe doesn't actually exist. Amazon.com not only allows ordering online at discount prices, it provides interactive elements to search using a number of criteria, and to read and write reviews of books purchased.

Creating even more of an online reading community is ArtsOnline, the UK's Arts Council site launched in winter 2000.[138] The ArtsReaders section is in fact a virtual book club whose members not only discuss contemporary books online, but invite the authors to join in.

For reasons of access speed and fears of transaction security, along with issues of intellectual copyright protection, the Internet still dissuades more artists than it attracts not only from offering their work online, but also from creating specifically for the medium. After all, if artworks cannot exploit the interactivity offered by the Internet, their presence online can only disappoint.

[137] *ibid*
[138] http://www.artsonline.com/

Digi Display

Painters, writers, photographers, musicians, designers, architects, film editors and others in the arts have discovered computer programs which save time and drudgery. Throughout recorded history a few rare artists including Mozart and filmmaker Alfred Hitchcock could conceive entire works of art in their head. Implementation was fairly straightforward.

Mozart claimed that recording musical notations for his prodigious output of 600 works was a matter of listening to mental dictation; Hitchcock's scene set-ups were so meticulously planned he is said to have "edited in the camera." Most creative artists, though, use the editorial process to stimulate and refine their original vision. They welcome so-called mistakes or errors as a stage of the journey. Countless startings-over, however, can also be tedious.

The ability to prototype designs or preview colour changes wasn't previously available to painters and designers without endless drawings or time-consuming model-making. Before the advent of word processing, a novelist working on the third draft quaked at the prospect of changing the name of a key character.

Even minor alterations meant painstaking page-by-page corrections, onerous indeed in longhand, only marginally less so when amending typed pages by multiple, messy erasures or with correction fluid. Now, almost at the wave of a magic wand, editing is nearly instantaneous. What a liberation! Of course, technology no matter how sophisticated, cannot inject talent into those who don't possess it. But it frees creative minds to concentrate on the creative process. And once a work is finished, Net technology helps to share it with others.

Many artists, particularly painters and sculptors, regard the Web as a display medium for their offline work. There's no doubt that disseminating visual art online brings it to a far wider audience than any building-based exhibit. It also allows direct sales without having to pay commission to a third party. Museums and galleries, too, are publicising themselves online, sometimes offering taster displays of particular artists or exhibitions to encourage real-time visits.

Among the substantial business benefits of such marketing strategies is the vast saving on printing and distributing glossy brochures which require reprinting as exhibits change. Once websites are active, it takes only a small effort to amend their content. The web has also introduced an entirely new way of trading in art and artefacts. Web auctions allow global visitors to bid for pieces, which not only makes artworks more accessible for those who don't inhabit the top end of the market, but helps disseminate the artist's creations and reputation worldwide.

Mirroring displays in museums and galleries, Amy Stone founded MOWA [The Museum of Web Art] in 1997 to provide a portal for online exhibitions. She justified the web presence, declaring "The World Wide Web is a new world, and its artisans are using new tools to create within it. Technology has become a technique, and technique is the result of technology. The Museum of Web Art was founded for the simple reason that excellence and innovation in this new, electronic medium must be made accessible to those who seek it, and displayed in an environment suited to its content."

Stone has also recognised that an online museum serves to create a sense of community, uniting visitors in a way that bricks-and-mortar spaces cannot. This is an added bonus of online display. Many people may share the physical space of the Louvre to gaze at the *Mona Lisa*, but nothing about the display encourages them to share thoughts and ideas which might enrich the experience for everyone. The best a few physical museums have managed are lecture programmes, another example of the we-tell-you approach. By contrast, though most people access websites in private, they can provide a forum for vibrant exchange, thereby enhancing the value of the viewing.

There is also the opportunity for contemporary artists to have a dialogue with audience and viewers, and on a world-wide scale. Many find this stimulating even salutary, since most artists rarely get such direct feedback about their work from others than professional critics, commercially-driven agents, and biased family. This is not to argue against visiting original works of art or attending live concerts, but it would be retrograde indeed to ignore the supplemental benefits of electronic presentation.

POV

In this context, it's worth noting the importance of viewpoint in any art-related discipline. Some works can only be seen head-on, including most framed pictures – although several painters have experimented with perspective so that some elements can only be interpreted if viewed from certain angles.

Even in a direct-line experience, and particularly for larger works, there is no constraint on where or in what order the eye must register whatever the painting depicts. Sometimes the field of vision is containable enough to take in the whole, much as the ear registers the totality of notes in a chord. Three-dimensional works, whether they're static or incorporate movement, allow even more freedom to absorb parts and whole. So the magnificence of Michelangelo's *David* isn't lessened if one first views it from the side, or starts at the knees or the nose.

Theatre, in the round or on a proscenium stage, provides a dual viewpoint: that of the director whose job is to construct stage-pictures which enlighten the action, and that of the audience, any member of which may focus on anything, even other audience members. I've been involved in a few theatrical experiments which subverted the traditional pov in order to offer the audience a more visceral understanding of the themes.

At an appropriate moment in Paul Foster's expressionistic play about the 18th century writer and activist *Tom Paine*,[139] the audience is invited onstage to discuss contemporary political events.

The Wherehouse LaMaMa's production of David Benedictus's novel *Hump*[140] presented each scene in a different location of the playing space, requiring the audience to move across to the next lit area. Since the play dramatised the inner life and fantasies of a main character searching for his true identity, this peripatetic experience physically involved the audience in the quest.

Our television version of *Uw Beurt*[141] which I directed for NOS in Holland extended the theory as the camera became an audience of one on an abstract journey through a textured birth canal out into a sequence of life experiences.

The projection of moving images forces more restriction, especially when a director chooses a close-up. Master shots as wide as theatre stages are rare in comparison to one-shots or two-shots. Such complicity between director and viewers serves the illusion of including the latter in the action, almost making them characters themselves.

Cinema directors, such as Jean-Luc Godard have subverted viewer expectations by pointing the camera away from the main action. Particularly in his films of the 60s Godard manipulated and commented on cinema-time in this Brechtian manner, sometimes to hilarious ends. In *Les Carabiniers*[142] a naïve soldier watches a make-shift screen as footage is projected of a woman preparing to take a bath. She keeps vanishing out of frame, and the soldier, who's never before seen a film, climbs up to the screen looking right and left for the woman, eventually bursting through the sheet, convinced she's hiding behind it.

As already noted, point-of-view and power-of-decision is what distinguishes the interactive arts – that transference of the seat of tyranny. Fears that one form will replace another are misplaced. Interactivity simply widens the choice for all artists. We-tell-you morphs into we-tell-each-other.

As constant a dialogue has emerged between the disciplines of Art and Technology as that between Science and Technology precisely because both Science and the Arts rely on the creative process. Technology becomes a means of implementation to objectify that process, to produce, edit and refine its tangible results. Perhaps the most ubiquitous example is that discipline of cinema and broadcasting known as Special Effects or SFX.

[139] Directed by Tom O'Horgan. and premiered by the NY LaMaMa Troupe on London's West End at the Vaudeville Theatre in 1967.
[140] Performed at St George's in the East, London, and le Théâtre de l'Ile de la Cité, Paris in 1970.
[141] Translated as *You're Next* and based on a live concept pioneered by Tom O'Horgan in NYC. A unique feature had each audience member being led through the performance one after the other.
[142] 1962 Rome-Paris Films; Laetitia Films; adapted from the 1958 play by Benjamin Joppollo.

Bending Reality

Digital effects provide an enriched experience because they can affect the process of storytelling. Before we examine some examples, it's important to distinguish between the way both human brains and program codes arrive at decisions.

For that vital creative link between conceiving a problem and implementing a solution, our thinking depends on pattern recognition. It's a process we evolved for survival, enabling us to map the world. It assigns rules, arrived at either by trial and error or observation. We don't have to wonder every time we walk that the surface underfoot might collapse. Pattern recognition tells us that the previous step was okay, the pavement appears to be consistent, therefore the next step is safe.

Digital programs which emulate human thought in order to offer interactive possibilities, are dependent on a pre-defined set of rules which must be encoded. They're known as logical operators. Three are mandatory, describing the parameters And, Or, and Not. I believe computer programmers who work with SFX artists are equally creative because they understand that essential lateral process of human thought. It's a quality they share with inventors.

As researcher on *The Dream Factory*[143] I uncovered a story which epitomises the creative approach of those who spend their lives inventing ways to manipulate and enhance film and television footage for greater visual impact. Back in the 1950s a Hollywood studio Western required a plague of locusts rising on the prairie. They had a lovely wide shot of the landscape, but how to achieve the insect plague on a limited budget greatly exercised the producer. After all, you can't just look up Dial-a-Locust in the Yellow Pages!

So the Effects Department was contacted with instructions to solve the problem quickly and to keep the costs down. The fx guru emerged about a week later with the following solution. A large scaffold was erected with a walkway about 20-feet high capable of holding a dozen people. Below, at table height, sat a clear fish-tank as long as the scaffold and filled with water. A camera was set up to shoot straight through the tank.

At a given signal, the people on the scaffold simultaneously released huge amounts of coffee grounds, which floated down and settled through the water to the tank bottom. The film was shot in slow motion. Then the footage was super-imposed onto the wide shot of the prairie and reversed. It looked exactly like millions of insects swarming up from the plains. The producer and studio were overjoyed with the result, particularly when they realised how cheap it was!

That extremely low-tech solution only highlights that what's important is the ability to conceptualise, synthesise and implement. The result, whether simple or sophisticated, alters real life to achieve a greater truth. Truly a modern alchemy. It's the same approach used by the best computer programmers to enable interactivity online, and one which needs even more precision when graphics and sound are involved.

[143] A 6-part documentary series about cinema special effects produced by Red Rooster Ltd in the UK.

Aside from the fast-palling "new toy" syndrome evoking awe at some technological device or gadget, people seem to need context, certainly to sustain interest in an artistic work. For greatest effect the use of technology to realise narrative must serve a story or theme. When it leads, the results, however spectacular, are ultimately unsatisfying. The context can be abstract or non-linear, but when it's weak or absent, the imposed technology will have the meaningless effect of a lava lamp.

Which is not to say that artists shouldn't be aware of or inspired by technological possibilities. Throughout the 20th century both the film and television industries have been entirely dependent on the mutual influence of artistic vision and technological implementation. The subject has spawned much analysis and comment for these populist media, both by critics and practitioners.

Although the photographic process was originally intended to reproduce and capture moments of reality, it didn't take long before creative minds saw ways to manipulate the real with the new technology. Even before the turn of the 20th century, filmmakers such as Georges Meliès experimented with photographic processing to achieve such simple effects as people suddenly vanishing from sight, or rocketships crashing into the moon. Such artistic subversion soon evolved from parlour trickery to extrapolation of meaning, in fact a prototype for the philosophy of semiotics.

By emphasising the repetitive monotony of the factory production line in his silent comedy *Modern Times* [United Artists, 1936], Charlie Chaplin juxtaposes ingredients including rhythm, design, and meticulous comedic acting skill with powerful machinery engendering both laughter and recognition of the exploitation of labour. Even more ironic, the message is delivered by a medium entirely driven by a similar technology and subject to the same abuses of the workforce.

Decades later, special effects guru Douglas Trumbull[144] made his directorial debut in 1971 with *Silent Running*, which provides a tragi-comic comment on the need for the dynamic of human relationships in an era increasingly dependent on technology for its survival. Further technological advances in cinema processing allowed Woody Allen to make credible his strange chameleon-like character *Zelig* [Warner Brothers, 1983]. Or allow the eponymous *Forrest Gump* [1993] to shake hands with the real but dead President Lyndon Johnson. Both films permitted the flawless integration of new fictional footage with archived documentary material.

[144] Trumbull had already provided the effects which helped catapult *2001: A Space Odyssey* into cinema history. He later worked on *Close Encounters of the Third Kind*, *Star Trek*, and *Blade Runner*.

Television, too, has risen to artistic heights generated by the technology which underpins it. Sadly those responsible for original programming use its potential less often and less imaginatively than the advertisers. There is another arena which provides a showcase for digital effects creators. In the UK programme titles such as for *The Fast Show*, and channel identification sequences, particularly those produced by BBC2 and Channel 4, compete for justly deserved craft awards and have spawned a thriving generation of consummate digital artists exemplified by Mitch Mitchell, award-winning former Director of Special Effects at London's Moving Picture Company.

"Video will never replace film – it will be digital that will replace both," he proclaimed at the BKSTS[145] Digital Weekend at Pinewood Studios in November 1999. The industry seminar's theme was a review of how far digital TV technology has advanced and whether the promised era of digital cinema is about to dawn.

Mitchell is clear that the industry will be dominated by digital, but warns "we as creative users who input to the process [must] make sure manufacturers get it right – and don't leave it to the engineers, or we might end up with something that doesn't work in the production environment."

He's long been exercised by the integration of technology into both film and television programmes. Having worked on many BBC science fiction programmems, including the classic *Dr Who*, Mitchell co-designed the first commercially available digital edit suite, collaborated on the design of a digital video-to-film transfer system and was one of the first exponents of creating video/digital effects work in post production rather than live at the time of photography. Currently Professor of Advanced Imagery at the University of Bournemouth, Mitchell spent most of 1999 as Effects Supervisor on the $47 million 10-hour NBC/Hallmark/Sky TV fantasy series *The Tenth Kingdom* which aired in April 2000.

At an industry conference in 1997, Mitchell presented a paper on The Digitization of Conventional Production in which he contended that every phase of both the motion picture and broadcast industries has "become almost totally dominated by digital technology – not just production, not just the economics, and it's not just an enabling technology – something to make things cheaper or more efficiently – it also makes possible certain kinds of creative functions." He cites the influence on the primary process of creating scripts right through preparing budgets, scouting locations, casting, designing sets, recording sound and vision, editing and processing. Even the distribution and exhibition phases have been digitised to some degree.

Considering how sophisticated film audiences have become in accepting the non-reality based depictions of mental states, dreamtime, and the world of the imagination, television executives appear hopelessly old-fashioned and patronising in discouraging creative/technological partnerings from their commissioning choices. How ironic that such talent finds a healthy outlet in the production of commercials.

[145] aka The Moving Image Society, a trade association for film, television and new media technicians and directors. Many thanks for permission to quote from the author.

The Net Effect

The many international award ceremonies honouring the arts and crafts of advertising reflect what money can buy. A one-minute spot can cost more than $5 million. Considering the average feature film budget totals some $12-15 million, you do the maths.

Stunning sequences that independent filmmakers can only fantasise about are routine in the promotion of conspicuous consumption. The very finest Directors and Cinematographers flex creative muscles in an arena devoid of all but the most meagre content, sometimes earning more in a day than on a entire 3-month feature film shoot. Household name directors and producers such as Ridley Scott and David Puttnam began in advertising. Scott, master of such visually arresting films as *Alien*, *Blade Runner* and *Gladiator*, went so far as to declare, "Advertising was my film school. I was able to be the insane perfectionist, controlling all the elements in one neat capsule."

In the cinema, visual effects can push already inflated budgets beyond the reach of many productions. They're usually saved for projects guaranteed to make profits by virtue of their stars. Filmmaker George Lucas became so intrigued by film effects he founded Industrial Light and Magic [ILM], an empire nearly as complex as the one featured in *Star Wars*. They also make computer games and commercials.

But the big boys don't always win the prizes. In February 2000 a Canadian upstart effects house called Lost Boys Studio beat out ILM for the prestigious Mobius Award for Best Computer Animation of the Year. Their entry, produced for an insurance client, featured quite a sinister computer-generated clown, and Lost Boys also won 2nd place for Outstanding Creativity for their effects on Bacardi's futuristic campaign. The studio was subsequently chosen to come up with the effects for Star Trek creator Gene Roddenberry's new series *Andromeda*.

Some of the directors who pull together such effect laden commercials hope they'll showcase talents they'd rather use in Hollywood. So it's no surprise that UK director Jonathan Glazer got his break to direct *Sexy Beast* on the strength of a memorable commercial.

Called *Surfer*, the award-winning black and white ad sold Guinness using an elegant metaphor. The campaign promoted the benefit of waiting for what you want. For surfers it's the right wave, for stout drinkers it's the slow pouring of the brew. The ad's stunning visual effects superimposed charging white horses onto big breakers as a voice over extolled the virtue of patience with all the arrogant verve of a beat poet. UK television viewers voted the ad the best of all time.

There are a few television programmes over the past couple of decades brave enough to enhance the viewing experience with effective technology. As with films, of course, digital effects cannot compensate for flawed storytelling, as the 1999 BBC mini-series of Mervyn Peake's 1950 gothic saga *Gormenghast* proved.

The so-called innovative use of visual enhancement to punctuate the 1999/2000 storylines of *Ally McBeal* are noteworthy primarily because they point up the dearth of such techniques elsewhere. Indeed as the series continues such effects have all but disappeared. And though the 2000 TV-drama serial *Attachments* [produced by Island World for BBC2] is actually set in a web company, it might as well be an insurance firm for all the creative use it makes of the industry's digital possibilities.[146]

Happily one groundbreaking television programme in the UK proved definitively how integral SFX can be to the viewer's experience, without breaking the budget. Back in the mid-1970s Thames Television ran 12 episodes of a mini-series following the rise and fall of a group of girl singers. It set standards and won many awards. Shot entirely in studio for economic reasons, Howard Schuman's *Rock Follies* used its original songs[147] to progress the action, often revealing the inner life of the characters. The Loony Toons episode of Series Two brilliantly integrated a camera distortion, as evidenced in the picture below.

Used with the kind persmission of Pearson Television Ltd.
NB: this is NOT a drawing!

During a number commenting on their collective paranoia that the music industry was treating them like two-dimensional beings, the four singers gradually etiolated into the very cartoon figures they were singing about. The intervening decades since *Rock Follies* have provided few braver TV examples than that paradigm. What could those executives be afraid of?

[146] Sadly, the one exception was a scene in which two characters indulged in a sexually explicit conversation carried out via the company's internal computer network. I say sadly because the idea was a total rip-off of a scene in the 1997 play *Closer*, discussed at length below.
[147] Schuman's lyrics set to music by Andy McKay, formerly of Roxy Music.

Playtime

It's impossible to discuss the evolution of the digital arts without acknowledging an enormous debt to electronic games. They exemplify all the principles which underlie the fusion between the Arts and Technology. From the early days of ping-pong and PacMan incorporating crude and simplistic graphics, interactive gaming has spawned one of the most lucrative global industries in economic history.

In 1998 the leisure software market was 1.4 times the size of the UK cinema box office and 1.8 times larger than spending on video rental. Some estimates place this multi-billion dollar market above that of arms trading in its financial influence. Perhaps even more important for our cultural development, however, is the innovative way technologists work together with designers, writers and musicians to produce a standard of work that can turn artefact into art.

Those early games established principles which still drive today's gorgeous and sophisticated creations. As well as combining graphics, sound, and often music, even the most simplistic games require a relationship between the player and the game which is achieved by increasingly complex programming code.

Evolution of Games Technology[148]

Game rules apply a variety of concepts including: the accumulation of objects and/or knowledge for its own sake or to achieve victory over an opponent, defence and evasion skills, answering questions and/or solving puzzles, appropriate reactions to unexpected or random threats or barriers. The parallels with drama and fiction are obvious. Some games incorporate narrative stories, either illustrated or with accompanying text, others take players on a journey presented from their viewpoint. Sometimes players can identify with characters rendered as 2 or 3 dimensional graphics. Games can be played by one person against the computer while others allow multiple players who can either team up or all compete.

[148] Used with kind permission by Sony Entertainment.

If the majority of such games fall far short of the intellectual food found in traditional literature, ballet, or sculpture, remember it's early days. Perhaps greater investment to stimulate an approach to content as sophisticated as that to presentation, might speed the evolution, but gaming entrepreneurs are more concerned with quick cash than culture. As we'll see below however, an increasing number of artist/tekkie partnerships are addressing less commercial agendas.

Nor are all electronic games solely for amusement. Like any child's toy, they can be valuable learning tools. Mammal children indulge in play to prepare them for the techniques of survival, including motor skills, and social relationships. The young of higher mammals enjoy most the challenge of problem solving, and we humans are no different. In fact toys have been found among the artefacts of the earliest human civilisations.

The more complex our games, the better prepared we become to integrate both conceptual and motor skills. Speed. Calculation. Anticipation. Analysis. Integration and combination. Spatial awareness. Precision. Aesthetic Appreciation. Inter-relationality of objects, people and processes. Electronic games incorporate all these aspects in a context which combines various Arts and Technologies.

The shelves abound with educational games which enable both kids and adults to learn in an interactive and enjoyable way. These may be supplemented by or in some cases supersede text material. For example, a game which animates the principles of flying, either by birds or airplanes, provides a more vivid demonstration than a written explanation ever could on its own. Interactive learning and counting games such as the popular *Putt-Putt* series, [featuring an anthropomorphic car who has various adventures in the community] has helped turn pre-schoolers into literate and numerate children without depriving them of play. Nor is there any rule that these kids must sacrifice social interaction.

Today's CD-ROM and platform games employ some of the most inventive digital artists and electronic musicians, as well as creative program coders to achieve the spectacular multi-media experiences on such classics as the highly amusing early *SpaceQuest* series by Sierra, RedOrb's *Myst* and sequel *Riven, Return to Zork* designed by Doug Barnett for Infocom, Virgin Interactive's 7th *Guest,* and Sony's recent story-driven *The Getaway* combining a digitally photo-real London with a narrative in which you must rescue your son from a local godfather named Charlie Jolson. Where they're all weak is in producing interesting narrative.

Britain is generally acknowledged as the world leader in offline games development, boasting some 250 companies dedicated to the task. As reported in 2001 by ELSPA,[149] "An estimated 5,600 people are employed in the creative development studio sector alone. The UK is now home to the European headquarters of all the world's leading leisure software publishers – including Sony, Acclaim, Electronic Arts, Sega and Konami among others – who are attracted by the UK's rich skills base and wealth of creative talent and its relatively flexible employment legislation."

In addition to its role as entertainment, the phenomenon of digital games addresses more subtle cultural anomalies, particularly for teenagers and adults. Increasingly fragmented Western society has exacerbated anomie and disenfranchisement which results in feelings of impotence over important aspects of any individual life. So many life-altering choices are made for us: work decisions, transport decisions, macro-economic decisions, etc Interactive gaming empowers people – at least it provides the illusion of power, albeit short-term, albeit in a fantasy world. Particularly if one's opponent is a computer whose feelings cannot be injured, who cannot object or punish or take revenge whatever gaming tactics are used. Moreover, if the computer wins any one game, starting over allows a second chance, a third, another, and another.

It doesn't actually matter that the concept of winning has no implicit financial reward.[150] In fact it probably helps, since losing is also financially risk-free. For those who play such games and most particularly for the current generation of children growing up with them, an expectation has been created of interactivity in all aspects of their lives, as well as a demand for the high standard of visual presentation known as eye-candy. Leisure, educational, and commercial pursuits accessed electronically will all need to engage with hefty dollops of interactivity and aesthetic achievement. As we'll discuss more fully below, many of the graphical realisations developed for gaming are providing models for a range of commercial and social interactive applications.

The Arts have never existed in a vacuum and affect our daily lives in many more ways than we admit. The upcoming generation expects the kind of experience produced only by the fusion between the Arts and Technology. Practitioners of both face an exciting challenge to join forces in meeting those expectations creatively. However it evolves in form, the Internet is sure to serve as the most effective global messenger. As recipients, we all need to be vigilant in assessing the quality of the message. Today we're in a transitional period. Those in the Arts and Digital Technology are at different stages of defining new working practices, finding new tools, and using each other to enhance their contributions.

[149] The European Leisure Software Producers Association http://www.elspa.org.uk/
[150] A number of online games do build in cash prizes which normally have more to do with an odds-poor random selection of game winners than any skill showed in the playing – in effect a kind of lottery of winners.

Let's look at some contemporary examples, starting with the visual arts. What unites all the following artists is their exploitation of available technology in realising a vision which in turn has been influenced by the technology. So although the creative process remains both as mysterious and universal as it's always been, none of these visions could have been fulfilled until the digital age.

Inviting the Viewer

The digital mechanism of interactivity can plant seeds for all kinds of applications which may have nothing to do with pure art. Ideas, like seeds dispersed by the wind, can sprout and evolve far from their birthplace. The work of Australian born artist Jeffrey Shaw provides just such an example.

Shaw has pioneered the use of interactivity and what he calls "virtuality"[151] in numerous international museum installations. Currently Director of the Institute for Visual Media at the ZKM Centre for Art and Media in Karlsruhe, he leads a unique research and production facility where artists and scientists work together to explore new media technologies.

His works invite the viewer to take a more active role, involving each in a world of virtual imagination. One requires individual viewers to peddle a stationary bicycle mounted on a platform surrounded by a panorama of curved screens. Depending on the direction of the handlebars, the cyclist seems to ride through a city constructed of giant letters, spelling out a series of texts. These digital streets are modelled on actual plans of Manhattan, Amsterdam, and Karlsruhe.

Such a concept has already impinged on the several interactive games, each a fine combination of beautifully presented digital graphics with highly sophisticated programming. Similar arts technology has also found application for online trading, tourism, and property development.

Whether or not Shaw's work is known by games-platform manufacturers, he's owed a debt in the underlying concept of racing games such as Sega's *Metropolitan Street Racer* and Sony rival *The Getaway*. An even more complex world is offered by Elixir's *Republic*, teaming gameplaying with Artificial Intelligence and due for release in late-2001.

[151] A combination of virtual reality and real-time experience.

Screenshots from Republic [152]

The game, brainchild of the extraordinary Demis Hassabis,[153] is set in Novistrana, an entire fictional Eastern European nation within which online players engage in socio-political power struggles. The game's remarkable graphics are complemented by what Hassabis calls the Totality Engine, which "is capable of rendering scenes of unlimited complexity in real time every frame. There is no upper bound on the number of polygons and objects that can be used in a scene, thus allowing for buildings or characters to be made out of millions of polys if so required. We don't draw all the polys in real time, but they are all there in the models; they are not generated algorithmically either."[154]

Not only is the game graphically flexible, it 'learns' by accumulating data about players' choices. Hassabis has long been interested in AI and feels although it is the key technology for the future of interactive gaming, it's "still in its infancy really. It is the AI that makes creating the games so challenging and difficult. But on the other hand I hope that's what will set them apart. We still have a long way to go on AI before as a designer I'm able to attempt some of the things I'm dreaming about doing. I think you're going to see the industry polarise to the two extremes: extremely cool and cinematic scripted games that are basically linear, and freeform epic games.

"Of course I'm most interested in the latter kind of game as I feel this is the type of entertainment that only games can provide, i.e. this is what they can do that no other creative medium can [like film or books]."[155] Such developments will require not only more complex programming but also a far-faster delivery. Hassabis is convinced that high-bandwidth technology must be made more widely available, particularly to enable the growing online community of multi-player games.

[152] Reproduced with the kind permission of Elixir Studios.
[153] Still in his mid-20s Elixir's Chairman and Chief Executive Officer became a chess Master at twelve, and was named International Grand Master at the Mind Sports Olympics before graduating from Cambridge with a Double First Class Honours Degree in Computer Science. After working as Senior Programmer for games developer Lionheart, he joined Peter Molyneux at Bullfrog to create *Theme Park* one of the most successful games of all time, selling 3.5 million copies worldwide. His company Elixir was awarded a multi-million pound development contract with international games publishers Eidos.
[154] All quotes used with permission of the author.
[155] *ibid*

Fashioning Worlds

In its early days as an Internet Service Provider, CompuServe offered subscribers a downloadable program called Worlds Away. It was a pictorial extension of their discussion forums, allowing users to exchange text messages via the online personae of cartoon-like figures who could be guided around a small town.

Choosing such a point-of-identification allows the web user to control the point-of-view; therefore the programming driving avatar[156] behaviour needs to be complex enough to anticipate a wide range of chosen actions and their consequences.

Controlling such phenomena in a graphically representational context ensures that the user's interactive experience is rooted in an identifiable reality, whether the realm created is one of fantasy or as the depiction of an industrial process. It's that vital point of view which makes the difference.

In the early 90s writer/designer Richard Lachman came up with *Animist Interfaces*, a foray into the creation of avatar behaviours. Lachman believes his Animist Agents "extend the language of the computer and the awareness of the user" by presenting what they know about any computational system in a graphical format. His intentions are clearly aimed at how people search the Internet.

"For instance," he claims, "an animist agent might exhibit levels of exhaustion as it drags in files from a far away server; another might belligerently challenge the user who tries to open an applet which the agent feels is untrustworthy; still another ambient agent makes the screen glow green if it felt in proximity to a virus."

In the early 90s as many as 20 MIT students helped design and construct Larry Friedlander's multi-phase *Consciousness Reframed*. His intention for the first, *Wheel of Life*, was "to create an immersive, text-free experience in which participants move around in a large, interesting, ever-changing space and interact intelligently with human-scale, three-dimensional objects.

"Three mystical, mythical sets and scenarios were implemented – Water, Earth, and Air. A theatrical installation, filled with sensors and visual displays both huge and small. Members of the audience participated alternatively as User and Guide. The Users moved through and explored the large-scale environmental spaces, while the Guides played sophisticated games at computer workstations."

[156] From the Hindu concept of a deity's earthly disguise in human form, the computing world uses the word to describe a digitally created being which can be guided by a person to carry out commands; at present they're most likely to be seen in online chat rooms or multi-player games.

The MIT lab has also attracted writers, such as Brian Bradley, creator of the 1997 project *Happenstance*, which he programmed in Java. Bradley describes the project as a "flexible storytelling testbed which expands the traditional literary and theatrical notions of Place and Situation to accommodate interactive, on-the-fly story construction.

"Important aspects of story content and context are made visible, tangible, and manipulable by systematically couching them within the metaphors of ecology, geology, and weather. Information-rich environments become conceptual landscapes which grow, change, and evolve over time and through use – information itself is imbued with sets of systemic, semi-autonomous behaviors which allow it to move and act intelligently within the story world or other navigable information spaces."

Mark Halliday's 1993 love story *Train of Thought* integrates video, an inference Engine built in ARLOtje and Framer, a representation language developed by Ken Haase to create a narrative partnership between the viewer and the programmed virtual agent.

"Jack is a slacker who is in between jobs. Nicole is a young woman who knows what she wants. The story is scripted to straddle the line between dream and reality. The research grappled with a long-standing topic – story design and story engine. While the viewer controls the line of their experience, a software story agent orchestrates the passage from introduction, through conflict, flight, discovery and final moment. The agent tracks story-element, thread, and character and makes choices according to a matched pattern."

Working with others at MIT, Halliday has expanded on the concept to incorporate what he calls Digital Cinema to present multi-threaded stories. It evokes the work of Roy Ascott, but is driven from a writer's rather than an artist's viewpoint. Halliday calls his piece *The Dream Machine*. Primarily dependent on Java, it uses the Internet, two-way pagers, and real-time environments to unify contributions from a variety of storytellers presenting to audiences separated by time and space.

Avatars are increasingly being used in industry as training tools. An interactive manual which responds to user questions and commands, particularly for complicated engineering and maintenance work, is proving much more successful a supplement to coursework than the printed word and/or two-dimensional graphics.

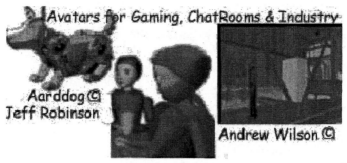

157

As more and more artists begin to see the Internet's potential in shaping and delivering their work, they're using it for more exciting creative purposes than just as an electronic art gallery. Typically, those with purely marketing remits have been slow to get the point. Films are a perfect example. A plethora of film-resource websites provide information galore, including the Internet Movie Database and Ain't It Cool.[158] The very concept of movies online hints at a relationship that transcends what you get in a cinema. Sadly, it's the interactive element which has yet to be explored commercially.

Lights, Camera, Let-Down

Several films claim the distinction of being the first online. On closer examination, however, that's publicity-speak not for interactive cinema but yet another way to watch movies – the Internet as a combined distribution/exhibition mechanism. That's the clear driver for initiatives such as the American Film Institute's OnLine Cinema, launched in 1997 to deliver serials and shorts.[159]

Daisy von Scherler Mayer's frothy feature *Party Girl* was the first to premiere on the Net in June 1995, the day it also opened at the Seattle International Film Festival. Had it not that distinction, it's unlikely anyone would remember the New-York-partygirl-meets-Lebanese boy story, which was just perky enough to spawn a short-lived television series.

[157] Aarddog used with kind permission of the artist. http://www.scamper.com/ Thanks to Andrew Wilson and the Department of Computer Science, University of North Carolina at Chapel Hill for persmission to use the Instructor Avatar.
http://www.cs.unc.edu/~geom/MMC/#images/
[158] Both originally amateur sites founded by net-savvy film-buffs which have evolved into two of the most lucrative online, http://www.imdb.com/ was founded by Col Needham in the UK, while http://www.aint-it-cool-news.com/ began in Harry Knowles' Texas bedroom.
[159] The website at http://www.afionline.org/cinema/ uses VDOnet technology "that enables viewers to watch films in real time, eliminating downloading delays normally experienced when viewing moving images on the Internet." More technical information on http://www.vdo.net/

When producer/director Don Frankenfeld was still in post-production with his biker rally documentary *Sturgis 2000: The Internet Movie*[160] he decided to make the unfinished version available for viewing online. More than that, he saw a way in which the technology could provide some limited participation from viewers. Frankenfeld realised that bandwidth was too problematic to stream the film, so "we decided to turn it into a creative opportunity.

"Instead of mounting one hundred minutes of material on one reel we are doing what movie producers have been doing since movies were invented, using multiple reels, although ours of course are 'virtual reels.' The difference is that each of our segments is only a minute or so in length. The viewer, not the projectionist or director, decides in what order to watch the various segments. In a real sense you will be the director, or at least the editor, of your own movie." What he fails to report, however, is the terrible quality of the Quicktime footage, which pixilates and breaks up on your screen. His concept has a lot in common with a round-robin version of story-telling addressed above.

A former forensic economist and graduate of Harvard Business School, Frankenfeld is a bit cagey about how much original footage he actually has. He calls his film "an organic project. We've asked other rally-goers to supply footage [and] when we find footage we like we'll add it to our movie, always giving appropriate screen credit of course." The movie, continually growing and possibly improving, will be available for viewing until August, 2001. After that it will be time for the sequel, tentatively titled *2001: A Sturgis Odyssey*. What Frankenfeld's website seems really about is presenting a warts and all tour through the rally, celebrating the biker gangs and camp followers. However tacky it may be, there's nothing wrong with that *per se*, but I wouldn't call it interactive cinema.

Nor is *Quantum Project*[161] released online and only online in May 2000. Co-producer SightSound.com definitely regard the Internet as a cyber-distributor/exhibitor, having pioneered online music sales in 1995, been first to rent movies over the Net, and offering downloadable trailers for a range of studio films.

Featuring a promising cast headed by Stephen Dorff and John Cleese, shot using a combination of live-action and computer-generated effects, and costing a reputed $3 million, *Quantum Project* sounds a bargain until you realise it's only 30 minutes long and thinner on plot than Cleese's hair. So that makes it the most expensive online film ever –yours for an upgraded Windows Media Player and a mere $3.95, or $5.95 for the better quality 166 MegaByte version. Since even the cheapo version takes nearly an hour to download on a zippy modem, the novelty of watching a movie on your monitor palls fast.

[160] http://www.rallybiker.com/
[161] http://www.sightsound.com/

Don't expect anything remotely interactive; the most the producers promise is a choice of several recuts. They don't say whether debut director Eugenio Zanetti, a former Oscar-winning production designer,[162] will be granted a similar afterlife. Probably the most interesting aspect of the film from Hollywood's point of view is the few weeks between shooting and release. Normally films take months of processing before prints can be distributed to cinemas.

SightSound.com's Chairman and Chief Technology Officer Art Hair explains online that "given the abbreviated production schedule, it would have been impractical to shoot in film and transfer to digital tape, so it was shot digitally and compressed for online viewing." Admittedly the film's 30-frames-per-second [compared with celluloid's 24] greatly enhances the quality of the image. Too bad it's not matched by the quality of the movie.

Quality at least is driving a new wave of streamed cinema,[163] shot either digitally or on video then processed digitally, and delivered to your computer screen. As reported in the magazine *Res*, dedicated to this new cinema, such big-screen luminaries as Tim Burton and Spike Lee are dipping toes into the digital pond.

Already a webhead with his own official site,[164] Burton has a contract with leisure software manufacturer Macromedia's sister-company Shockwave.com to provide 'made for the web' shorts. "Medium and idea share a chemistry," Burton declared in an interview with *Res* on 12 December 2000. "For some stories, you have to wait for the right medium." The director of such complex features as *Batman, Edward Scissorhands*, and *Mars Attacks* believes his toon *Stainboy* will carry 26 'webisodes' starting in June 2001. "I think it's the perfect forum to tell a sad little story like this one. *Stainboy* is a character that doesn't do much; he's a very minimal superhero – he's not saving the city or anything. He's just perfect for 4-minute animations."

Shockwave, which requires users first to download a plug-in from Macromedia, has been enlivening high-class commercial sites such as the Cartoon Network for several years. Web designers are fond of the software since it's a great showpiece for their skills. It primarily serves the we-tell-you type of entertainment, using large bold colour washes particularly suited to cartoons.

[162] For *Restoration*, Michael Hoffman's version of the Rose Tremain novel featuring Robert Downey Jr, Meg Ryan, and Hugh Grant.
[163] The method by which packets of data flow in a stream from a host server but which are not stored within the PC. In other words it behaves like a radio or television programme but it's delivered digitally to a computer.
[164] http://www.timburton.com/

Shockwave.com's foray
into big-name content with
Stan Lee's 7ᵗʰ Portal and Tim Burton's Stainboy

So it's no surprise that Macromedia has also done a deal with creator of Spiderman and other Marvel comic heroes, Stan Lee. Instead of Spidey and his pals, this time Lee's constructed *The 7th Portal*, with a whole galaxy of new heroes and villains.

South Park creators, Matt Stone and Trey Parker have also been lured by Macromedia to make 39 web movies that feature Cartman, Kenny, Chef and the whole gang free from their Federal Communications Commission rules and regs.

Reeling You In

The examples above were never conceived in either form or content to push the boundaries of their novel means of delivery. This parallels Disney's *Fantasia 2000* for release on the giant IMAX screen. Whatever you think of its aesthetics none of its sequences was creatively influenced by its eventual exhibition.[165] It's hoped that the next generation of filmmakers will include at least an awareness of digital possibilities when they choose the Net for storytelling.

Early exemplars include Nick Stillwell, co-founder of production company Extreme Motion and director of a series of horror shorts collectively titled *Urban Chillers*, which are available both online and on cable. He's one of the few who recognise the way the non-linear Net experience can enrich his films.[166]

Though Stillwell primarily regards the Net as a distribution medium, he's excited by how the website[167] can supplement the shorts with "a whole load of other material – so you can watch the film then go off and explore aspects of it that are outside the linear experience." Stillwell is convinced that providing such extras as production stills and news reports is what interactive filmmaking is about, rather than some mechanism where the audience votes for a particular ending.

[165] Indeed, the film was widely released in conventional movie houses where it played just fine.
[166] More mainstream is Michael Winterbottom's *The Claim*, [a modern retelling of Thomas Hardy's *The Mayor of Casterbridge*] whose website http://www.theclaimmovie.com/ documented the shooting as it happened.
[167] http://www.urbanchillers.com/

A slightly different approach is embodied in Aardman Animation's web-only character called *Angry Kid,* created by Atom Films.[168] You can download the antics which make his name so appropriate in the form of two Flash games and a series of QuickTime episodes. Launched in May 1999, *Angry Kid* is a product of the company which produced the Wallace & Gromit short films and the model animation feature *Chicken Run. Angry Kid* is their first web production and the first web only production by a major studio. By winter 2000 the website had serviced over 3.5 million download requests. However, users cannot fully experience *Angry Kid* online, except for the Choirboy game which was available to visitors of *Electric December* referred to below. For now we must return to the MIT MediaLab to glimpse the evolution of interactive content in the cinema of the future.

During the 1990s, MIT's Interactive Cinema Group has been developing aspects of the Shareable Media Project to "expand the ways people utilize video-based storytelling. Research in the Shareable Media Project includes tool design, exploration in aesthetic structures and methods for developing Shareable Media communities. The research infrastructure supports applications concerned with contextual browsing, context sensitive display as well as the formation of contextual communities."

In 1995 Writer/Director Tinsley Galyean produced *Dogmatic* to "explore and develop methods for creating narrative coherence in a 3-D immersive environment." The short film experiments with the notion of how the setting can influence the perception of story, plot and character for the viewer. "The viewer encounters a 3D computer-animated dog who has been endowed with certain high-level behaviors. The dog plus the presentation mechanism ensures that the viewer sees the full exposition of the plot." Limited to a single thread the narrative permits only one audience member to be 'in control.' In 1996 the Group produced a short film called *Two Viewpoints* in which an imaging system allows a viewing of the story from the point of view of either main character. The overall story needs to work structurally no matter which version is chosen.

One continuing project, *The Dream Machine,* was begun in 1996 by a team including Stefan Agamanolis, Freedom Baird, Brian Bradley, Joe Paradiso, Arjan Schutte, and Flavia Sparacino, under the supervision of Executive Producers Glorianna Davenport and Michael Bove. They've combined elements of cinema, theatre, and architectural space design into an interactive improvisational narrative delivered to several audiences using high-bandwidth connections to the Web, pager networks, and in various real-time public spaces.

Lee Morgenroth and Richard Lachman's mystery *Lurker,* which takes about five days to unfold online allows real-life audience members to affect the sequence of the narrative by an exchange of eMail messages sent to and from the fictional characters.

[168] This little web-terror is available at http://www.angrykid.com/ Actually, the project was originally commissioned for broadcast on Channel 4, but there was a disagreement about online rights, so the company decided to release the Kid's adventures online only.

Tinkle, Tinkle Little NetStar

Certainly the Internet has been recognised as a delivery system by the traditional distributors of recorded music. As already noted, no matter where you are in the world, if you're online and have the appropriate sound cards and speakers, you can receive streamed transmissions from radio stations to accompany your surfing time.

Music can also be downloaded directly onto your hard-drive or onto a recordable CD-ROM. Although they're plagued by issues of piracy and disintermediation, particularly as technologies such as MP3 allow such easy download of musical tracks, both recording companies and musicians recognise that Internet distribution will only become more widely used. The legal implications of this phenomenon are discussed more fully elsewhere in this book. More relevant to this section are those popular musicians who use the Net for their own musical ends.

Recording artists may or may not enjoy being on the road, but if they want to sell albums they're obliged by the record companies to tour. Very few such gigs actually make money, but the publicity value results in vital sales. Recently the Net is changing the very nature of promotion with repercussions on the relationship between performers and their fans.

A Webcast is the transmission of a live event from venues of whatever size, made accessible around the world to anyone with an Internet connection. Such online events have always attracted the largest number of viewers. 6 million people accessed the Tyson-Holyfield website during the week of their first fight. Nor is Webcasting the sole province of entertainment. Millions turned first to the Net to hear pronouncements in the Clinton-Lewinsky case or for updates in the investigation of the death of Princess Diana.

Best-selling performers such as Sir Paul McCartney and Madonna, already firmly in control of their careers, have understood the power of Webcasting as an outreach tool to global fans who can now share in a live concert. In November 1999 over three million fans logged on to a McCartney concert. A year later Madonna broke all Net records when a staggering nine million people, mostly from Europe and the US, eschewed long ticket-lines to access her gig at London's Brixton Academy [a venue holding less than three thousand].

Webfans also avoided having to pay anywhere from between £100 to a reputed £5000 for a ticket. Madonna's Web producer was the Microsoft Network, which easily recouped expenditure from the online advertising such an event attracts. In sheer business terms, if live star events can be presented more cheaply from smaller venues, record companies can mount WebConcerts to do multi-duty. The companies are saved the travel and accommodation expense of touring not only demanding stars but their entourage. It appeases stars reluctant to take on the hassle of arduous tours, yet keeps their profile high when it needs to be. It also allows the whole concert concept to serve as a relatively inexpensive marketing promotion of upcoming bands, to build up their fanbase. Such musicians, unable to pull in large crowds on their own, don't even have to be in the same country to appear as support acts on a Webcast.

Clearly the Webcast rivals television in its presentation of live events to larger audiences than can gather in one venue. But apart from the BBC, television relies on attracting advertisers, and most of them want to be associated with the mainstream. The Internet can march to a different drummer.

Peter Lawrence heads an innovative company which disseminates popular musical culture called the Big Chill. His mission is to "challenge pre-conceptions, fuse art forms and provide an environment where artists from different disciplines ... meet, network and discuss possible new ways of working together." Lawrence has always taken seriously the fusion of live art and the club scene. "By creative and imaginative fusion of unlikely art forms, fresh and often unclassifiable work is often created."

In October 1999 Lawrence and Ruth Addison, Deputy Representative of The British Council[169] in Cairo, collaborated on an unusual Webcast which introduced a UK element into the emerging Egyptian club and rave culture. Not only did the event include UK musicians such as Baka Beyond member Tom Green and singer-songwriter Louise Mills, who teamed with Egyptian talent, the whole performance was creatively coordinated by VJ Justin Eade from Glimpse. A VJ, by the way, is the digital evolution of the DJ. Eade for example not only stage manages the order of musical numbers, he also combines natural-life footage with computer generated graphics on screen.

In addition to linking global audiences, musicians around the world are taking advantage of the Internet to play together in real-time though separated by country or continent. Up to now the concept has been restricted to a few jam sessions, notably one organised and webcast by BBC television's science and technology programme *Tomorrow's World*, but a whole new phase of CyberConcerts is waiting in the wings.

Lawrence expects future Big Chill projects to fuse music with film in new ways "so that DJ culture can sit comfortably alongside a play, a dance performance, a short film, a live acoustic music set or poetry.

"Digital cameras allow us to choose either the central screen at the physical event with the latest communications technology, or enable interactive web activity, whereby we send the programme out to the world via the web, and also solicit and edit those logged on with the appropriate equipment to make a valid [and very live] contribution from Finland, India or wherever.

"The great strides taking place in technological innovation are facilitating the global links we are establishing – Providing a context where people can talk to each other and communicate is important in promoting understanding and eliminating ignorance. The power of shared experiences through music and other art forms should not be underestimated."

[169] The British Council has for decades funded UK representatives from all the Arts to tour the world, disseminating new British works and artists.

Webcasts have also featured classical music. As Adam Baer pointed out in the 11 November 2000 edition of *The New Republic Online*, pairing more mainstream pieces with those which demand more of the listener, helps contextualise both and make them more accessible.

He cites Global Music Network's October 2000 webcast of *Funeral Music for Strings,* written as a tribute to Bela Bartok by the Polish composer Witold Lutoslawski [1913-1994] and Beethoven's *Violin Concerto in D Major, Op. 61* [recorded in 1999 at London's Royal Festival Hall] as a case in point. Baer also explores how webcasts personalise the very act of listening.

"I realized that my experience of hearing it might be unique. GMN.com provided me with the files that compose the concert before the webcast began. I listened to those files in the order I wanted, only later to realize that they might be webcast to the listening public in a different sequence. This is not a minor consideration. Concert hall administrators plan the order of pieces very carefully. In this case, some would choose to place the contemporary music first, offering the Beethoven as a comfortable counterpoint to the jolt of the Polish composer's eccentric wail.

"Others would undoubtedly open with the Beethoven, easing the audience into the contemporary world of the postmodern funeral. An eMail query revealed that my listening experience was indeed unique – but so was everyone else's. GMN.com presents its concerts to the public the same way they presented them to me: as discrete files that listeners can navigate as they see fit."

The Internet provides increasing opportunities for the exhibition of interactive media as well as a forum of introduction for interested participants. But how many contemporary writers, musicians, and other artists are taking advantage of it? With the Net still veiled like Venus from the mainstream, who is brokering introductions to stimulate more creative work? Apart from a few exceptions discussed in this section, most artists today are still coming to terms with the phenomenon of the Net, rather than thinking of it as a possible creative home.

Music to Your Ears

An exception is digital pioneer Brian Eno. Long before the Net was being used as a cyber-venue, innovative artist/musicians such as Eno and his frequent collaborator David Bowie fundamentally grasped its importance, not merely as a delivery mechanism for new work, but as a means of including their fans in the very creation of their music. Both have offered on their websites the means to turn interested visitors into individual collaborators, putting into practice what Berners-Lee calls "intercreativity." Eno is particularly coherent about the effect of technology on the very future of composition, claiming, "We have been looking for art in the wrong places."[170]

Though many contemporary composers employ digital composition and recording devices, Eno is especially exercised by the inter-relation between the composer, the music, the electronic tools of creation and the evolving audience. I've quoted him at length because his overarching vision is the most cogent analysis I know of the creative relationship between artists and technology.

An innovator since his early recording days, including solo albums such as *Before & After Science* [1977], *Ambient 1: Music for Airports* [1978], and *Nerve Net* [1992], his website [http://music.hyperreal.org/artists/brian_eno/] defines his philosophy. As a rock musician trained in the fine arts, with an Honorary Degree in Technology from the University of Plymouth and a visiting lectureship at the Royal College of Art, Eno rejects traditional orchestral composition as being too rigid.

Equally frustrating for Eno is the nature of the computer, how it engages so little with the user. "You've got this stupid little mouse that requires one hand, and your eyes. That's it. What about the rest of you? If you want to make computers that really work, create a design team composed only of healthy, active women with lots else to do in their lives and give them *carte blanche*."

Of course Eno does use digital devices in his compositions, but his interest in creating what he calls "music systems" predates computers by many years. "I've used systems of multiple tape loops that are allowed to reconfigure in various ways, while all I do is supply the original musical sounds or elements and then the system keeps throwing out new patterns of them. It is a kaleidoscopic music machine that keeps making new variations and new clumps. My rules were designed to try to make a kind of music I couldn't predict. That's to say, I wanted to construct 'machines' [in a purely conceptual sense – not physical things][171] that would make music for me." So, like other conceptual artists, Eno rates process.

[170] This and all following Eno quotes are from an extensive interview about his artistic philosophy conducted by *Wired* executive editor Kevin Kelly in May 1995 which is archived at http://hotwired.lycos.com/collections/multimedia/3.05_eno1.html/
[171] The similarity in approach with Turing's Universal Machine is striking.

"By the early 70s, I had made and experienced a great deal of systems music, as all this had come to be known. I wanted to make music that was not only systemically interesting, but also that I felt like hearing again. So, increasingly, my attention went into the sonic material that I was feeding into my 'repatterning machines.' This became my area: I extended the composing act into the act of constructing sound itself."

This concept of sound construction has led Eno to predict a shift in the relationship between composer and listener. The very words are misleading, since he's convinced the technology will allow a partnership between the two. He feels the term interactive is inappropriate in this context, preferring the word "unfinished" to describe the music. No mere whim of redefinition, it's an attempt to counter the traditional idea that the cultural perception of any manufactured element of the world has some immutable essence.

"Think of cultural products, or art works, or the people who use them even, as being unfinished. Permanently unfinished – the 'nature' of something is not by any means singular, and depends on where and when you find it, and what you want it for. The functional identity of things is a product of our interaction with them. And our own identities are products of our interaction with everything else."

Eno points out that a piece of music [or whatever] which allows people to further manipulate it is *a priori* interactive. It provides a specific contributory role for the recipient. "Your job," he professes, "is to complete something for that moment in time. A very clear example of this is hypertext. It's not pleasant to use – because it happens on computer screens – but it is a far-reaching revolution in thinking. The transition from the idea of text as a line to the idea of text as a web is just about as big a change of consciousness as we are capable of. I can imagine the hypertext consciousness spreading to things we take in, not only things we read.

"I am very keen on this unfinished idea because it co-opts things like screen-savers and games and models and even archives, which are basically unfinished pieces of work. What people are going to be selling more of in the future is not pieces of music, but systems by which people can customise listening experiences for themselves. Change some of the parameters and see what you get. So, in that sense, musicians would be offering unfinished pieces of music – pieces of raw material, but highly evolved raw material, that has a strong flavour to it already.

"I can also feel something evolving on the cusp between 'music,' 'game,' and 'demonstration' – I imagine a musical experience equivalent to watching John Conway's computer game of *Life* or playing *SimEarth*[172], for example, in which you are at once thrilled by the patterns and the knowledge of how they are made and the metaphorical resonances of such a system. Such an experience falls in a nice new place – between art and science and playing. This is where I expect artists to be working more and more in the future.

"In the future, you won't buy artists' works; you'll buy software that makes original pieces of 'their' works, or that recreates their way of looking at things. You could buy a Shostakovich box, or you could buy a Brahms box. You might want some Shostakovich slow-movement-like music to be generated. So then you use that box. Or you could buy a Brian Eno box. Say you like Brahms and Brian Eno. You could get the two of them to collaborate on something, see what happens if you allow them to hybridise. The possibilities for this are fabulous."

Eno's approach fundamentally challenges the infrastructure of the popular music industry, which reduces art and artists to commodities. "Most attempts to mechanically manufacture music are apt to fail because they are modelled to create sameness, whereas what interests us is difference. Having said that, I'm quite keen on the idea of evolutionary music because it doesn't attempt to base itself on some sort of absolute theory about what makes good music."

Just as he challenges the model of the creative process, Eno is also convinced the role of the artist is evolving. That evolution is just as true for visual artists as musicians. "An artist is now a curator. An artist is now much more seen as a connector of things, a person who scans the enormous field of possible places for artistic attention, and says, What I am going to do is draw your attention to this sequence of things.

"If you read art history up until 25 or 30 years ago, you'd find there was this supposition of succession: from Verrocchio, through Giotto, Primaticcio, Titian, and so on, as if a crown passes down through the generations. But in the 20th century, instead of that straight kingly line, there's suddenly a broad field of things that get called art, including vernacular things, things from other cultures, things using new technologies like photo and film. ...

[172] So-called "sim" games depend on complex programming codes which allow the elements of any presented environment [people, animals, plants, armies] to be manipulated either directly by the player or to change in some way as a result of some apparently un-related action. So, in the course of a sim-game, if a player decides to increase factory production, the computer program takes account of the effect on raw materials in another part of the sim-world. This is allied to the game *Republic* discussed above.

"What postmodernist thinking is suggesting is that there isn't one line, there's just a field, a field through which different people negotiate differently. Thus there is no longer such a thing as 'art history' but there are multiple 'art stories.' Your story might involve foot-binding, Indonesian medicine rituals, and late Haydn string quartets, something like that. You have made what seems to you a meaningful pattern in this field of possibilities. You've drawn your own line. This is why the curator, the editor, the compiler, and the anthologist have become such big figures. They are all people whose job it is to digest things, and to connect them together."

Eno epitomises the mutual influence between music and its technological means of delivery. He's convinced that the very nature of recording, producing the ability to hear the exact same performance a multiplicity of times, has made commercially sustainable such forms as jazz, "because you can make sense of something on several hearings – even things that sound extremely weird and random on first hearing. I did an experiment myself last year in which I recorded a short piece of traffic noise on a street. It's about three and a half minutes long, and I just kept listening to it to see if I could come to hear it as a piece of music. So, after listening to this recording many times, I'd say, Oh yes, there's that car to the right, and there's that door slamming to the left, and I would hear that person whistling, and there's that baby coming by in the pram. After several weeks, I found I loved it like a piece of music."

Technology, Eno feels, will also allow a completely different means by which people access music. He predicted current forms of Internet music distribution: "as it becomes ubiquitous, people will want music purpose-designed much more. Just as you choose to arrange things and colours in your house in a particular way, I think you will choose music like that.

"Imagine that you order an evening of music over the Net. You say, 'We're having a dinner, people should be able to talk over the music, I'm fond of Pachelbel's *Canon* and Joni Mitchell and Miles Davis. Can you put together three hours for me?'

"Whereupon the brain of the system looks through its ever-evolving 'taste-clumps' – the product of continuous customer research – and says, 'Someone who likes those things is quite likely to also enjoy some of the quieter moments of Hector Zazou, Jane Siberry, and Jon Hassell.' It will compile a combination of all those. This is an autocurator. You could even tell it how experimental you wanted it to be: 'Really surprise me – pull out a few long shots.'"

There can be no more comprehensive example of Eno's musical approach than the musical design project of William Oliver, John Yuy, and Eric Metois at MIT's MediaLab. They called their project *The Singing Tree: Design of An Interactive Musical Interface*, and claim it "responds to vocal input with real-time aural and visual feedback."[173]

[173] The piece was presented as part of a highly acclaimed interactive experience at exhibitions in New York City and Florida in the US, and also Austria, Denmark and Japan.

According to the description online, *"The Singing Tree* was first developed to be one of six novel interfaces used in the Mind Forest [Act I] of the *Brain Opera*, an interactive opera composed and developed by Tod Machover and the Opera of the Future Team at the MIT Media Laboratory. *The Brain Opera*, based in part on Marvin Minsky's book, *Society of Mind*, is divided into three parts: the Mind Forest, in which the audience explores and creates music related to *The Brain Opera* via six novel interfaces, the Internet, in which internet participants explore and create music via Java applets, and the Performance, in which three performers use novel interfaces to play written music and introduce audience and Internet contributions to the piece."

To achieve part of the musical content, *The Singing Tree* invites people[174] to enter a constructed environment inside a white hood resembling an ear and containing an LCD[175] screen. Once inside they don headphones and sing into a microphone.

"The hood's height is adjustable, and it can enclose the singer to provide maximum sound isolation as well as reducing feelings of self-consciousness about public singing.

"[It] has the appearance of a tree, large and round at the top with a slender set of three poles comprising the tree trunk." The microphone transmits each voice for analysis, and the captured vocal parameters are then recycled to "drive a music generation engine and a video stream which are played back in real-time.

"Several design specifications and constraints dictated the development of *The Singing Tree*. ... The aural and visual feedback is used actively to lead the participant to an established goal, providing a reward-oriented relationship between the sounds one makes and the synthesized music one hears. It is an interesting musical interaction experience for both amateur and professional singers. The system software is flexible, allowing new goals, new music, or new video to be incorporated easily. ... Our goal was to create a meditative experience with a beautiful, angelic response as the musical reward."

[174] It's clear a new generic word will have to be coined for members of an interactive audience.
[175] Liquid crystal display.

Obvious to its sponsors including IBM, the MIT lab creators of *The Singing Tree* are well aware of future applications for its technological foundations, particularly in the field of voice recognition and vocal feedback. "The results are potentially far-reaching. Interfaces which can seamlessly extract useful information from a human voice in real-time and provide meaningful feedback will play an increasingly important role in 'smart' applications – for example, a 'smart' room or automobile interior. ... Designs which determine a gesture or intention based on information extracted from the human voice without resorting to speech recognition would open new possibilities for seamless computer interfacing."[176]

Next Stages

The remarkable success of British playwright/director Patrick Marber's second comedy-drama *Closer*[177] illustrates how a time/place-based art such as live theatre can reflect the power of technological change. A witty and pungent examination of contemporary relationships and questions of identity, one of its most extraordinary scenes occurs in silence as two main characters, one falsely assuming a woman's gender, exchange sexually explicit messages in an Internet chat room. The audience witnesses the conversation on a huge screen above the characters' heads.

Yet, when he wrote the play in mid-1996, former comedian Marber, hailed in the press as "the finest British dramatist of his generation," was not even online, though he admitted in an interview for this book that he was aware of eMail and chatrooms. "Within my social circle [the Internet] was just beginning to take off. I realised it was going to be something big. It was in the press, I'd heard friends talking about it. This was a big happening thing. Like when fax machines first came on the scene."

It was only in 1999 that he finally upgraded from what he calls his "neanderthal laptop" loaded only with MS-DOS to a system with Windows, and that was only because the hotel room he was in got flooded, damaging his computer.

That same year he got an eMail account – some three years after he wrote the famous scene. "I think technology is always hard for you until you get it! By nature I'm a technophobe because life's too short to read all the manuals. I literally can't be bothered. I will get a DVD player in time, but for now I'm perfectly happy with my CDs. Before that I was perfectly happy with vinyl and cassettes. I get by with the minimum I can get away with."

[176] Further detail, including technical specifications can be found at
http://theremin.media.mit.edu/
[177] After its debut on 29 May 1997 at the National Theatre, *Closer* transferred to the West End. It won the 1997 Evening Standard Best Comedy Award, the 1997 Critics Circle Best Play Award, and the 1998 Olivier Award for Best New Play. The play enjoyed a UK national tour, ran for 6 months on Broadway and has played in 50 countries all over the world including the Czech Republic and Russia.

The Net Effect

The Internet chat scene in *Closer*, so pivotal to the development both of plot and character, was researched in a couple of sessions at an Internet café. "I thought it was a neat idea, and I had a sense that by the time the play opened it would be a potent comic notion. By May '97 people were still 'oooh, what's that all about.' At the time it was quite radical. I did a bit of [what do you call it?] lurking, I joined in a bit, pretended to be someone else. But I had the idea for the scene before I researched it."

Marber provides an insight into how the process of dramatising ideas can be influenced rather than dictated by technology. "If the Internet hadn't been around I would have manufactured some other device for the scene. It's hard to remember whether the plot or the scene came first. It worked organically. It was only after I'd written the play that I fully realised how much the scene was about alienation. I probably re-wrote the scene to make that clear, so it took on more resonance. Initially the impetus was more comedic."

As Marber freely acknowledges, the scene is "actually a traditional, Shakespearean device, just using new technology." Nor has writing it made him particularly more interested in exploring new ways to present his work. "I'm suspicious of the overuse of technology. I'm a bit of a purist, a classicist. I'm not the kind of playwright who's interested in crossing forms, using video technology onstage, that kind of thing. Not to say I won't ever use those references, but it's tough enough creating credible characters and putting then onstage. Nothing is more original than a well turned line. And probably I don't feel confident enough to explore those other forms."

I suspect it's in part that element of confidence which stops more artists integrating interactive technology into their work. Marber, however, also remains adamant that the very essence of our culture is being hijacked to a certain extent by such change. "I think there's a war going on between the way technology and society are evolving, developing and pushing out more traditional values of reading, writing, live theatre." Though his work dating back to his days as a successful stand-up comic continues to be based on an intimate familiarity with contemporary culture, he describes himself as "pre-computer-game man."

When pushed further about the validity of fuzzing boundaries in the context of live theatre Marber concedes, "I saw the Woocester Group recently in New York in a very high-level technology show, and it was perfectly enjoyable. But I wouldn't do it myself. I come from a live tradition. I'm interested in making stories that make people leave their homes to see. That [interactive, non-linear storytelling] is probably the future, but not a future I welcome. Of course for people who can't get out or afford it, it's wonderful.

"What I want when I write is for people to gather together in a space. To my bones I am a playwright. And I'm a bit of a curmudgeon. You have to get plays to a high standard to compete with new technology. What can't happen is a digital theatrical performance. I think there will always be a need to see people live onstage."

Marber's perception implies an either/or domination which I disagree with. There's creative room for both as well as a degree of integration, though he's right that the increasing appearance of technology in the arts is bound to influence it. Of course the Arts are so exhilarating precisely because of their progression and integration of form, as well as the relationship between form and content.

Another director who shares Marber's passion for live theatre is also a consummate musician who's incorporated digital elements in his work since the late 1950s.

"I'm in love with the theatre, which has to do with the now moment. Keeping it different and fresh," says Tom O'Horgan.[178] Generally acknowledged as helping to revolutionise modern theatre along with contemporaries Jerzy Grotowski and Peter Brook, O'Horgan's stage work has always incorporated musical elements, not surprising for a composer and director of opera as well as theatre, and owner of one of the largest collections of ancient instruments in the world.

He has written over forty musical scores for operas, plays, dramas, films, and television. He was the original director of Ellen Stewart's award-winning 1960s LaMaMa Troupe, directing US premieres of work by Jean Genet, Sam Shepard, and Lanford Wilson. He remains the only director to have had four musicals on Broadway and two plays off-Broadway running simultaneously.[179] His awards for Best Director include the 1967 Obie and 1969 Drama Desk Award for the LaMaMa production of *Futz* and the 1968 Vernon Rice Award for Paul Foster's *Tom Paine*.

O'Horgan.'s more recent musical projects include Berlioz's *Les Troyen* for the Vienna State Opera, and the premier of Kirchner's *Lily* at the New York City Opera. He directed the highly successful *Starmania*, France's first rock musical, and staged the post-minimalist opera *Power Failure* by Paul Dresher, as well as Harry Partch's microtonal music dramas *The Wayward* and *Oedipus*. His production of his friend Leonard Bernstein's *Mass* for the Kennedy Center's tenth anniversary celebration, was broadcast on PBS TV in 1981.

O'Horgan. speaks from a bedrock of digital musical experimentation in the context of live performance. In 1959 he composed a digital accompaniment to the Chicago Studebaker Theater production of Arthur Miller's *A View From the Bridge* starring Luther Adler. In an interview for this book he described providing the "digital matrix upon which live instruments were played.

[178] Having worked, like Marber, as a comic on the Chicago circuits supporting such acts as Lenny Bruce and Nichols & May, O'Horgan came to international prominence in 1968 with the success of the rock-musical *Hair* which he directed at the Biltmore on Broadway, in Los Angeles, San Francisco, Chicago, and on London's West End. In 1969 he directed the film of *Futz*, adapted by *Psycho* screenwriter Joe Stefano. O'Horgan. also scored and directed the 1977 film of Ionesco's *Rhinoceros* starring Gene Wilder and Zero Mostel, and composed the score for MGM's *Alex in Wonderland* starring Donald Sutherland.

[179] The Broadway shows were: *Hair, Jesus Christ Superstar, Lenny*, and *Inner City*; the off-Broadway productions were *Futz* and *Tom Paine*; the four other *Hair* productions also ran during this prolific period.

"We used the principle of the theremin, distortion and impedance, devices made to control pitch by tuning dials." Even earlier in 1953 O'Horgan. had recorded human voices, music and random sounds, altering pitch and speeds, and re-recording onto a paper wax disc to produce a sound collage. "It was all so primitive, so uncontrolled, so I went back to writing for more traditional instruments. Then the instruments themselves became more controllable. I experimented with scores just using the synthesiser.

"In 1964 I scored *Balo 73* [an independent feature film] for Robert Downey Sr and Taylor Mead, combining synthesiser and traditional instruments. As primitive as the early stuff was, it was really pure." What O'Horgan. wants to achieve in his film and theatrical scores is a sound-based embodiment of narrative ideas. Instruments, whether traditional, digital, or newly made from such mundane objects as garbage cans or heating pipes, become the tools of delivery.

O'Horgan. acknowledges the contribution of other composers who integrated technological sound into compositions, such as Edgar Varese's 1954 piece *Déserts* and his *Poème électronique,* which premièred at the 1958 Brussels World's Fair and incorporated the architecture of the building as part of the music's spatial design by playing directly from tape over 425 loudspeakers in the Philips Pavilion.

He also recognises a role for the Internet's dual capacity to stimulate creativity and share results, partially counteracting the heavy hand of commercialism currently dominating the music industry. "The Net will bring us back to dreams," he prophesies.

"Every composer from early on has been influenced by the daily rhythms which they heard all around them, like horses' hooves. Today different influences like rap underpin composition. There's not much connection with human daily life; we're surrounded by damaged mechanical units. People have become used to that. They find any hint of subtlety amazing. I think we're witnessing a very bland period. The machines themselves are capable of enormous subtlety – the point is to create a new sound universe from electronics. I think young people have been sold down the river, because it's an easy way to make a lot of money for people who don't give a shit about the music. The Net is the way it's got to be."

Buttressing the ThinkTank

The digital Arts need a support system both to stimulate experiment and praise results. But, as Stephen King remarked above, the issue of support cannot ignore the lack of imagination which business has shown so far in helping to fund online arts. Commercial organisations still have failed to grasp that they can better achieve their marketing goals by searching out and sponsoring challenging and astounding content then by trying to force the Net into the narrow transaction-driven paradigms so familiar offline.

As expected, MIT is in the vanguard, filling the gap with *Leonardo* [both a website and hard-copy journal] which brings together artists, scientists, and technologists. The Xerox PARC[180] combines artists and engineers in an equal ideas generator, while Interval Research, based in San Francisco, allows artists and technologists a platform of experimentation for projects which might go to market.

Though the United States has taken the lead in such blue-sky research,[181] other agencies around the world are beginning to exploit opportunities for digital art projects. Under the Artistic Direction of Peter Ride, a Digital Arts funding agency DA2[182] was established in the South West of England to fund a range of new media artists. Some projects are purely visual, others such as *Water Water Water* by Christy Sheffield Sanford and Reiner Strasser involve a new approach to literature.

The piece treats the concept of collaboration as if it enjoyed the chemical composition of water, including elements of polarisation, ionisation and solution. Described as "an inventive and beautiful exploration of creative text [which] makes web space into a sensual environment, in turns fluid, turbulent and misty," the project was demonstrated last year in Bristol. DA2 is also involved in an ongoing city-wide annual digital media project called *Electric December*, an online Advent Calendar.

The city that is home to such luminous creative companies as Aardman Animation [producers of *Chicken Run*], the Bristol Old Vic Theatre Company, and The Internet Movie Database offers each of them and others a virtual window on http://www.electricdecember.org hosted on the website of the Watershed Media Centre, a pioneer exhibition space for digital arts.

The city also boasts a unique web project which I had the privilege of coordinating. Called the Online Aquarium, it serves the dual functions of providing an online showcase for Bristol's excellent multi-media community of artists and programmers, and it portrays species in the real-life Aquarium at Bristol Zoo Gardens in a non-text-based context providing both an educational and entertainment experience for visitors to the Zoo's website. The entire project was done on a pro-bono basis by more than 20 working professionals and took over a year to realise, since all concerned worked on it in their spare time. It launched to the press on 3 March 1999, and was presented as a gift to the zoo, forming a module on their existing website.

[180] Palo Alto Research Center.
[181] Research without a pre-defined commercial value.
[182] Digital Arts Development Agency http://www.da2.org.uk/

Some of the fish appearing in the module were digitally enhanced original paintings, while others were rendered as Flash™[183] sequences using various multi-media software packages or with program coding. Combining such renditions with a soundtrack produces an interactive experience which is at once informative and entertaining. It's quintessentially a web creation, decidedly not a mini-movie or video.

In addition to conventional hypertext menu choices, visitors are greeted by Neptune riding his seahorse chariot, explaining what's on offer in a lordly voice. The two main sections of Ocean and River are activated by clicking on two fish, each revealing its aqueous origins. The seahorses, currently one of the Zoo's breeding programs, feature again in an interactive online game for children. Instead of text pages of information about the various species, when visitors click on the fish swimming about in the Ocean section, each will stop and tell you about its habitat and lifestyle. Unique to the module is the pairing of a VRML encoder with a choreographer to produce a virtual fish ballet in which a couple of clown knife-fish dance with a corps de fish ballet in a bubbling river.

Another section features a specially commissioned poem which has been digitally rendered using poetic text behaving like underwater creatures. The module was named Site of the Month in *Internet Magazine,* and was short-listed for a Best Website Award by the British Interactive Multi-media Association. Because the Online Aquarium was designed for tomorrow's speed of delivery, it's best viewed with ADSL[184] or other high-speed Internet access. A fast modem will work, but speeds will depend on prevailing web traffic. Be patient, it's worth the wait![185]

Access speed is one of the key barriers to artistic expression online, since elaborate effects such as those described above are contained in extremely large sound and picture files. Heavy bandwidth is needed to transfer these files from the server on which they are stored into your computer. We'll deal later with how such problems are being addressed technologically. Until bandwidth is no longer an issue, experimentation with interactive Net art is hampered by its dearth of commercial funding coupled with the scarcity of experienced programmers who primarily choose more lucrative if less creatively challenging careers in industry. Non-digital visual artists also share some of that technophobia discussed in the previous section.

Despite this, a growing number of online visual experiences are available, including those mentioned below. I am not making aesthetic judgements about the quality of any of these presentations.

[183] Flash allows digital designers to animate sequences online using a software package which has embedded the programming code for moving text and graphics around the screen. This means that designers can concentrate on storytelling with words and/or pictures in a much more dynamic way than setting out blocks of text on the screen; nor do they have to divert their skills into learning programming code.

[184] Asymmetric Digital Subscriber Line.

[185] The Online Aquarium can be accessed via the Bristol Zoo Gardens website: http://www.bristolzoo.org.uk/ First find the section detailing zoo exhibits, click on the Aquarium, then click on Enter the Online Aquarium and follow the instructions.

It's important to understand that electronic creation is still in its infancy. We should, however, be aware of what some early adapter artists have already accomplished and know the influence they are having on a new generation.

Try these on for size:
> ➤ Reinhold Kucza's mixed-media flash movie can be viewed at: http://mme.cosus.de/99-2000/fiktiveMMAgentur/intro.html
> ➤ There's an online interactive art exhibit at: http://www.spiritart.org/interactive.html
> ➤ You can participate in a bout of non-linear storytelling at: http://www.stunned.org/playlets/begin.htm

Reaping Rewards

Important in the promotion of Digital Art is public recognition, usually in the form of Awards. Various commercial and non-commercial interactive projects have begun to receive acclaim at festivals around the world, including ResFest[186] which spotlights digitally produced short films and music videos.

In 1997 San Francisco-based Maya Draisin founded the International Academy of Digital Arts and Sciences which hosts the prestigious Webby Awards, under the slogan "Celebrating the people behind the machine." Even for sites not specifically arts-related, judging criteria include design as well as content, voted by professionals such as David Bowie, Frances Ford Coppola, Deepak Chopra, Julia Child, Bjork, and Richard Branson. In addition to providing helpful signposts of excellence to Internet users, Draisin wanted to "recognize and track the amazing work that was being developed online [and] honor the best of the web."[187] What sets apart the Webbies from such as the Oscars is that the public has a chance to vote interactively in each category; Draisin "worked with Pricewaterhouse Coopers [to] develop a process that was diverse, rigorous, and credible."

In 1997 VRML inventor Mark Pesce[188] teamed with Lisa Goldman to found the Interactive Media Festival in Los Angeles. In 1998, the British Academy of Film & TV [BAFTA] introduced a Digital Category to its prestigious annual Award Ceremony, and the British Interactive Multi-media Awards have long been recognising digital achievement by UK webhouses. Both, however, concentrate on commercial work employing the software of their primary sponsors, which disadvantages those creative, non-funded independents.

[186] Founded by *Res* Editor Jonathan Wells.
[187] From an interview graciously given by Maya Draisin. From its first ceremony in 1997 attended by 650 people, the 2000 Webbies attracted an audience of over 3000.
[188] More recently, Pesce has been writing and lecturing on the future of the Internet, convinced that being able to access and navigate online will be more important than acquisition of knowledge. He believes this will fundamentally change our concept of study, even of intelligence – nowing where to go for information becoming more important than retaining it.

BAFTA Scotland's New Talent Awards 2000, however, honoured May Miles Thomas's digital feature *One Life Stand* with five firsts including Best Drama, Best Writer, and Best Director, as well as a Scottish Screen award of £10,000 for outstanding achievement. I suspect we'll have to wait a few more years before bandwidth improvements allow a fast download to the desktop. There simply isn't enough investment currently going into digital exhibition venues, even though the technology slashes production costs.

There really is a difference between a web-artist's proficiency with a piece of complex graphics software and artistic vision. Some of the UK's and Europe's more forward-thinking Art Colleges have introduced degree courses in multi-media and digital art. Career options for graduates, however, are dominated by webwork, and university posts have been created whose function is to liaise with the business community. The Web is undoubtedly ready for the equivalent of a Sundance Festival focusing firmly on independent, non-subsidised work.

Sponsored every second year by the European Commission in association with various private companies, Europrix invites digital artists to compete for large cash prizes. In 1998 the Multi-media Art award went to Peter Gabriel's RealWorld for his moving and stylish CD-ROM *Ceremony of Innocence.*

This impeccable production traces a love story by Nick Bantock based on the Griffin and Sabine trilogy, brought to life by an international cast of actors including Isabella Rosellini, Paul McGann and Ben Kingsley. While the criteria for nominations in the year 2000 reflect a diversity of artistic achievement for the CD-ROM market, nominations for websites appear to concentrate on those which provide complex programming solutions for eBusiness and the Marketplace, the exception being http://www.cyber-pirates.com/[189] which provides an entertainment and online zine for potential buyers of their streetwear.

In addition to awards ceremonies, industry professionals now have opportunities to exchange ideas and engender potential partnerships at an increasing number of conferences dedicated to the fusion of Arts and Technology. One of the first outside the United States was presented in Bristol in September 1998 by the Multi-media Research Group at the Department of Electronics and Computer Science, University of Southampton in conjunction with The University of Bristol. It provided the focus for the 5th annual ACM Multi-media Conference, "devoted to presenting and exploring technological and artistic innovations in the field of multi-media – for researchers, artists, developers, educators, performers, and practitioners." Hosting some of the seminars and exhibits was Hewlett-Packard's Lab which has its headquarters in Bristol and can be described as the commercial equivalent to the MIT lab.

Among several events with fewer overt links to the commercial world, Stockholm's Multi-media community funded The Fuel, a two-week festival in June 2000 with events throughout the city.

[189] Produced by Scholz & Volkmer for Intermediales Design GmbH, Germany.

In July 2000 *GetWired*[190] hosted the 2-day Wired and Dangerous in Leicester. The theme of this last in the Get Wired series exploring new technology and the arts was The Impact of Technology on the Creative Process. Featured were a wide range of artists representing disciplines as diverse as graphics, dance, music, multi-media, literature, and emerging amalgamate forms. There were also sessions about protecting intellectual property rights, project funding, and training.

In September 2000 the University of Wales at Lampeter presented ReMote: Creativity and Technology in Wales.[191] The two-day seminar set new media activity in the context of regional economic development, education and creative practice.

The Price of Talent

Cinema exhibitors can teach the Net a lesson. They understand people visit movie theatres to see films. Yet a bottom-line analysis proves that approximately 85% of cinema profits come from the sale of food and drink, and not from tickets. Of course if you asked movie-goers where they'd choose to eat, rarely would anyone reply "the cinema."

So even if companies online want to increase sales and/or brand awareness, imaginative web content has to be the magnet. It must be content creators who specifically address the interactive nature of the medium. We have witnessed in our own lifetime the cultural diminishment of The Classic, which has been sacrificed at the altar of The Disposable. Instead of what the Romans [and MGM] called *Ars Gratia Artis*, Art being appreciated for its own sake, it has become a product of what the late sociologist and musicologist Theodor Wiesengrund Adorno dubbed "The Culture Industry," which transforms works of art into commodities.

The interactive media industry is capable of so much more. It is capable of helping to re-elevate The Arts, to bind all of us together in an expanding notion of culture. The industry requires as serious investment in its creative conceptualisers as its salesforce. As we've already noted, those who use the Internet increasingly demand an engaging experience. Provide it and you can guide them to address your own agenda, whatever it may be. The Arts must take their place alongside Technology and Commerce as a key driver of the medium.

[190] http://www.getwired.org.uk/
[191] http://www.bloc.org.uk/

section 4: the internet experience[192]

No-one can deny the Net's a confusing place. As we've seen, its parents have been tekkies and marketeers hand-holding those Creatives itching to make their online mark, while the public lags way behind, put off by access speed and technophobia.

But

unless more people continue to sign-up to the Internet Experience, no vested interest is safe. And too many non-adaptors will miss out on its many benefits. As part of my demystification mission, this section will sketch out the way the Net works, both for those who use it and those who shape it. The first bit is for the Net Novice, so skip ahead if you're a confident user.

[192] Grateful thanks for the illustration used with kind permission of Bettina Newman, who also designed the cover.

WWWwhat else is there?

Most casual users equate the Internet with the World Wide Web and believe it's composed solely of websites which are brought to your computer-screen down a phone line. Certainly that's the focus for the bulk of this section, but it's useful to understand what else comprises the Internet, particularly since all signs point toward greater and greater convergence of Net technologies. We'll concentrate on the primary Net applications: eMail, intranets, Newsgroups, and FTP. There are also other standardised protocols such as Telnet, Finger and Ping, which allow behind-the-scenes tracing of data-transfer routes, server-to-server communication and other performance monitoring.

Whichever service is required, the data traverses the Internet according to the same general principles. The first step is in the form of an initiating request from someone typing or speaking commands into a device with an Internet connection. The request goes out from the input device to a series of servers where it's processed and the relevant data returned.

It's called a push-pull sequence: you push out a request and the data is pulled from an appropriate source back down to you. The more individual requests made at any moment, the greater the strain on the servers. When countries with high Net usage are awake and active, such as the United States, the burden on both intermediary and primary servers can be so great it causes temporary stoppages to all requests travelling that particular route. But don't panic – because of the way it all fits together, what won't happen is a total stoppage of the entire Internet.

A comparatively small number of backbone servers[193] act as giant staging posts for storing and passing on packets of data. These primary servers are connected to a network of hub servers throughout the world. They're owned and managed by Internet Service Providers [ISPs], multi-national companies, universities, the military, government. There's no restriction on how many such servers can operate simultaneously.

Various ISPs own networks of local servers which provide connections to subscribers. Each server is identified by a unique IP[194] address. When you type an http:// address into your browser, part of that address identifies the server hosting the webpage you're requesting. The networks can serve local or global connections. WANs [wide area networks] and LANs [local area networks] operate independently. Some ISPs such as CompuServe or AOL place inbuilt restrictions on incoming and outgoing data traffic. In fact, the data from such organisations actually travels at a slightly different speed from the rest of the Net. Some companies have discrete internal networks, the number of servers dependent on the size of the company.

[193] In May 2000 these were in 15 locations, including Washington DC, Silicon Valley, and London.
[194] Internet Protocol.

The bedrock of our Communication Age is the ability to send instant messages anywhere in the world either very cheaply or for free. Before eMail an anomaly of written exchange in Western society was that the intra-city runners of the 18th century provided a more reliable and more frequent service than today's post office. Often the 'letter-carriers' as they were known delivered upwards of a dozen or more exchanges in a day, primarily for commercial or amorous correspondents. Interestingly, payment for letters was originally levied not on those who sent them, but to their addressees. Long-distance communication, of course, was a different matter with letters often taking months to reach their destination from other continents and weeks or days between cities and towns – hinting why Net users call such real-world post Snail Mail.

In our era of itchy feet, far-flung families and industry branched around the globe, all prisoners of local time-zones, eMail has revolutionised human dialogue. From its early invention for the ARPAnet, and the first transatlantic connection in 1973 to University College, London and the Royal Radar Establishment in Norway, eMail has become the most widely used Internet component.[195] It's the electronic equivalent of leaving a message on someone's telephone answering machine. It's private, instant, and the recipient will receive and act upon it at their convenience.

The privacy is qualified. Mirroring phone-taps, eMails can be and are being monitored, for instance by companies anxious to protect privileged information and by law enforcement agencies. Ostensibly such monitoring by public bodies requires warrants and due cause, but the process is open to abuse. The issue exercises civil rights and free speech defenders throughout the world.

At the moment most eMail depends on the typed word, but speech-based systems are already in train. They operate in a similar way to voice-mail, sending spoken messages for recipients to access when they can. Language differences are also being addressed technologically. Soon it will be possible either to type or speak in one language and have the message recipient read or listen to it in their own language. With the increasing availability of digi-cams, videograms are also proving a popular option, the next best thing to being there.

Most eMail services are a component of the package of goodies offered when you sign up to the Internet with an ISP.[196] You'll be assigned a unique eMail address, as unique as your telephone number. This follows a certain protocol comprising one or more words separated by a dot [.], the symbol for the word 'at' [@] and some word or phrase identifying your mail host.

[195] There's lots of helpful eMail stuff at
http://www.thirdage.com/community/email/help.html/
[196] ISPs parallel the provider of your telephone or cable services; they are enabling companies which sell or rent access to the Internet. Some phone and cable companies also provide Net access.

That can either be the name of your ISP such as demon.co.uk or a private domain name which has been registered to you.[197] So I could be beth.porter@isp.com or beth@myownhost.co.uk The dots and @ are as vital a part of the eMail address as is the fact that there are no spaces between the words and symbols.

The domain name part of the address identifies the particular mail server hosting your account. Think of how you address an envelope for the equivalent offline format. You identify the person or company at a particular number on a particular street in a particular city or village in a particular country with a particular postal code. Get any of it wrong and the letter probably won't be delivered correctly.

eMail is accessed within a mail program, which is either integral to your ISP-supplied software, part of the software bundled with your computer, or an independent program. They each have slightly different set-up instructions and customisable features, so it's wise to wade through the help files or get private instruction.

You can compose messages offline and log on to the Net merely to send them, and all your messages can be sent at one click of your mouse. No envelopes. No stamps. No worrying about whether you've missed the postal delivery. You can even send one message simultaneously to a group of people, each with their own unique address. You'll also be provided with a virtual address book which allows you to address your future eMails at the click of the chosen name, rather than always having to type out the information.

If you're replying to a received message merely hitting the 'Reply' button automatically brings up a window, already addressed to the recipient. Adding to the experience, some message programs provide stationery options, so you can use illustrations on your virtual notepaper, or format the text to match your mood. You can also attach files to your message, much as you'd enclose a magazine article or photograph inside a letter. Audio and video files, too, since they're encoded as binary data. Just make sure your recipient has the means to decode them at the other end. Although they're both getting better, be warned that Windows-based systems cannot always access files created on Apple-systems and vice-versa.

One of the problems with eMail addresses supplied by ISPs is that should you decide to change service providers you'll receive a new address. As it's unlikely your old ISP will forward your mail, the onus is on you to inform all your correspondents of your new address. Electronic alternatives include getting a free eMail address from such as HotMail or TimeSmart's talk21, which are independent of your ISP, but only available in cyberspace.

[197] Many companies provide such services; specialist magazines are full of industry comparisons.

Unlike tied addresses which download received messages onto your hard-drive then let you compose replies offline, online mail encodes and stores your eMail on its host server ready for you to access when you log on with a password. It's like having a *poste restante* address when you're abroad; you can also send eMail this way from anywhere in the world. As you'd imagine, this service is used extensively by travellers to keep in touch with friends, family and/or business colleagues. Another solution is to get one eMail address 'for life' which follows you around no matter which ISP you're with.[198] In fact with convergence, you can now obtain a for-life phone number which allows people to ring one number wherever you happen to be in the world. It also takes voice messages and delivers them to you as eMail audio files.

Although eMail messages can be sent back and forth many times in a day, it's essentially a one-way communication which may be followed-up by another one-way communication. This is due to the delay between sending and receiving, which can be several hours depending on when the recipient accesses the message, how busy the rest of the Net is, and how overloaded your ISP's hosting server happens to be at the time.

Internet Relay Chat or IRC allows immediate real-time conversations online. You'll need special software, free to download or acquire, and you'll have to go through a host [either supplied by your ISP or independent]. Once you're into the program you can type messages to anyone else who's also subscribed. There's even an indication of who else is online the same time you are. This facility is the basis for the scene in the play *Closer* discussed in the previous section.

The word 'chat,' of course, euphemistically describes typing. eMail, IRC, and most of all 'messaging' [or the even more inelegant 'texting'] are affecting idiom, syntax and grammar.[199] Because people use these messages like postcards and Post-it™ notes, space and time restrictions have spawned special jargon and abbreviations, which have spread remarkably quickly. These include 'btw' [by the way], 'imho' [in my humble opinion], 'rotfl' [rolling on the floor laughing], 'ygti'[you get the idea]. Spelling, too, has been affected, virtually eliminating capital letters and using Americanisms such as lite=light, wanna=want to, lemme=let me, u2=you too, b4=before. So, if someone wants to arrange a meeting and texts you the message 'icu 8' it won't mean the 8th intensive care unit!

Brief typed messages often fail to convey the spirit and tone of the author. So-called emoticons such as :) for a smile, ;) for a wink, and :(meaning unhappy quickly illustrate and enlighten the mood behind the message. In fact, icons have become integral navigation tools through cyberspace. The Net's taking us back to Babylon! What's particularly interesting is the *ad hoc* adoptions of such linguistic development, mirroring the evolutionary way formal language has been codified.

[198] *ibid*

[199] How widely has this phenomenon spread? Cultures such as Spanish and Japanese are already learning to overlook what they regard as the rudeness of such straight-to-the-point interchange.

Newsgroups provide another means of communication, but instead of one-to-one, this time it's one-to-many. They grew out of the BBS or BulletinBoard System which allowed early Net-heads a solely text-based display. Messages posted are available to be read by all those who subscribe to the group; you can download recent messages to your hard-drive.

Closed ISPs offer their own versions, but there's a huge alternative range available via your mail program. Newsgroups is a misleading word since they have nothing to do with the News industry. In fact, they're small online communities of people who share various interests. Joining is free to access literally hundreds of thousands of specialist topics from aardvarks to zygotes. Newsgroups can be social, business-related, fun or serious. They are a means of exchanging information with like-minded people, and so create virtual communities. Some are moderated, often by their progenitors to keep undercover marketing opportunists, spammers[200] and other unwelcome intruders at bay.

There is no imperative for any Newsgroup posting to be accurate, so if you're seeking information I don't recommend them as the sole source. That said, a group comprised for example of pet-owners and veterinary surgeons can provide invaluable information about keeping domestic animals. Where else could you discuss such obscure a passion as baseball trading cards with people all over the world?

We've already noted that eMail programs allow file attachments, but sending large files can be onerous both for sender and recipient. For one thing data compression and packet switching still are not perfect technologies. We've seen how meta-data can help track files which have gone astray. Data transfer is also affected by the amount of Net traffic at any one time. When large numbers of people log on, the burden can cripple host servers and those acting as staging posts. Low bandwidth and access speeds, too, affect eMail transmissions. It's frustrating indeed either to send or receive a large file attachment only for your computer to crash at the last hurdle.

Happily, there's another way. Not perfect, it does reduces the risk of data loss and corruption. It's called FTP or file transfer protocol. Because the data journey is more direct, with fewer if any intermediate server stages, the whole process is faster and safer.

FTP is used primarily for downloading large program files [such as games programs or business applications] from a central server, or by business for transferring multi-MegaByte files between their own servers. Mirror sites allow the same files to be stored at a series of servers. Anyone wishing to download files can choose the nearest server reducing transfer time.

[200] People who abuse free lists and groups by posting irrelevant commercial messages or otherwise subverting genuine discussions. Unmoderated groups usually self-police very effectively.

What about intranets and extranets? Think of websites as doorways. Some are always open, others need the right key. An intranet works in the same way as the larger Internet, but instead of being available to anyone, it's a closed system unlocked only by those with the correct password. The business world is the prime user of intranets. Sensitive company and pricing information can be posted online solely for those who need to know.

Extranet is primarily a marketing term for an intranet which transcends the borders of a particular company. Although the word is falling out of use, the facility is particularly handy for setting up online business-to-business transactions. For example if an assembly-plant consistently orders components from a manufacturer in another country, the shared extranet greatly reduces labour, communication and printing costs for both.

Here Be Dragons

Once you are online and wandering around the Web, how do you navigate between millions of sites? Even the most elegant port is wasted if you can't find it. The nearest we have to a cybermap, the Search Engine, is about as efficient as those flat-earth parchments with huge areas warning 'here be dragons.' The maths tell a sad tale: even the best engines such as the remarkable Google[201] only cover between 15-20% of available sites, yet over half of all visits originate from them.

Equipping Net visitors to use engines efficiently is one of the aspects least addressed both by trainers and websites wanting to increase traffic. There are some golden info nuggets out there including the BBC's Search Engine tips,[202] but people need telling and reminding!

Searches are powered by massive databases using algorithms and programming code [called spiders or worms] to retrieve information. So they're only as good as their coding and the quality of the user's input.

[201] http://www.google.com/
[202] http://www.bbc.co.uk/webwise/know/index.shtml/

I Want IT and I Want It Now

For most people online at the dawn of the 21st century, the Internet is a desk-bound experience. Whether at work or home, you sit in front of a monitor and type commands onto a keyboard which trigger the interactivity required for Net access. You request, it delivers, offering further options. You request again, it delivers offering further options. And so on until you terminate the session or it's broken, either by a computer crash or a server overload. But what if you want to go online when there's no computer around? In fact there are some extremely exciting IT developments which we'll detail in the next section. A wireless alternative is already available.

In response to the West's ever-increasing peripatetic lifestyle, and in conjunction with the proliferation of portable phones, the wireless Internet is now available through a handset combined with a built-in LCD screen. The internet protocol which allows such transmission is called Wireless Application Protocol [WAP].[203] By the end of 2000, various Internet-enabled portable telephones allowed online connections to search for certain kinds of information sometimes accompanied by small graphics; some even accommodated game-playing. These phones communicate with other portable devices such as personal digital assistants [PDAs][204] and short messaging service [SMS]-based pagers.
What they don't do, perhaps what they can't do in that form, is provide the total interactive Internet experience. It must be said, however, that wireless developments are in train to bring more of the Net more quickly and more clearly to those on the move. Mobile Net provision currently focuses on business and wagering. Constant access to share prices or sports results provides an edge over fellow travellers bereft of equipment.

Banking on the move can help take advantage of changing interest rates and allow bill-paying or money transfers from wherever you are. Early knowledge of share prices can make an important difference to profits. Wireless game-playing is not so urgent, though considering how lucrative the market is, it's no wonder that improvements to hardware and software tumble from company brochures almost on a daily basis. Enhanced micro-browsers. Secure download agents. Mobile Management Servers. Customisable ringing tones and tunes. Payment packages for downloading entertainment. Digital images to decorate display screens.

[203] Such phones can prove invaluable as when in February 2001 Rebeccca Fyfe, a passenger on a ship adrift in the Lombok Straits sent a text message to her boyfriend in the UK and a rescue was effected.
[204] Likened to the electronic version of the filofax.

Game friendly fold-out handsets offer a wider screen taking up half the instrument, the other half containing a keyboard. Some mobiles restrict Net access to the download of music files using MP3 compression. Shapes, too, are changing expanding the range to include elliptical sets nestled in one palm while instructions are keyed in with the other hand. It's easy to extrapolate the benefit of a voice activated Internet

showing space for image & input

Hands-free devices to accompany vehicle travel are also on the market and being refined. Prototypes are currently being tested enabling drivers to access GPS[205] information to help choose better routes and prepare for weather and road conditions.

Shorter range Internet phones are also available, acting in the same way as wireless handsets used exclusively in domestic or business premises, limited to a few hundred feet. Bluetooth and 802.11b protocols drive devices which operate on radio-wave connections. They can recognise each other and both transmit and receive data. An early problem has been they both use the same radio frequency, so simultaneous use causes data interference and corruption. Such teething troubles are being solved with the introduction of dual-mode platforms which support both protocols.

The news media reported that as of January 2001 a billion text messages are being sent every month. For those who believe all such communication is trivial, heed this: in January 2001, the Philippines, dubbed texting capital of the world, saw usage rocket to 70 million messages in one week as the population organised the street protests which ousted President Joseph Estrada.

Market analyst Gartner Group forecasts global sales of WAP-enabled handsets to reach 100 million by June 2001. Yet many early adopters of WAP technology report disappointment in the speed of access and clarity of display text and images, as well as restrictions on total Net availability.

[205] Global-positioning system

Japan has led the way in the development of mobile Net access, and has made available far more efficient receiving and input devices called I-mode phones which will soon reach the rest of the world.[206] NTT's DoCoMo[207] system is filling the Internet gap in a country which lags way behind the West in PC ownership. Its 12 million subscribers primarily use it for eMail and access to some 20,000 websites, but they miss out on streaming audio and video, high-quality sound and graphics, and of course the majority of sites on the Web. Programmers enjoy the system since it's easy to adapt existing web code, whereas WAP requires a new language. Such new devices deserve a name more descriptive than 'telephone' of their multi-functions. They've already engendered another Net protocol called General Packet Radio Service or GPRS.

The bandwidth for data transfer is increasing all the time, and it won't be long before we each enjoy a permanent connection to the Internet, assured of safe and speedy results. Mobile devices won't replace stationary ones but will co-exist with built-in compatibility, connecting wirelessly to each other and offering appropriate solutions to all our digital requirements. Such multi-functionality is what is meant by convergence technology.

We've already seen how various Internet usage ignores interactivity, concentrating on the means of delivery. Whatever it offers, both hardware manufacturers and software programmers, busily anticipating demand, need as many people as possible to have Net access to justify their massive investment. That's why many governments have funded projects to bring the Internet to every home. UK Prime Minister Tony Blair promises the whole country will be online by 2005. In Singapore the government handed out free Net-ready computers to every household.

Governments don't act so altruistically for no reason. They know that the very nature of employment and industry has shifted dramatically from the mechanical to the digital and the trend will not reverse. The entire labour market of the future depends on people being able to solve day-to-day problems in new ways.

We'll find out more about some of these integrated solutions in the next section. First I want to detail how the neonate Web industry has evolved, paying particular attention to working practices. It should be remembered that the industry has only been viable for less than ten years. You must compare its development on every level with any other new sector at that stage to appreciate how quickly society has responded to the digital revolution. But what a long way there is still to go before the industry can claim cohesion.

[206] Further information on the wireless Internet is publicly available from the US Security and Exchange Commission's Electronic Data Gathering Analysis and Retrieval system at http://www.sec.gov/
[207] Nippon Telegraph and Telephone; DoCoMo translates as "anywhere"

Worker Rights & Wrongs; Web Pros & Cons

Little did Tim Berners-Lee realise when he invented the World Wide Web that it would spawn such a thriving sector in Western economy, including multi-national companies dedicated to web production. When I first began working in the industry the Net was publicly perceived as a bit of a joke populated by geeks and freaks. Apart from a few visionary companies investing properly in eCommerce, most small and medium businesses [SMEs] either shied away in terror from going digital or rejected it outright on cost grounds. The media dismissed the Web with patronising smugness.

It wasn't until the end of 1997 that serious attention began to replace the jokes, probably because both business owners and politicians had finally understood how much potential revenue was at stake in the new economy. We've already seen how the offline software industry fed into the world of the Net. In turn the World Wide Web has attracted a bevy of allied service industries.

Much attention has been paid to those so-called dotcom companies which have cashed in on the Web, using websites as virtual shops; not enough has been said about the workforce which builds and maintains these cyber-stores. In this context I'm particularly interested in those professionals who construct websites rather than marketing experts who happen to work online. Because it's not often spoken of with any degree of honesty or knowledge, I'd like to concentrate on worst practice by all concerned, paying particular attention to corporate sites.

Most designers and programmers who construct professional websites are as talented and intelligent as any media workforce. The Web business has often been likened to the Gold Rush of the 1840s and 1890s, unregulated, exhilarating, and rewarding those who strayed into new territory with hard work and big bucks. Such pioneering spirit is predisposed toward profit, but it's sometimes at the expense of human dignity. Fraud was rampant then and it still is, on all sides. Back in 19th century California and Alaska men [and it was only men back then] from all walks of life, arrived to find their fortunes. Those self-made miners were so far away from the structures of society, they made their own rules.

Whether self-taught or professionally trained, those who make the web come alive are distanced not by miles, but by their very skills. Sadly their employers often take advantage of them with work practices all too reminiscent of that earlier century. And some take equal advantage of clients. The Industry has woven a tangled Web indeed, and all are responsible: bosses, workers and clients. Before the tangles can be smoothed, each strand must be examined.

Two types of web company have emerged: those with affiliations to other industries and those which have evolved from *ad hoc* freelance work. The latter usually start out as very small or micro-companies, consisting of one or two people with design and/or programming skills. Some are prepared, efficient and talented. Others have familiarised themselves with some basics and either by accident or design acquire clients whose knowledge and standards are even lower. Despite some helpful signposts in specialist magazines, so far no one's setting standards or judging impartially. Quality control is often cursory and itself unregulated.

Increasingly many younger people boast the ability to design for the web and write program code. Many are self-taught, though some take advantage of the still far from adequate training opportunities. There are, of course, valiant exceptions, but what most of them lack is work experience. Because they cannot sufficiently analyse the needs of potential clients, they simply don't know how to apply their skills to a commercial enterprise with its own agenda.[208] Many don't set out to deceive and are simply naïve; others learn to be more calculating.

It's rare that at this stage such variously skilled young people will ally themselves with others who have a better commercial overview and experience. Struggling to make sense of it all, they're unaware of legal obligations both to themselves and their clients. They're careless about the tenor of business relationships – unable to predict work schedules adequately, they promise what cannot be delivered. Nor do they understand how vital such timings are, especially for SMEs which operate on tight margins.

They often can't cope with simple transactions such as taking accurate telephone messages, and fail to document discussions for future reference. Sadly, what many want is to receive untraceable cash in return for what may or may not meet client requirements. And, since their measure of adequate recompense is based on a non-existent earnings history, they often attract clients by undercutting commercial rates. Others charge below the market as a first step in building their own business credibility, quickly acquiring a client list. Some even work for free until their track record justifies payment.

The knock-on effect of bad practice by such opportunists has already done much damage not only to unwary and gullible clients, but to the web industry as a whole. By far the most pervasive effect is unrealistic pricing expectations. If you're running a small business and all you know about the Net is that you'd better jump aboard for reasons of competitive advantage, you're ripe for exploitation.

Would you hire someone to build you a car just because they can change a tyre? Would you let someone re-design your kitchen who'd only read an interior decorating magazine? Somehow I think not! Yet many SMEs employ equally unprepared people to put them online.

[208] Good business practice for the industry has been included into the curriculum by such innovative academic institutions as University College London, whose Foundation Course in Digital Business is supplemented by a Students Business Club supporting entrepreneurial efforts.

Too many business people decide to contract the web company or freelancers who promise to build a site for the least money. Far too many award web work to their children, for understandable albeit misplaced reasons. They have little or no basis of comparison for either qualitative standards or market rates, nor a comprehensive means of assessing the business benefits of their site.

They're unaware that merely constructing a website takes no account of maintaining and updating it, introducing eCommerce elements, creating and uploading content, registration with search engines and other publicity initiatives, collection of usage statistics, indeed a whole range of allied business issues unlikely to be met either by the eager, well-meaning tyro or the con. Many SMEs become disillusioned with the Net based on the inadequate service they've received.

Web professionals, too, suffer from such bad practice. Their pricing policy is based on experience of the actual working time involved in delivering web solutions; then they're challenged by clients claiming they've been quoted much less. Larger webhouses may deal realistically with their clients, but many make outrageous demands on their workforce – not because the CEOs are sadists, but because in the early days everyone was learning on the job. And because of their origins.

Since the majority of business websites are still mistakenly considered as marketing exercises, no wonder so many are constructed by subsidiaries of advertising agencies. Heavily-funded new media divisions set up shop with household-name clients able to afford the finest designers and programmers.

Many such early webhouses modelled their administration structures on the advertising agencies which spawned them. Although money was on tap, where was the labour force for this new industry? Where were they to train? And were budgets going on a classy corporate face or actually being spent on the workforce?

Webhouses recruit from a variety of sources, some driven by standards of excellence, others by cheap labour. Though they're getting better, clients are still too easily manipulated into accepting outrageous production schedules and costs to compensate for a workforce with predictable inexperience. If neither the boss nor the programmer really knows how long a web element takes to build, how can the client receive an accurate prediction of budget and delivery time?

Partially due to the dominant economic climate in which the Net evolved and partly because of its unique nature, best working practice for the field had no precedence, and adoptions from other industries proved unrealistic. Management was often in the hands of equally inexperienced entrepreneurs with no real understanding of the level of skill required to produce effective webpages. Abuse of the labour force was rife in what remains a non-unionised and unregulated industry.[209]

Webhouses may convince clients to hire them because of the awards they've received from the industry. As we've already seen, though, many of the judges for such awards come from the sector which manufactures professional web software. The result is entrants [who have to pay large fees just to be considered] are evaluated on whether or not they've used that particular software. That greatly disadvantages smaller webbuilders who have perhaps provided more innovative design to offset their smaller budgets.

By mid-2001 the UK still has not been able to sustain an industry body to set and maintain standards. A significant number of webhouses have gone under, nor have the survivors necessarily learned lessons. For instance, to meet unrealistic client demands, it's common for web workers to put in 16-20 hour days with no overtime pay. Charge-out rates on their services far exceed individual pay to an extent not justified by employer overheads or premises designed to impress clients.

More enlightened bosses distribute performance-related bonuses or profit-shares. To attract talent, some contracts include generous share options. To compensate for long hours, some webhouses provide free dinners, taxis home, even on-site masseurs to help ease the pain. But since there's no regulation, there are no guarantees.

Most companies still operate on short-term contracts which offer no job security. You wouldn't expect a window cleaner to ascend a skyscraper tethered by string, and you wouldn't supply a heart surgeon with a blunt scalpel. Yet working conditions for webbuilders can be appalling, downright unsafe. Improper lighting, unergonomic desk design, inadequate seating all contribute to health and safety risks. The industry demands its own best practice to serve a labour force which spends the majority of time in front of a computer screen.

[209] In the UK bodies such as the BKSTS and SkillSet have tried to categorise web workers with definitions borrowed from the film and television industries, but since web teams are still evolving their own structures, these imposed parallels are of little help. Web producer, for instance, is a title variously awarded to programmers, senior designers, marketing managers, project managers, and in rare cases to someone with the creative input of a film director.

For instance, designers who do a lot of mouse work require support of the forearm if they are to avoid considerable nerve damage to the neck and shoulder area. Designers and programmers, too, need adjustable chairs and monitors to counteract neck strain which can result in serious damage in later life. That means adequate investment, yet many companies don't even supply wrist-rests. Employees don't complain because they're often too inexperienced to assess their own situation, there's little attraction in acting alone, and some perversely ignore such health risks in much the same way they ignore the documented consequences of smoking.

Unsurprisingly for an industry still defining itself, the constituency of the workforce supplying websites for business has little in common with any other. Of course there are some similarities. As with broadcasting and cinema before it, employers recruited staff from allied fields. When the early film-studios decided to contract a stable of writers, they turned to the theatre. When Webhouses needed digital designers they often recruited from the print and advertising world. To implement interactive database systems, programmers started adapting their offline codes. At the beginning, everyone was learning on the job. Given the almost daily rate of technological change, the learning curve remains steep.

One of the key lessons was the Internet requires different skills from any other medium. For example, ignorant of the fact that people don't read screens the way they read paper pages, many designers from the print world decide page layouts which alienate web-users rather than taking account of the medium.

Perhaps the most telling difference between web workers and others is that for the most part the most sophisticated skills reside in the very young. It may be what's so far allowed the kind of exploitation we've discussed, but I believe it is also what will change forever the way future business is conducted. Designers and programmers always face the trade-off.

FREELANCER	WEBHOUSE EMPLOYEE
Pros:	Pros:
➢ choosing jobs of interest	➢ relative job security
➢ setting your own rates [and hoping there'll be enough work to sustain you]	➢ no admin hassles
➢ making your own schedule	➢ working in a bigger team
➢ getting the kudos when the job's a success	➢ making contacts and forging alliances
Cons:	Cons:
➢ finding your own clients	➢ little or no choice of projects
➢ negotiating terms	➢ little say in how things are run
➢ paying taxes, bills, etc	➢ working terms and conditions open to abuse
➢ providing all your own equipment	➢ taking orders from management
➢ taking the flack when the job's a disaster	➢ clients who may not have a clue
	➢ the company comes first

The ease and appeal of any interactive element online is conversely proportional to the complexity of its programming. Whether for commercial, legal, or any other corporate application, the most sophisticated websites require topnotch programming skills. In the run-up to the millennium, many programmers were swept up on extremely high salaries to protect global systems.

Now there's a premium on those who can supply encryption against hackers and fraudsters. Larger companies also budget for reproducing their Net pages for other platforms such as WAP. No wonder some computer programming graduate students are earning more in their spare time than their professors.

Governments and industries which can afford to are staffing in-house IT departments.[210] That will never be an option for cash-starved smaller companies, just as they don't employ in-house caterers or car mechanics. I can't think of any other than the Web industry whose quintessential skillbase resides in the hands of those who have equal access to the means of production, distribution and exhibition as their potential employers.

This unique workforce is gradually learning it needn't work under exploitative conditions. Some are themselves becoming employers, hiring in vital management and marketing skills. The tables are turning. Though this is not the forum for a detailed economic analysis, I believe the impact will affect profoundly the market perception of dotcom companies and those who invest in them.

Online traders need the same standard of focus, structure and management as those offline. The whirlwind of impetuous investment based on a mis-perception of the market and a desire not to miss out is finally abating. But eBusinesses including 'clicks-and-mortar'[211] still do require investment. What's lacking is a far-sighted assessment of how the web can really work.

Certainly in the profit-driven West, far too few professional Net-folk acknowledge any responsibility to guide clients ignorant of website effectiveness. I'm convinced the problem pivots on whose agenda leads the process. Unless it's the user's agenda, vested interests both by client and web-builder fail to maximise any business site's potential. The Internet Experience is satisfied by three key elements, all requiring a synthesis of content and presentation.

> ➤ To find out stuff
> ➤ To be engaged
> ➤ To get stuff, usually for free

[210] Sadly, too many IT managers are given responsibility for company websites when they're inadequately prepared. This is because company executives confuse all things computer with Internet, and because those with IT skills don't want to admit their Net ignorance.
[211] Those supplementing offline trading with online options.

Leading with the User's Agenda means creatively incorporating at least two of these three elements. As we've already noted, SMEs cannot compete with multi-nationals on brand, so they must carve out niches as effective online as those they have offline. Nor can they depend on passing street trade.

Making a website 'sticky' is the most effective marketing tool available. Word spreads remarkably quickly online redefining the concept of People Power. Clearly it's a force that transcends trading.

Power to the Net People

Offline, we're constantly making judgements based on a variety of elements having little to do with the true value of what's on offer. For example, social experiments prove a person's appearance accounts for over 90% of how the content of their ideas is perceived. Culturally, we've learned to assess on irrelevant factors. The Net, however, concentrates on content. It's less easy to bamboozle on the basis of superficial appearance. That's an empowerment we haven't seen before on such a scale. We've entered the Age of the New Emperors, governed by the power of ideas.

At its best the Net can be a powerful communication tool for all, wherever they are, whatever their interests. It allocates everyone an equal voice, and in that context is the future of democracy. Threatening indeed for those who've assumed their ideas intrinsically merit more by virtue of their political, financial or social position!

In our fragmented world, the Net has the potential to unify any non-dictatorial political process. Since multi-nationals have amassed so much economic and political power unfettered by national boundaries, the Internet is proving a useful counter-tool of direct action. It has the power to address any popular dissatisfaction with socio-political abuses whether perpetrated by political representatives, enforcers, or corporations.

Acknowledging the power of the Net results in a dilemma for democratically elected governments. As voting numbers decline, governments of whatever hue continually need to justify their mandates. They spend money and effort to understand voter apathy, at the same time ignoring the impotence and irrelevance felt by growing numbers who mistrust the electoral process. It's no use mouthing platitudes about every vote counting when what people crave is for their own voices not merely to be aired on radio phone-ins, but to be heeded. They either want direct participation or for their representatives to subjugate personal ambition to the popular will. It raises profound questions of whether true democracy can exist in societies too unwieldy for meaningful debate and enactment.

Until the advent of the Net, the logistics of such a process were prohibitive. The prescription for democratic health has always been an informed, active electorate. Not long ago, the perception was that those running for office were *a priori* qualified and the best candidates. Today's greater freedom to access more and more information has revealed the feet of clay supporting yesterday's heroes. There's an increasing popular awareness of the global consequences of weaving both national and alliance policy strands of trade, agriculture, mineral wealth, military activity, and environmental control into the eco-political tapestry.

The growing incidence of direct action protest against such global policies indicates an awareness of the connection between real power structures and the public face of politics. That it's transcending so many national boundaries is almost entirely due to the Internet.

The phenomenon has created a new word, glocal. It incorporates a global perspective with local action, and it's made viable by the Net, which is used as a tool of information, dialogue exchange and organisation. This is direct democracy, and it's scaring the pants off governments.

Both Stand and FaxYourMP[212] have automated the process not only of discovering your MP [member of Parliament], but effectively lobbying them to register views on issues you care about. These sites, conceived and built by Tom Loosemoore, Stefan Magdalinski *et al* proved partially effective in forcing the UK government to amend the wording of their recent Regulation of Investigatory Powers Act, [which still puts an onerous burden on web-owners in a misguided attempt to crack-down on net-savvy criminals, and which we'll discuss more fully below]. UK Citizens Online Democracy supplies another site for information about eDemocracy and the chance to speak out.[213] There are inevitable snags.

Dr Janice Brodman of the US Education Development Center recently noted, "Despite much talk about expanding participation in decision-making, few international or national organizations are actually altering their decision-making processes to include input from those ordinarily outside the process." She was contributing to an unusual international debate entitled *Boosting the Net Economy 2000* which was conducted entirely online over five days in April 2000.[214]

[212] http://www.stand.org.uk and http://www.FaxYourMP.com/

[213] http://stingray.ivision.co.uk/

[214] I had the great privilege to be invited to participate in this stimulating ThinkTank designed, managed and hosted by new media publishers HeadStar http://www.headstar.com/ and sponsored by the Bull Group. Participants from over 40 countries represented governments, NGOs, The UN, multi-nationals, charities, educational institutions, charities, and trade organisations. The debate archive is at http://www.netecon2000.com/ and its BT-sponsored follow-up was held in March 2001.

Dr Stephen Coleman[215] of The Hansard Society emphasised that any effective change must be "conducted by trusted bodies," noting instead of vested-interest government and industry initiatives, "we need more and bigger independent bodies charged with enabling and resourcing civil society."

Representative democracy evolved to maintain a semblance of participation for larger and larger constituencies. As society splinters, fewer people feel their representatives actually represent them. Mainstream parties campaign on policies which are little more than broad-based mom and apple pie slogans. Special interest groups focus on issues that fail to address the wider political agendas required for government.

In recent years we've seen the beginnings of eDemocracy which, like any unformed neonate, is still discovering itself. Nations are finding different ways to address the role the Internet can and will play in the political process. Discussions range from defining the optimal infrastructure for dialogue in a virtual context, to issues of social inclusion for the physically and economically disadvantaged, to changing the way representatives account to the electorate.

Predictably, most government webpages are information resources, the we-tell-you syndrome again. Agencies such as the UK's Hansard Society are encouraging debate about how democracy must evolve.

Dr Coleman graciously agreed to an interview for this book. We discussed the nature of interactive democracy and the fact that most existing online resources make no effort to encourage a meaningful dialogue between representatives and the electorate. We also touched on the imperative to make transparent the identity of anyone contributing to such electronic dialogue using digital signatures, and the danger that any online public contribution would be regarded as a kind of electronic Hyde Park Corner, where anyone can say anything but no-one takes any real notice.

Coleman explained the Society's role vis-à-vis government policy, particularly in dealing with issues of eDemocracy and inventive ways to use new technology to achieve the Society's goals. "The Hansard Society is not a political pressure group or reform organisation, but exists to promote more effective representative democracy. The three main party leaders serve as its vice-presidents, so it is non-party political, and it does carry weight within Parliament.

[215] Coleman is Director of Studies at the Hansard Society and heads the Society's Media and Parliament Research Program. He also teaches at the London School of Economics and has written and edited several articles and books, the most recently published being *Electronic Media, Parliament and the People*, *Televised Election Debates* and *Parliament in the Age of the Internet*. http://www.hansardsociety.org.uk/

"It informs the public about what Parliament is doing and informs Parliament about what the public is thinking. Our view of representative democracy is that it exists. We want it to be more effective and believe technology *can* help. I'm not actually interested in the technology for its own sake, but I believe it's a facilitator. For me Internet technology is analogous to the rise of print.

"If we analyse representation in a political sense, there's a recognition that people simply can't make all decisions on their own. In addition, there are problems of complexity of issues and policies. And this is increasing. There is, of course, a danger of having a one-legged theory of representation. Its two legs are voting and deliberation. The UK has done pretty well with voting; it's a hallmark of democracy.

"But we haven't really started with deliberation. We're hovering on the boundaries of feudalism with that one. The media has taken that role, and they're usually pretty patronising. At their worst they produce commercialised trash. And they're *not* hugely representative. So we have the problem of a gap in the media system with no accountable communication, and it's not actually based on an imperative to have people deliberate and become informed.

"Because we've produced a system that's good at throwing out politicians via regular elections, we've landed ourselves with a twisted democracy. And we're not good at considered reasons for views or actions. Our system is not based on an intelligent mandate, which must be part of the voting system. That mandate needs to be nourished. I think technology can help with this. We've advised government to establish an interactive dialogue."

The Society launched UKOnline which defines 15 life stages affecting eGovernment. It's been adopted by the Blair administration, but as Coleman explains that's not where it ends. "eGovernment is essentially authoritarian. It advises about the *status quo*. We need to add-on eDemocracy so it's not just a government transaction. Not that many people currently in government know how to do this, but they do know whom to ask. The Hansard Society is one of these contacts.

"eDemocracy must be central to people's lives and therefore it must be properly resourced, it must create trust [if people see their contributions are disappearing into some fog, they won't come back again], and it must be structured.

"Debate is at the heart of it, and we just don't have a debating culture. The cut and thrust of debate is available within public schools and Oxbridge, but that's it. We *did* have it in the trade unions, but no longer. It's become atrophied. Research conducted by Ivor Crewe discovered that families which don't instil a culture of discussing issues result in less interest in politics in later life.

"We've just introduced citizenship into the curriculum, and some of this will occur online. But we must be careful about attributing all delay with these issues to government. Some local authorities are all for it, but others are blocking. Actually all institutions are deeply conservative and self-protective. It's true, more and more local transactions don't actually need government. We should interact more with like-minded communities."

While recognising the importance of verification for online voting and consultation, The Hansard Society is well aware of how complex any encryption solutions must be. "There's a major drawback," explains Coleman. "The flipside of any identification policy is the security danger to civil liberties.

"People will have to make a choice. And if enough people say no to identity cards or digital signatures or whatever, they can't be imposed. "I believe this is a reasonable concern for people. I think the way it will develop is offering people more government transactions, for example the ability to pay tax online. Then you'll need more online security via registration. So it becomes a need-driven initiative. The alternative is to say everyone must do it, and that's more difficult.

"In some respects eCommerce can familiarise people with methods of online security. Which in some ways is antithetical to eDemocracy. But if enough people need some form of electronic I.D. before they can shop, then there's a psychological carry-over to ceding personal information for the purposes of eDemocracy."

The logical future of such participation is more and more dialogue between the electorate and their representatives. Politicians, historically more concerned with the short-term, will probably be most interested in the process in the run-up to elections. However the Net is used for eDemocracy, preparing the electorate needs to take account of a range of issues from assuring adequate funding through alerting Ministers to a potential avalanche of electronic correspondents who will demand non-formula responses.

Coleman feels "the answer is to encourage new skills. On a political level, online debates need moderation and moderators must be trained. Society must learn the art of deliberation. On a technological level, there's a need to design new interfaces. No one yet has invented really good discussion software. So far there hasn't been any proactive initiative to broker dialogue between politicians and technologists. In terms of joined-up government – it's not very!

"There's not sufficiently connected thinking between people who design and people who program. I would like to see the setting up of a real institution for developing online discussion. Designers, social scientists *et al*. I don't think the concept of interactivity is such a problem for people in power. And things have changed recently behind the scenes. In a year or so we'll see the results of how the big suits have thought through what's needed for the next election."

As more and more people realise how easily they can communicate directly with government, does Coleman think the society will edge toward more direct democracy, and would that threaten the fabric of a representative system at either national or local level?

"Direct democracy is certainly appropriate at certain levels, and the alternative is nothing. A sink or swim mentality. But, no, we're not on the verge of direct democracy. eVoting isn't just around the corner, and it's far less important at government level than a strong, informed mandate. It's different at local level, where we need strong communities. And that may result in more direct democracy."

Britain lags behind America and such European countries as Finland and Switzerland in providing interactive sites with local and macro socio-political focus. The US traditionally values States and local rights issues within the wider context of a national agenda. In 2000 the US government created a 'one-stop gov shop' amalgamating all online manifestations of public information. Less attention is paid to interactivity. The Swiss eGov site addresses Dr Coleman's concerns about the importance of "deliberation" before eVoting. http://www.egov.ch/ is used by the Federal Department of Foreign Affairs and the Department of Economics for public discussion boards about such issues as bilateral contracts with the European Union. The Swiss Parliament also voted to establish it-forum-ch as "an interface between parliament, administration and business."

The UK has followed suit with various initiatives, including a free-registration site called YouGov [http://www.yougov.com/] which not only provides information and a forum to express personal views, but solicits online polling on a variety of political and social issues. They're also linked with a People's Parliament.

It's not that big a leap from online referenda to full-blown virtual elections. If online voting is to catch on, however, it will depend, as offline voting does, on an electorate not only provided with an independent range of views but with the motivation to assess issues objectively. As a political tool for local enfranchisement and at least the perception of popular involvement, the Net is the most effective. It would be premature to predict the total demise of local government, but surely its role and structure beg to be redefined.

Perhaps one of the most effective online consultations was mounted by the Hansard Society for residents and ex-residents of a women's aid refuge. They debated various aspects of domestic violence for a Parliamentary Working Group, setting their agenda and contributing in a completely unthreatening environment.

But as Marion Scott of Women Connect noted in the *Boosting the Net Economy* debate,[216] "Now they want to know what will become of their testimony – the challenge to politicians." The British power-base is more reluctant to concede such changes at any level. As implied above by Coleman their favoured weapon is delay wearing the guise of further investigation.

[216] *op cit*

However, since the business community has convinced politicians from all parties of the urgency to address Internet issues, and since Prime Minister Tony Blair declared an intention to modernise government, he created the post of eEnvoy. Its first appointee was Alex Allan,[217] who generously agreed to be interviewed for this book.

Allan explains the post as "a need to coordinate what was happening across the whole agenda of eGovernment, covering eCommerce, helping to get the market right, seeing what business needs, helping people get online, making sure people have the skills, getting government itself online."

To this end the British government has made particular progress in the areas of employment and taxation. There's an employment service target for all job vacancies going online by the end of 2001, and equipping 1,000 of the nation's Jobcentres with interactive kiosks. Meanwhile the Treasury has established the Electronic Commerce Consultation Forum, described by Stephen Timms, Financial Secretary to the Treasury, at the OECD's Forum 2000.

It will enable "tax officials to meet with business representatives. Clearly it is in the interests of all of us that we exploit to the full the advantages that developments in technology offer and that we successfully deal with the challenges. And we can only really do this in partnership – a partnership of governments and businesses from around the world."

Allan recognises that despite differing political systems, it's important for friendly governments to exchange views on the implementation of eGovernment. "I think all governments are working in this area, and there's quite a lot of interest in sharing ideas." Indeed Allan has travelled widely, in dialogue with the US Federal administration, the Governor of California, and other world leaders in Australia, France, and Norway, among others. "So there are lots of contacts going on, because of course the issues are similar."[218]

Predictably eGovernment tends to prioritise economic matters, but Allan is in no doubt about an increasing role for eDemocracy. He thinks it's "an important component because it's not one just for government. Under our constitution, obviously Parliament plays a big role. There's local government, and there are all sorts of other bodies. But certainly we're actively involved in thinking about that: ranging from what can we do to make voter registration easier, right through to what we do to get MPs online, what we do about online voting, etc."

[217] Allan had previously held posts as British High Commissioner to Australia and Principal Private Secretary to the Prime Minister. Sadly for family reasons, Allan had to step down from his eEnvoy role in October 2000, when Andrew Pinder was named Acting eEnvoy. Pinder, a former director of IT at the Inland Revenue was permanently appointed to the post on 31 Jan 2001.

[218] http://www.e-democracy.org/intl/ supplies documents addressing international coordination of various electronic democracy initiatives. Meanwhile, UK plans to take a lead in eCommerce are behind schedule at least partially due to the lack of international agreements, according to a report by the eMinister Patricia Hewitt in July 2000.

He's equally convinced of the impact at more local levels. "We're working very closely with local government bodies [and] associations. I think one of the great strengths of the Internet is that it can pick up what's happening at local level, and give it a say on a much wider stage. One of the key tests is how can we nurture that without getting overwhelmed by volumes of information. Really tap into a lot of the good stuff that's happening locally, and really take that forward, both at a national and a local level."

One innovative UK deliberation initiative was launched in August 2000 as a pilot scheme called ePetitioner. Following on from its trial phase already in place with the Scottish Parliament in association with the International Teledemocracy Centre at Edinburgh's Napier University, the scheme allows people to sign petitions online, countering security fears with periodic postcode, address and other spot checks. It's proving an asset to high quality debate, primarily about local issues.

Allan trusts that the growing number of domestic Net users will trigger its own impetus to a provision of greater individual participation in all areas of life. He implies that the market will sort out the details, though he's aware that Government needs to address those who can't gain Net access for whatever reason, and provide funding.

"We are spending money, for example, in setting up IT and UKOnline Centres in Community Centres or whatever. People are putting in bids to set up these access centres, whether in libraries or wherever. Sometimes the bids are from Councils or Community groups. We're really looking at what works best in a particular locality. That may vary between a rural area, an inner city area. So that's an area where there will be money spent. Some of the other things may be more in the area of encouraging the roll-out of digital television, which may be an important way that people get online."

I must declare a personal prejudice here about the way such hardware is being marketed. To a largely uneducated public afraid of nerdy computers, digital television beckons the UK, promising a cosier Internet delivered through the TV screen.

I just don't believe you can fold telly into the Web like eggs into custard. As of mid-2001 Web TV picture reception is inferior, input devices extremely limited, there's no global standard. And the fact that most widely available TV Net ports are trading-related limits access to the wider scope of the Net.

Though he agrees, Allan wisely takes a longer-term view. "I think what we'll end up seeing is a variety of different devices for accessing the Internet for different things. For example, devices that bring people the information they need on the move. Clearly as we move to broadband there'll be the facility for much more content, streamed video and that sort of thing, where television may indeed be the obvious way to receive that. Also, I suspect people are going to come along with better and better devices, and better physical means of controlling them.

"I recently saw a demonstration of the OnDigital[219] set-top box and I was very impressed at the way it rendered ordinary standard webpages. And I think in time there'll be others similarly tailored for television. We may well see the whole concept that information is stored somewhere and front-ends pushing out content suitable for display on PDAs, phones, televisions, computers, almost anything – fridge doors, whatever it is.

"I don't think anyone at the moment would buy a digital television purely to get on the Internet. But if they get it along with the whole package, it can be a very cost-effective way of getting online which they wouldn't otherwise have."

Our discussion moved to what role Government should play in increasing use of the Internet by business. One of the most obvious differences afforded by Net trading is summed up by the dictum "No one knows how big you are online." Hitherto, most national policy regarding trade and industry has concentrated on companies of substantial size.

Even the SME acronym defines small business as those employing hundreds of people. Of course, there have always been viable sole traders or companies which employ just a few people. But their wider market success has been determined by their willingness to grow, even if that implied eventual take-over. The definition of business health is traditionally linked with its attraction to investors.

The Internet is redefining the rules, spawning a new category called the micro-business. Annual turnovers can rival much larger offline competitors since virtual trading requires very different and more cost-effective structures of the workforce, premises, and marketing. There's confusion, too, among the investment community which often bases new-economy company growth predictions on old-economy stratagems. Unsurprisingly a new breed of investors is moving in.

Allan feels the government does have a role to play in this area. He recognises that micro-businesses will benefit from the Net, primarily because there's less emphasis on brand in a medium which provides quick and easy shopping comparisons. He acknowledges the dangers, too, noting it's a matter of balance.

[219] With 1.087 million subscribers as of 1st quarter 2001, OnDigital take-up was never going to reach its 2002 target of 2million. In April 2001, independent television partners Carlton and Granada [joint owners of OnDigital] renamed it ITV Digital, retaining existing chief executive Stuart Prebble. Company spin claimed that the new name lent greater coherence to the brand for potential subscribers, but more objective analyses saw the change as a ploy to reverse the trend of OnDigital's 22% cancellation rate. Take-up targets were reduced to 1.7 million by 2003/4, marked as the year the company will break even.

"The DTI's new Small Business Service has actually changed the focus from Small-to-Medium to Small-to-Micro. Recently I visited a company in the East Midlands, literally a husband-and-wife business. It was quite an eye-opener seeing the kinds of issues they were facing, and I think we do have to find ways to address those issues, see what we can do to help.

"If people are seriously being ripped off then there are standards of fair trading, if there's a real scam. If it's an issue of people not being given the best advice – well, we don't want to get into issuing government licenses for every business and everyone providing advice. Basically the Small Business Service is there to put people in touch with others who can help them. The best recommendation is normally to find one business recommending what's worked for them to another business.

"Of course trade associations can help. I do think there is an issue here. Smaller businesses need to feel they can get the best advice. I think the new Small Business Service will have a part to play."

Allan's overall approach as a coordinator is to assure that various agendas are being addressed rather than providing solutions all tied up with ribbon. Nor is he convinced it's the role of government to become too hands on in any one area. He does admit, though, that the focus has been stronger on commerce issues than, say, cultural ones.

"There have to be limits about what it's sensible for the government to do. Government has a role in setting a framework, creating conditions in which all these initiatives can thrive. But they're not going to thrive because the government takes active control. They're going to thrive because individual people see opportunities, grab them, and run with them. And find their own ways, maybe totally unexpected ways."

He predicts more government attention to areas apart from trade and industry. "I think you will see more of that as we get into it more. The Department of Education and Employment are rolling out access centres. That initiative will be backed with something that is more broad-based in terms of encouraging people about what's in it for them, various other possibilities. Obviously the more commercial message is drummed in by the commercial sector, but I think you will see it changing."

In terms of social inclusion and online accessibility Allan proudly points to the guidelines which have been implemented on all UK government websites so that those, for example, with physical disabilities can take advantage of the Net. "In part," he says, "it's leading by example, rather than mandating."

He's more cautious when it comes to predicting the future, though convinced government will play a role. "We're working at different levels. At quite a high level we're producing a communications web paper for autumn 2000 particularly focusing on regulations, and how that will change with convergence, the implications for broadcasting, regulation of service, content and so on.

"At other levels I think the government needs to be flexible. Clearly, these technologies are changing very fast and not ones in which anyone can even see a broad trend. You'd have to be very brave to say exactly what it will be like in a year's time, let alone 4 or 5 years. So we need to have our eye on what's coming, trying to think ahead in terms of setting up structures, rules, whatever, that are flexible enough to cope. Trying not to get too bogged down with anything that's too technology-specific."

Securing The Net

Ever since our species proliferated throughout the globe, maintaining personal space has become sacrosanct. Whether it's manifested in a bedsit, a corporation, or the world inside your head, threaten it at your peril. Most animals develop biological, behavioural, or mechanical methods to protect what's precious. Predators abound.

In the offline commercial arena, security is breached all the time, and customers end up paying for the loss. When you're solicited to sign-up for a credit card, no one tells you that the interest rate reflects the level of annual fraud. Nor does the supermarket shelf price declare how much you're subsidising merchandise pilfering. Yet we hear endlessly about the insecurity of online transactions, as though thieves and fraudsters only existed in cyberspace.

The very essence of the Internet arose from a need for more secure protection and transmission of vital data. Coding and encryption are integral to its function. So it's ironic that most industry surveys analysing online behaviour identify issues of trust and security as primary barriers to increased usage.

An entire auxiliary industry has emerged to address these issues, headed by software companies employing some of the most sophisticated programmers in the world. They use the survey statistics to market systems ever-more impenetrable to hackers and criminals. Then the seesaw begins.

Regulators react with even more onerous demands on ISPs and website owners to allow transparency for reasons of crime detection and the woollier area of surveillance. Hackers home-in on uncrackable systems for the sheer challenge of infiltration prompting the development of even newer software. If it weren't so serious, you could probably turn it into a computer game.

Users, however, rarely distinguish between providing personal data online for registration designed to protect them and the site-providers, or for marketing exploitation, even fraud. Particularly in privacy-valued Britain, there's a suspicion that any such information may be monitored by government, business, or whomever for sinister purposes. We're left with the current dichotomy between greater transparency in public life, more secure protection of sensitive personal and commercial information, and abuse of civil liberties.

Part of the suspicion results from misunderstanding exactly what can be extrapolated by the program code which drives any interactive system. Users are baffled by claims that websites 'know' how you got to them, and where you're going when you leave. They mistakenly assume that if a website can be so smart, it can invade their computer and monitor every aspect of their lives.

Now I ain't gonna lie to you – there are extraordinarily sophisticated programs and devices on the market, online rivals of the apparatus used by Gene Hackman's character in *The Conversation*, Francis Ford Coppola's 1974 intriguing film about surveillance. That's how government, big business, and cybercriminals both protect and ferret out sensitive data, whether for purposes of maintaining law and order, gaining commercial advantage, or perpetrating major fraud. Not for ordinary use.

More conventional encryption systems are built into most eCommerce transactions. Increasingly you're given security options on eMail software. Of course, if you and I know about them, they're long obsolete in the stratosphere of high-level security software! They do, however, provide a degree of safety for all.

Most data-protection software depends on key encryption, the 'key' being a long series of ciphers, far too long for anyone to commit to memory. To transfer key-encrypted data, both sender and recipient must possess copies of the key to 'unlock' the code into a readable form. There are two types, symmetric and asymmetric. Symmetric keys require both parties to have the same key; asymmetric encoding is more flexible, providing each user with a pair of keys, one private, the other public. Data is encoded using a public key, which can even be built into a word processing package. At the other end, however, it can only be decrypted by someone with the appropriate private key. This too can be automated.

In other words, it's the software which encodes and interprets.[220] Think of a combination lock. Left-right-left combinations are relatively easy to crack; more sophisticated codes take much longer. Electronic locks and keys have a huge advantage, since not only can the length of coding be increased, it can automatically be randomised.

Obviously the length and randomness of the key ensures its effectiveness. The more complex it is, the more robust will it be against a hacker, who may be a kid fooling around in another country, or a global criminal intelligence agency. Assuming a truly robust system, the global agency uses the most sophisticated electronic processors costing millions to crack codes in hours or minutes, while the young genius, however dedicated, needs to devote years.

[220] While more sophisticated in the algorithms which determine the coding properties, this principle owes everything to those WWII devices of Turing, Flowers, Scherbius *et al*. As Tunny proved, merely knowing how something works doesn't necessarily mean you can crack into it.

There are still a couple of obvious snags. First, any system, however secure is only as safe as the people who operate it. It wouldn't matter that you live in a bomb-proof bunker – if you don't lock the door anyone can walk in. Then there's the question: how does the computer know that if you send me an encoded message and I decrypt it, that I'm really me? That my computer and I have not been taken hostage by someone you really didn't want to see that information?

Come to that, how do I know that you're really you and are sending me the genuine stuff?! Even digital signatures can only verify the validity of a document. They have no way of assuring the intentions either of sender or receiver.

Perhaps most worrying of all to regulators and legislators is an entirely different method of data transfer. [You didn't think information security still relied on WWII technology, did you?] Steganography is used by criminals, big business, and the military which calls it TransSec or Transmission Security. Instead of relying on traceable cryptographic keys, it hides the very fact of the secret communication, burying it 'inside' an innocent-looking chunk of data.

Those who know call it both "a science and an art." To work, steganography hitches a ride on the inevitable 'noise' which accompanies any kind of electronic transmission. Sophisticated steganographers are expert at fitting the hidden transmission precisely into the patterning of the 'noise.' It's a bit like dubbing a voice over lip movements. If you're accurate enough, you can appear to make someone say something entirely different from their original words.

Security software companies know such problems won't go away. So do legislators, despite the fact they're passing laws which totally ignore the latest transmission/retrieval systems. But there's corporate resistance against what would truly be more effective: highly sophisticated real-time network monitoring which costs big bucks and requires proper training time. Without it, as the well-publicised hack into Microsoft showed in 2000, even major players are vulnerable. Despite all that, it's actually safer to tap in your credit card number online than to hand it to a sales assistant or recite it over the phone. Current levels of encryption at least provide traceable electronic layers between buyer and seller.

As some assurance to the average Net user, I'm comforted by the theory that the global agencies wouldn't be interested in anything I have on my hard drive, and the hacker seeking a challenge would prefer to penetrate the Pentagon rather than my paltry bank account.

If you're not happy providing any information required of you by a website, or it's not providing proper assurances to you, leave! Go somewhere else. Make sure you understand exactly what it is you're buying, exactly how much you're paying for it, what you're being asked to divulge to get it, when you can reasonably expect it delivered, and whom you can contact if things go wrong. You have the power.

Until everyone feels cyber-safe the Net will be hampered from fulfilling its potential in commercial and information arenas. And that's just bad business for all those companies and organisations which have banked on a digital future. They must take more responsibility, not just in protecting themselves, but in reassuring their web guests. So how will the Net array itself to appear more user-friendly, cosier, more like a pal?

True, brand names have been an identifiable measure of offline success, and no one can deny the continued lure of familiar labels on wearables, eatables, and playables. But the rules are changing. Brand loyalty hasn't really replaced wartime devotion to king and country! So if you can't assume what's on offer behind an unfamiliar logo, how do you decide to put your money into their pocket?

In the late 60s there was a joke going around New York [used to more formal supermarket names] about the West Coast chain Ralphs. People found it funny because it seemed to imply a less serious and therefore less trustworthy commercial operation. Would you, the joke asked, bank at Joe's?

Popular cyber-banks called Egg and Smile now offer a trendy young image along with financial packages. You're nobody's fool when you consult The Motley Fool for investment advice. The Net not only reflects a more casual and wry approach to life in general, those who trade online are finding that catchy, memorable, even surprising names attract attention, competing aggressively with offline providers of a variety of goods and services. Which may be a generational thing, along with 'dress-down Friday.' It's no guarantee against failure, of course. Click Mango, for example, had to put the virtual boards up on its cyber-health portal, but that may have been due to its flagrant cynical marketing hiding behind a 'good for you' image.

Business is learning to its cost that web-users are not buyers first and foremost, and they're a pretty canny lot. Treat them like guests and partners and never underestimate them. That follows-through to the tone of any editorial content. No-one trusts you if they think your entire focus is on their wallet. Slowly, eTraders are starting to provide reassurance by being transparent.

Golden web-trade rules: Be clear about the level of security you're providing. Assure people you will only use the data requested for the purpose stated, nor will you ever make it available to any third party without the user's express consent. Opt ins are friendlier than opt outs. Provide clear, easily accessible Terms and Conditions, and, if possible, make purchases possible only after buyers have read and agreed. Make sure such Terms contain liabilities and warranties of the seller as well as the buyer. Provide a back-out option before the final purchase.

Probably the most important to give people peace of mind: have a last-resort point of contact in case things go wrong and act quickly on complaints. Ideally, this should be an informed human being capable of more than merely listening, and not an automated eMail or phone or online FAQ[221] page. Additionally, there are local trading schemes which award the display of security logos, such as the UK's Consumer Association's imprimateur. Be creative, too. Offer visitors a chance to trade knowledge about your goods and services, praise you, slag you off. Don't take yourself so seriously – when brain surgeons crack jokes during an operation, it doesn't mean they're not excellent doctors. In short, give web-guests an Experience. Your site should be somewhere they want to be, feel safe, and want to visit again.

Meanwhile, governments continue to address online security in a number of ways, some more enlightened than others. Early in 2000 the US Federal Trade Commission set in train its Advisory Committee on Online Access and Security, comprised of household corporate names, security, advocacy, and eCommerce experts, and responsible for presenting fully documented and budgeted reports on security options online. Such diverse vested interests make universal law tricky.

In April 2001, Detective Chief Superintendent Len Hynds from the UKs National Crime Squad was appointed Head of a new National High-Tech Crime Unit. Said to represent "a major component of a national strategy that calls for integrated partnerships between Government, Industry, Police Forces and other Law Enforcement agencies," the Unit will combine criminal intelligence with investigation, technical support, and policy assessment and development. It will be responsible for "investigating the most serious and organised hi-tech crime offences, ranging from attacks on national infrastructure and networks to the more traditional crimes that have moved to the eWorld."

Hynds will oversee both Investigators seconded to the National Crime Squad and Intelligence operatives with the National Criminal Intelligence Service. The relatively low starting salary of £22K suggests they'll attract more junior staff who may have both the interest and necessary qualifications for the 3-5 year term of the contract, but who could lack some life experience.

The Unit is legitimised by the Regulation of Investigatory Powers Act [RIP], referred to above. Its rushed passage and ultimate adoption as law reflects the very dilemma with which this section began. This isn't the platform for a detailed analysis, but a full explanation is available on the websites for Stand and FaxYourMP.[222]

Briefly RIP requires key escrow encryption both to protect Net transmissions against fraud and to allow the High-Tech Crime Unit to swoop on the bad guys. Escrow in this case implies that encryption keys be lodged with third parties and handed over to the law on demand. Failure to comply can result in instant arrest with no appeal. The government softened some of the more draconian wording after lobbying by business interests, but it's by no means a satisfactory or long-term solution.

[221] Frequently Asked Questions
[222] *op cit*

The problem is the ease with which technologically expert criminals can subvert the rules, leaving open to abuse the prosecution of innocent albeit careless or ignorant people. Also, since the Act can only impinge on data stored within the UK, various companies and organisations have already taken advantage of free hosting outside its boundaries offered by such as Freedrive.com, not because they're corrupt, but because they don't ever want their private matters to be subject to less than perfect legal scrutiny.

No one wants to promote fraud. But legislation of this kind not only fails to prevent it or its detection, it potentially threatens civil liberties. Burden of proof offline is the responsibility of the prosecution. Why should it be different online?

A brief comment about viruses. Yes, they exist. Yes, you can protect your system. Yes, you need to be vigilant.[223] The word virus derives from the Latin for poison and is aptly applied to infiltration and corruption of computer programs because they mirror biological viruses in certain key ways. Viruses which cause illness and disease cannot reproduce on their own. They contain partial genetic coding [DNA or RNA, but not both]. Each virus is shaped differently to attach itself onto healthy plant or animal cells and merge with their genetic information. The mutated cells then replicate throughout the organism, causing illness even death.

Similarly, computer viruses, which are written in programming code, need to invade the command files of a computer application such as a word-processing or eMail program, or even tip-toe into the top-level command of the computer itself. Some computer viruses are benign, sitting quietly in the system, perhaps bringing up a harmless message on the screen at a certain time. Some pretend to be destructive, issuing warnings of doom and destruction which never materialise but are very disturbing. Fewer still can cause systems to malfunction or stop running altogether. Viruses spread from computer to computer by sharing or downloading files. Strictly speaking so-called trojan horse programmes are not viruses; you install a program for one purpose, but it actually does something else.

Computer programs can't become infected by themselves. Viruses are written by people, the majority by very net-savvy young people who regard spreading real or mock destruction as a practical joke or badge of honour among their peers. Not usually driven by greed, they climb the virus mountain because it's there. Many security-software companies send representatives to hacker conferences and gatherings to recruit such programmers as soldiers in the battle against cyber-fraud.

I don't want to deal here with the protection of complex corporate systems. Individual users can take advantage of several cyber-condoms. It's wise to accept eMail only from those you know, but it's eMail attachments which require vigilance. Data files with the extensions .txt or .doc or .jpg cannot carry instructions and are safe. But if you receive an attachment of a command file, one which issues instructions, never double click it unless you are totally sure of its origins. It will have an extension such as .exe or .com or .vbs.

[223] http://www.cai.com/virusinfo/virusalert.htm/ is an excellent virus information resource.

Of course you can buy software only from big brand-name companies, and never download anything from the Net, but that's a bit like going on vacation to far-flung climes and only eating food you've brought with you. You may avoid a tummy-ache but you might as well have stayed at home!

Alternatively, you can install virus-protection software, which will generally filter out what's unwanted. But … [You knew there'd be a but, didn't you?] First, you must remember to upgrade the program regularly, since new viruses are being detected all the time. Most anti-virus programs offer one or more free upgrades. Second, no anti-virus program is perfect. They can give false-positive reports of viral infection, though none of the standard options should fail to notice a real invasion. Third, no software program can protect you against something that you may diagnose as a virus but which is, for example, a temporary glitch in your computer's operating system causing various software programs to behave strangely.

All this may seem overwhelming to the uninitiated. But liken it to the first time you heard a rattle in your car engine and assumed it would blow up. Though possibly a warning of something dire, most of the time a trip to the mechanic will sort it out.

As the Internet becomes an evermore integral part of all our lives, it's no wonder there's a lot of mis- and dis-information flying around. Vested-interest groups with little knowledge of the mechanism of data transfer and detection advocate impractical regulatory solutions. One of the most potent arenas of discussion revolves around the protection of children from online sexual predators. In the domestic context of Net security, as indicated above, there already exist numerous electronic filtering devices. I contend the most important allied action involves training and dissemination, and that transcends issues of security.

For many the whole Internet thing is like providing everyone with cars in a society where no one has learned how to drive. People may somehow manage to get where they're going, but at the cost of many accidents and damage. A coordinated approach is needed. Local government can fund, partner, and coordinate projects to raise the skillbase of current and potential Net users. Community groups can work with schools and industry to provide outreach solutions to the disenfranchised.

Slipping Through the Net

Governments and business have a vested interest in extending Net usage to as many people as possible. But not everyone agrees that empowering women, racial minorities, or the poor is *a priori* a good thing. Many sectors of society fear being left out in the cold while everyone else basks on the Costa del Internet.

Predictably, the biggest prohibition is financial. Though hardware and connection costs drop daily, the initial investment is substantial to those on low incomes, whose normal spending decisions are between staying warm or eating supper. But you don't have to own a computer to go online. Internet cafés and public-access points offer you the Net in the way a phone-box allows you to telephone whether or not you're connected at home.

Happily, more enlightened governments, both national and local, sometimes in partnership with industry, are putting in place Net-enabled access points. I've been on the lookout since the mid-1990s for Internet terminals in public phone boxes. Finally at the start of 2001 BT announced a 5-month free access using Multi-phone touch screens mounted in selected shopping centres, train stations, airports, and motorway service areas throughout the UK. Of course, as mentioned above, many people already log on to free online eMail accounts. Enlightened projects such as Bristol City Council's dual initiative to provide universal net access in all its libraries and to raise the IT skillbase of the city's women require a greater funding commitment and need to be mirrored by all communities.

Money's not the only issue. Developing nation decision-makers need to get their infrastructure act together and alert the population to the Net's advantages. So long as there's a protectionist patronising attitude some people remain excluded from cyberspace, panting at the gate and hungry to participate. But not for ever. Information has a way of seeping through. The same Trevor Bayliss who invented the wind-up radio described above, is working on a wind-up computer which could be shared by a whole community.

The United Nations' website UNITeS offers a cybermeeting space to volunteers throughout the world, helping to bridge the technological gap between developed and developing countries. Their UNIFEM programme urges governments and industry to provide women with equal opportunities to train.[224]

Berners-Lee reveals in his book that W3C set up the Web Accessibility Initiative to "devise protocols and software that can make the Web accessible to people with visual, hearing, physical and cognitive or neurological disabilities," working to guidelines jointly devised by tekkies and disabled people themselves.[225]

One of the most potent agents of exclusion is access to the information about the Internet itself, from the very fact of its existence to more complex questions of its numerous benefits in every social activity. Bureaucracies, whether political or industrial cannot have it both ways. Either an ignorant society operates under universal constraint, or informed people are encouraged to exert greater control over their own lives, and to influence policy for their benefit.

[224] http:// www.unv.org/ and http://www.undp.org/unifem/
[225] *op cit*

Lenny Bruce, the prophetic US comedian of the 1950s, summed up this dilemma when he had a prison warden bemoan the new-found intellectual confidence of an inmate: "I'm sorry I ever gave him that library card." In the era of the Net, no controlling agency can ever again afford to be sorry. Even when enlightened initiatives are launched in the West, few go out of their way to target other than the usual suspects: mostly male, white, and middle-class. It's just bad marketing!

Such laudable exceptions as Audrie Krause's non-profit NetAction[226] were set up "to educate the public and promote grassroots citizen action on technology-based social and political issues." These empowering sites help counter the more prevalent short-term appeal only to those who can currently afford what everyone can benefit from. By everyone I include those with something to sell. With a bit of foresight you can expand your potential client base. Companies rich enough to sponsor training sessions in inner-city and rural areas not only prepare a more discerning electorate, more demanding customers, they also engender loyalty in an arena where [as we've seen] no one is a prisoner of habit.

That's exactly what hit Rio de Janeiro where free public Net cabins were made available to teach teenagers how to access information in a project attracting funding both from local business and international grant aid.[227] Aptly noted by Charley Lewis of the Congress of South African Trade Unions, the Internet has also helped the Korean union KCTU subvert persecution from the government, among a litany of workers' battles with abusive employers throughout developing nations.[228] As Net access depends less on literacy than exchange, so it increases the potential for eDemocracy. Could we really beckon back the Global Village?

The Net industry continually faces a skills shortage. So why isn't there more emphasis in elementary and higher education on preparation to fill those gaps? Every analysis of academic performance reveals that though girls outrank boys in maths and science in the early years, by the time they're considering career options, women label computer and IT studies as male bastions. Women who do opt to enter the Net arena still report discrimination, not only by their peers, but sadly both by their professors and employers.

I'm outraged that the European Commission's Advisory Group on the future of the Internet contained not one woman. Why is the UK government positing importing IT workers from 3rd-world countries without simultaneously requiring policies in schools and industry which ensure gender parity to benefit the emergent digital economy? What any of these initiatives needs first and foremost is political will. Sadly too often what's on offer is political won't.

<center>✿✿✿✿✿</center>

[226] http://www.netaction.org/
[227] As reported by Dafne Sabanes Plou, Women's Networking Support Programme of the Association for Progressive Communication, Argentina in *Boosting the Net Economy 2000; op cit*.
[228] *op cit*

Learning CyberLessons

From its ancient origins over 3000 years ago in India and China, educational policy has focused either on reinforcing the ethos of any particular society or on developing the skills of the individual. Today, most schools try to integrate both, recognising too that learning doesn't stop after graduation. The Internet is already proving effective as a University for Life – not only as a resource supplement to existing systems, but a valuable mechanism for lifelong learning. Because the Net provides fascination and expertise in so many knowledge arenas, it offers a flexible cyber-classroom to people at whatever educational level.

Primary school children, college students, and those looking to enhance vocational skills increasingly find what they need online. Educational bodies, too, have understood the value of this different way to learn. Following its enlightened strategy in the early 80s paving the way to integrate IT into the curriculum, the UK government has ensured the Net has a part to play. Campus 2000, for example, provides a linked-up eMail and conferencing system for educational purposes. JANET is a discrete network connecting all UK universities to information resources; its broadband successor SuperJANET provides high-speed delivery of multi-media for academic research and development. Clyde Virtual University, Europe's first and resulting from an initiative to provide higher education to the geographically disparate population of Scotland's Highlands and Islands, offers both coursework and assessment, supplemented by private tutoring and public discussions, all online.

Elsewhere, privately funded colleges, such as the University of Maryland's University College with its own WebTycho software, or the African Virtual University which links sub-Saharan Africa with prestigious academic institutions around the world, deliver online courses in a range of disciplines. The California based Virtual University has grown from a grassroots information provider into "a global learning community and the largest educational portal on the Internet."[229]

As a logical outgrowth of offline IT solutions, the industry itself has pioneered distance learning software, primarily to upgrade skills in coding and Net technology. Ziff-Davies has been selling such online courses for years. The business community, too, has recognised the potential and is responding to opportunities such as offered by BlueU, which customises online training packages for industry.

I believe all these systems will prove increasingly irresistible to education authorities and training departments if nothing else than for economic reasons. The only caveat is how dependent they all are on the self-motivation of the student. *Plus ça change*!

[229] http://www.vu.org/

Community Spirit

The pre-Internet novel *Slapstick* is subtitled Lonesome No More. Its author Kurt Vonnegut muses how strangers with common interests might find each other for mutual advantage. That's precisely the theory behind online communities, perhaps the most powerful tool for combating social exclusion.

Offline we expect communities to share physical proximity; online that's the least important criterion. They can serve any self-determined group from house hunters to brickmakers, Gregorian chants to pop-star gossip, brides to divorce lawyers, games to employment legislation. It's the commonality of interest that beckons them together online.[230] And community can speak unto community. Various online social and cultural projects have already linked residents in cities and villages throughout the world.

The virtual replaces face-to-face meetings among people restricted either by location, schedule, or mobility. Often this presages physical meetings. In the mid-1990s a group of women in Stockholm began communicating online about issues of ageing. They discovered more and more local women wanted to participate, sharing ideas, remedies, shopping tips, family experiences. They called themselves SeniorNet,[231] and eventually they arranged a get-together, finally meeting those they'd already begun to know online. Membership grew, word spread and mirror-communities sprang up, not only throughout Sweden but all over the world.

Such communities are supported technologically by Newsgroups, eMail groups or listservs,[232] real-time chat, MUDs [multi-user domains], bulletin boards, dedicated web pages and any combination thereof. Some are open to all, others require registration or declaration of interest and intent, while more private groups might insist on payment. Communities can evolve organically or be constructed to achieve specific ends. Some are under strict monitoring and control, others just hang loose.

Some listservs require limits on messages size; others won't accept eMails composed in html. Some communities supply a digest of any particular discussion or thread and/or archive everyone's contribution for future reference.

Always seeking another marketing door, many commercial ventures have set up communities either serving actual communal interests or pretending to do so in order to push products. In fact, when you deconstruct the proliferating Channels offered by large content providers, ISPs and some search engines, it's the sense of community which they're counting on to provide a sense of the familiar.

[230] Last year, Barcelona hosted 400 delegates from 35 countries at the first Global Summit on Community Networking.

[231] http://www.seniornet.se/english.asp/

[232] A dedicated mailing list automatically eMailing any single posting to every member.

The Net Effect

One of the biggest virtual communities celebrated its third year with the annual Internet Fiesta 2001 held between 2-4 March. Funding comes partially from the European Commission and industry. This self-selecting international community is open to anyone in the world by free registration at http://www.internet-fiesta.org/ inviting people either individually or in groups to provide something online to share. National organisers coordinate contributions all linked to the central website, whose engaging animated graphics beckon participation. One of this year's projects solicited written or graphic expressions of what the Internet means for people which were subsequently released inside thousands of balloons. Another project invited people to express online their concept of home. A Global Village indeed!

coda: quo vadis?

It's time for Janus to focus on the digital future. Considering the rate of electronic change, peering too far ahead would strain the prophetic vision even of Macbeth's witchy trio. Most Net pundits concentrate on shorter-term commercial aspects, such as who'll win the browser war, or which eCommerce software solution will dominate. I'm more concerned with the bigger picture. The Internet industry has long been aware of both technological and social barriers to its evolution, seeding solutions via commercial research and public policy amendments. Add to this an awareness of developments already in train, and it's perfectly reasonable to inquire *quo vadis* Internet?

we solve problems of access, speed, and security, and as the Net enables the sharing of all kinds of ideas across national boundaries, where will the SuperHighway lead? The hour of digital domination is nigh. Sesh Valmoor of the Foundation for the Future declared in *Boosting the Digital Economy 2000*, "While the digital divide may exist and still doesn't allow billions to get on the Internet, it is a matter of time." It may also be a matter of evolving social structures.

Growing Like Topsy

With intercreativity Berners-Lee posits that unexpected and aleatory connections among a containable group determine the way creative ideas develop and evolve. His challenge is how to mirror that small-group exchange in the broader context of the virtual which invites unlimited contribution. In other words, how can the Net retain its structural essence as it continues to expand? W3C goes a long way to unifying technological standards, including sanctioning a more flexible and intuitive language for meta-data. Berners-Lee feels that by providing such guidance structures without assigning them any centrist powers, the Internet can evolve to fit changing structures of society. The one will unwittingly influence the other just as individual neurones effect thoughts and ideas which they cannot be aware of.

Perhaps the most relevant challenge is the matter of organisation, but it cannot be addressed in isolation. I believe that's what's missing in much high-tech back-end development.[233] Users inextricably link content and access; their journey is pro-active and non-linear. No solution can ignore that. Paradoxically much of the Internet's charm resides in its anarchic construction. Yet people need points of reference. As we've seen, search engines can't cope.

Predictably, market dominant companies seek to compete by modelling themselves on cable TV channels. They offer solutions combining customisable homepages backed by powerful search facilities [increasingly displaying paid-for result placements],[234] portals to delineated content, and an assumption that web users are primarily web buyers. Case in point: Ask Jeeves purports to be an intuitive search engine. Type in a consumer-related question and it seems to deliver bespoke answers, but ask it imaginative questions and you discover what it's actually programmed to return is a list of commercial sites. Not only will such restrictive options never solve the problem, they're likely to backfire as future generations demand more control and more precision.

Nor can the wholesale importation of traditional marketing paradigms address online behaviour. Are we really asking the most relevant questions when the starting point is so often: how can we make more money from the Net? The recent Time Warner/AOL merger may presage a brief era of such household name alliances. As we've seen, however, merely delivering content online won't address the expectations of a generation already jaded with fragmented media options.

[233] Such projects as Bill Cheswick's fascinating cybermaps of data-routes for Bell Labs have little to offer ordinary Internet users. http://www.cs.bell-labs.com/who/ches/map/gallery/index.html/

[234] Companies can pay premiums to have their sites appear among the first results of any search.

Asking Better Questions

There are much more innovative, albeit embryonic, solutions which put people's needs first. The most promising completely rethink online categorisation, positing a kind of Digital Dewey Decimal System. That implies hefty development finance but, just like those blinkered investors in the pre-ARPA days, today's moneybags prefer shorter-term projects. I believe this, too, bodes ill for profits. As we've seen, those with the skillbase can exist independently of investment. They may sometimes be arrogant and naïve about traditional business patterns, but no one will prevent them working on projects of their own. Projects which could re-write the rule book.

Even the most prestigious think-tanks need to be more creative both in how they define their agendas and in whom they invite to the table. It's probably inevitable at this early stage that members are self-appointed and unaccountable. What's more open to question is the American dominance, lack of imagination about where to go for wider representation, and arrogance in assuming that those on other continents will blithely accept decisions. That said, I don't want to diminish the enlightened and preparatory work, inspired by W3C and expanded by such umbrella organisations as The Internet Society [ISOC],[235] whose annual conference was held in Stockholm in June 2001.

Non-profit and unlinked to any government, this international body with its dual HQ in Reston, Virginia and Geneva, Switzerland, was granted NGO Operational Relations status by UNESCO. ISOC links over 175 organisations and 8600 individual members from more than 170 countries, each concerned with standards, public policy, and education and training. Members include the International Engineering Task Force, the Internet Research Task Force, the Internet Societal Task Force, Network Training Workshops, and Sustainable Internet Training Centers.

Other international membership bodies offer degrees of participation in setting and maintaining Internet standards. However enlightened, their US dominance not only assures big business a disproportionate voice, but [if not outright xenophobia] a hint of suspicion of other cultural approaches. The Internet Corporation of Assigned Names and Numbers [ICANN][236] appointed computer entrepreneur Esther Dyson[237] interim chair until the post was filled by Vinton Cerf. Among other quasi-governmental tasks ICANN oversees IP space allocation and root server system management.

Vanguard[238] is "a research and advisory program which provides senior business and technology executives with information about advanced information technologies, and offers insights into how those technologies can be leveraged by their organizations." It invites its high-level corporate membership to attend conferences to hear equally powerful international speakers. The Board includes Leonard Kleinrock and John Perry Barlow.

[235] http://www.isoc.org/
[236] http://www.icann.org/ evolved from the Internet Assigned Numbers Authority.
[237] Dyson's impressive credentials are available on her website
http://www.edventure.com/esther.cfm/
[238] http://www.ttivanguard.com/

However much it might suit the corporate world, it's unlikely that the Net can split neatly into separate entities: one for commerce, another for leisure, a third for information, and somewhere for communication and participation. The very inter-relationship made possible by Internet technology is what makes being online so intriguing. I believe people are more interested in the question 'what can I do online?' than 'what can I buy?' In the end it's about us, the users.

We deserve our say. And ex-Grateful Dead John Perry Barlow wants to give it to us. In 1990 he co-founded the Electronic Frontier Foundation[239] [EFF] in the belief that governments become dangerous when too efficient. From its dual San Francisco/Washington DC bases, EFF works through its membership "in the public interest to protect fundamental civil liberties, including privacy and freedom of expression in the arena of computers and the Internet."

The future of the Net is an integral component of its present. It may be impossible to coordinate every project, whether it's commercial, political, cultural or social. As always, it's essential to learn as much as we can of current developments which will profoundly affect our lives. No one's forecasting that any of the initiatives described below will be universally available within a specific time. Patterns of per-capita distribution of television sets or running water prove that what one culture takes for granted another may just be aware of.

Let's peek at some new developments in the context of how they'll serve an evolving relationship between the Internet and its users. It's not really possible to prioritise the ways tomorrow's Net will evolve. Unlike past eras, however, in which such development occurred behind closed doors, not only are we in a position to learn about what's happening, we're also able to influence it.

A parallel is taking place in the bio-technology industry. Research, primarily funded by those with commercial intent, has provoked much debate with regard to issues of genetic engineering of plants and animals. For example, while multi-nationals and governments privately agree testing sites for genetically modified crops, people who'll be directly affected are voicing their doubts in very public ways – ways which have already damaged the commercial credibility of the companies concerned.

Having taken over a century of preparation, the Internet is helping people realise that in a world fueled by competition for profit, purchasing power is proving a more powerful agent of change than voting by ballot. In this context it's important to understand that any notion of companies developing products to meet some mythical popular demand is misplaced.

Every woman I know would rather wear clothes that were impossible to stain than a new lipstick. But no one's asking us and we're still waiting. Few if any of the initiatives mentioned below were based on statistically significant market research. Indeed, those grant bodies which fund multi-million dollar and Euro projects seem determined to ignore calls for research which would quantify the self-identified needs of any given population.

[239] http://www.eff.org/

Who knows whether this is deliberate, a tacit agreement between those allocating public money and its commercial recipients, or just an unfortunate coincidence. Whichever, it marginalises from the development process the very people whose lives will be most affected. You're gonna get this stuff whether you want it or not! It's as calculated as a record-industry manufactured popstar. That may be a viable strategy when your target market only has to shell out the price of a CD, but when each new rung on the Net ladder implies a substantial outlay for yet more new hardware, surely there's a point of diminishing returns.

Okay, Wotcha Got Now?

Before we examine some of the socio-cultural mechanisms made possible by the Net for future generations, let's look at a few products just entering the market. Technology convergence will eventually render the Net as ubiquitous and invisible as electricity. Convergence projects have long been exercising the R&D departments of universities and industry. One of the hottest arenas for research is Smart Spaces: domestic or industrial environments in which all appliances are electronically connected both to each other and to the outside world.

Now we're starting to see the results for sale. By mid-2001 Full House Control in Michigan had already developed a command device which remotely prepares your home for your arrival: adjusting temperature, automatically lighting rooms as you enter, assuring food is prepared, and greeting you with your chosen music or entertainment. It's marketed as "the foundation for tomorrow's automated home." Another US company SmartHome manufactures X10 devices using cables based on PLC [power line carrier] to connect phone jacks with desk-top computers, telephones, and home appliances. PLC technology was devised about 30 years ago in Scotland by Pico Electronics. The company is especially targeting the home entertainment market, enabling instant downloads of audio and visual material.

California-based Nomadix devises highspeed infrastructure platforms called Universal Subscriber Gateways which coordinate the interaction between users and the Internet. Its Chairman and founder is the same Dr Leonard Kleinrock who invented packet-switching and led UCLA's node of the ARPAnet. He declares, "I see Nomadix as a way to move to Smart Spaces."[240]

In September 2000 the UK Millennium House opened its doors to volunteers for testing. The house is an attempt to prepare not only for an ageing population, but one which is fiercely independent. By 2010 there will be more than three million Brits over the age of 80. The trial period is being sponsored by BT, Age Concern, several health care companies and an unidentified Japanese corporation.

[240] Kleinrock is the principal investigator for DARPA, leading the development of infrastructures for nomadic computing.

Made possible by a £1.2 million Government grant, the house was developed by the Bioengineering Department at Brunel University under the direction of Professor Heinz Wolff.[241] Its eventual application will enable any existing home to be converted by means of a widely available kit costing about £3000 to buy outright or £50 a week to rent [including monitoring by a call centre and assistance from voluntary organisations]. There's already interest from local councils for its use as an alternative to sheltered housing.

The Millennium House speaks to its residents, emits olfactory messages such as the smell of perked coffee as a cue to get up, and plays soothing music to induce sleep. Convergent technology allows the house to analyse itself, using motion detectors to track its residents. Professor Wolff explained to the press, "A sensor in the sofa will register if the occupant is sitting down. It could then play a recording, in the occupant's voice, of them wondering if they want a cup of tea, or it could play a few notes of evocative music to prompt them to do something. In an emergency, it will automatically phone them. If they do not respond, it will alert the emergency services." Radio sensors are also built into entry doors, kitchen appliances and the doors to each room. Since this circumvents the need for re-wiring, the conversion kit can be installed within a few hours.

In 2000 a similar eHome kit was released in Sweden selling for just under £300,000. It features entry by fingerprint, remote temperature control, a robot lawnmower, and a fridge which not only orders supplies but suggests meals based on available ingredients. The recipe is displayed on a Net-enabled screen encasing the appliance, which can also offer time-tables, weather reports and auto-routes. The 3-bedroomed abode can detect faulty appliances, alerting the owner to a leak, a breakdown or if the cooker's been left on. Such appliances are currently in addition to the basic cost of the eHouse, rendering it unavailable to all but the rich. Of course, that parallels the standard introduction of the inside toilet or electricity over the past 100 years.

Not quite available but coming very soon is the ability to generate, digitise and transmit smells electronically. California-based DigiScents has been chemically analysing smells, indexing them on a scent spectrum, and creating a small binary file. Upon request, the file is transmitted using a so-called personal scent synthesiser cunningly called iSmell. One cable plugs into your computer's serial port, the other end into a standard electrical socket. When it's activated, it releases the synthesised odour in your direction. Just as combinations of a limited colour palette can generate millions of hues, iSmell's cartridge of 128 primary odours combine to produce thousands of familiar scents.

The most lucrative deals already signed by DigiScents have been with various games distributors as an added element of verisimilitude. Imagine racing games that deliver the pungency of burnt rubber as you rack up points. Shoot-em-ups with a whiff of gunsmoke. What about a Net Western enlivened by the smell of horse and leather saddle? A song about the salty sea, or a thriller featuring a walk through rainy urban streets?

[241] Wolff appears periodically on UK TV as a boffin who makes science fun and accessible to all.

These electronic scratch & sniffers have already caught the eye of the advertising world. It doesn't take much to imagine how such an additive could enhance shopping online for perfumes, flowers, or chocolate. Since the sense of taste is determined by that of smell, it's no surprise that there's a device in development which allows you to download odours of edible stuffs, print them out and lick the paper. Its inventors TriSenx call it a SENX machine.[242] It too uses cartridges imbued with various scent components and is battery powered. Pre-ordering list price is under $300.

Whichever device eventually scores market share, the domestic and work environment will undoubtedly become a discrete hub to the Net. The interactivity implied will, I believe, also generate friendlier means of accessing electronic services such as a performance or conference, a chapter from a rare book, or a medical diagnosis.

The box we call the computer will become absorbed into the premises themselves. Any wall will be your access screen. You'll be serenaded by a hologram of your favourite string quartet or rock group, either pre-programmed à la Eno or as part of a live event. Enhanced convergence of virtual reality and artificial intelligence morphs your leisure centre into a virtuality booth, enabling you to sample holiday destinations or restaurant dishes, recreate historical events, test drive a new car or fly onboard a space probe.

When you emerge from your super home, it won't be a mere phone which connects to the Net. You'll carry it with you, or rather on you. Wearable computers and other SmartWear have been the subject of research by MIT's MediaLab and others since the early 1990s.

They all start from an assumption of a permanent Net connection so there's no dial-up strategy. Some are devices to be strapped on, others weave microprocessors and LED[243] screens into the very fabric of your clothing. All are able to be configured to your requirements, just like your desk-top, lap-top or PDA.

The bulkiest incorporate headsets, wristscreens, belt-packs and gloves, and some are powered by CPUs in the heel of a shoe. The most flexible are computing garments fashioned into shirts, dresses and underwear. In Europe Levi is trial marketing a musical jacket developed at MIT by Josh Strickon, Rehmi Post, Josh Smith, Emily Cooper and Maggie Orth, using conductive fibres to emulate a keyboard.

This is the closest we've come yet to meeting the Eno challenge. Why be a prisoner tethered to your computer? Maybe you can listen to music while you're online, but you can't go for a run. SmartWear allows the online experience to integrate with other aspects of your life. It also erects another layer between you and any 3rd party, since it doesn't depend on computer-to-computer connection. Those who fear hidden cameras or radio-waves tracking their online activity are allayed by wearables in several ways.

[242] Sensory Enhanced Net eXperience.
[243] Light emitting diode.

SmartWear can take account of our individual physiology to promote privacy. The computing components could be distributed between undergarments containing higher-level command functions and outer wear woven with encrypted transmitters enabling communication links.[244]

The fabric can also monitor such health indicators as heart rate and blood pressure. Results could easily be transmitted to your doctor. In fact the US Navy funds researchers at Georgia Tech to develop such medi-friendly fabrics into SmartShirts for military personnel. Applications are planned to monitor athletes, and to prevent infant cot-deaths.

Such SmartWear requires more sophisticated cloth than our current closetful. Researchers have been experimenting with silk organza, a fabric which integrates copper foil into silk. Such metallic cloth has long been in use for Indian saris and more recently by the fashion industry. Silk organza is ideal for SmartWear because it's reliable, resistant to heat, and a robust electrical conductor. Methods are being developed to insulate each fibre to avoid the danger of computer circuits touching. Any number of additional components can be soldered directly onto the copper foil, including crystals, resistors, and circuits. Power can be derived from wind, the sun, or by the very motion of the wearer.

One of the most sophisticated developments in train has less to do with product than process. NASA's Jet Propulsion Laboratory [JPL] is determined to fling the Net wide into space, creating interplanetary, even inter-galactic connectivity. Crucial to the terraforming of Mars [which has been on the Space agenda ever since the first Moon landing] was the collection of on-site data. However, such missions as the 1999 Mars Polar Lander were prone to lose contact due to unstable data transfer rates as well as time delays inherent in speed-of-light/distance equations.

To overcome this constraint the JPL is coordinating Internet enhancements of the existing Deep Space Network.[245] One of JPL's chief advisors is Vint Cerf, whose early developments of Internet protocols are discussed above. He's working on a new set of hacker-proof protocols to bounce data off a series of 6 antenna-satellites orbiting Mars plus one mega Marsat, allowing far more rapid communication over millions of miles, eventually over lightyears.

In 1997 the data from Pathfinder was transmitted to Earth at some 300 bits per second, which even your PC can beat by a factor of 200. Though his precise dates may be off by a few years, Cerf recently predicted online, "The goal is to deploy the first satellites in 2005 which would enable ... significant activity in 2008." That translates to an initial data transfer rate of about 11,000 bits per second [still slower than your computer], rising to a whopping 1 MegaByte per second, sufficient to convince you you're right there on Mars.

<p align="center">🏵🏵🏵🏵🏵</p>

[244] There are some interesting websites detailing various aspects of SmartWear, including: http://wearcam.org/mann.htm/ and http://wearcam.org/, and http://wearables.eyetap.org/
[245] The DSN, as it's known, aligns signals from high efficiency facilities in the US, Australia and Spain.

Tomorrow

Back on Earth all roads lead to the SuperHighway. I hope what you've read so far will help convince you to jump on. Once you're surfing, what can you expect to see over the Internet horizon? One thing's for sure: you won't have the road to yourself.

Various global surveys reported by industry analyst NUA[246] indicate phenomenal growth-rates in the West and the Pacific Rim. For example, over the course of 2000, Korean online users leapt from just over 8 million to 19 million, most of them under 30. Online business-to-business spending will reach more than $80 billion by 2005. Despite political troubles and with a PC distribution rate of 11% at the start of 2001, 9% of the Malaysian population were online. European web advertising revenue is forecast to rise to nearly $1 billion by 2002, dominated by Germany with the UK not far behind and Scandinavia in third place. Australia, boasting an increase of 1.9 million users during 1999, had nearly 7.5 million at the start of 2001.

Its structure, speed and form are changing, but the Internet concept is here to stay. I won't commit to a time-frame, but I'll try to extrapolate from current Net developments. And I pre-accept any potential future embarrassment if I'm way off. I take as a given Mark Pesce's contention that it's increasingly important to know where to get what you need, rather than trying to retain everything in your head. The rest is contingent on that premise.

In 1968 science journalist Gordon Rattray Taylor published a book of scientific prophesy called *The Biological Time Bomb*,[247] which proved so arresting it was popularised by The Book-of-the-Month Club. I don't want to rate the accuracy of his predictions, though his record is pretty good as you'd expect from such a rigorous reporter. More relevant is the necessary emotional adjustment to such radical socio-cultural change which he knew was inherent in the outrageous scenarios he painted. As we grapple with similar equations of societal fragmentation and the rate of technological change fuelling our future, we must keep measuring the magnificence of our achievements against their human effects.

The Net is a process not a thing. Whatever else guides developers, I believe people will continue to demand engagement. In an online world of proliferating data, they'll want available mechanisms to manage the quality of their choices.

We're likely to see an integrated approach to the online experience which I predict will combine game-playing with information gathering. Sure, trading will play a role, but as part of that synthesis.

[246] http://www.nua.ie/surveys/
[247] Thames & Hudson & The New American Library.

As the Net drives more of our everyday lives, protecting personal security will beckon us to consider solutions unthinkable today. The technology foreseen in the mid-1970s television series *The Six Million Dollar Man*[248] is closer than we think. Viewers may have cheered Col Steve Austin and Jaime Sommer[249] as they fought bad-guys with bionic enhancement, but there's still much resistence against scientists playing God in real life. It may take many decades, but we'll eventually accept a greater degree of bionic integration. From plastic hip to genetic chip.

We already inject pets with electronic identity tags. Chip manufacturers are even now transcending silicon, experimenting with coding microprocessors directly onto organic cells. In April 2001 researchers at Northwestern University in Illinois unveiled their new cyborg to the press, describing it as "a half-living, half-robot creature which connects the brain of an eel-like fish to a computer and is capable of moving towards lights." Using electrodes, the cyborg unites the brain stem from the larva of a lamprey, a bloodsucking fish, with an off-the-shelf Swiss robot. Placed in the middle of a ring of lights, the robot's sensors can detect when a light is switched on. Signals are relayed to the living lamprey brain, which floats in a container of cool, oxygenated saline solution. The brain then returns impulses instructing the robot to move on its wheels towards the light. With the lights turned off, the robot remains immobile. When one of the robot's eyes is masked, the disembodied brain is temporarily confused, but learns to compensate.

Though it's using eels, this kind of research is aimed at humans. Rivalling skilled magicians, scientists in Atlanta, Georgia have already achieved remarkable results. They implanted a tiny glass electrode in the cerebral cortex of a quadriplegic patient, coaxing neurons to grow inside. When a transmitter was attached, the person was able to move a cursor on a computer screen by the power of thought alone.

Some futurologists foresee us all as cyborgs. Coded chips would enable us to declare our uniqueness electronically and provide us with a direct connection to the electronic world. In essence, each of us would become a node of the Net.

At birth, even in the womb, babies could be implanted with chips combining their genetic code with digital functionality. This hybrid couldn't be stolen since it would only work within the person whose genetic code matched.

It could assist most of our activities, altering the whole concept of security for all transactions. It would solve problems of intellectual copyright since anything produced would bear the unique identifier of its creator. There'd be no more infiltration of premises since entry would be safeguarded by genetic criteria. Locks would only open to micro-genetic keys.

[248] A hit series based on Martin Caidin's *Cyborg* novels, *The Six Million Dollar Man* began as a trilogy of feature-length films on ABC TVs Suspense Theater in 1973. The sci-fi series featured law-and-order characters whose injured limbs were replaced by performance-enhanced robotic arms and legs connected to the brain. Most of the episodes are still available worldwide on cable channels and video.

[249] Played by Lee Majors and Lindsay Wagner

Theft would all but disappear. There'd be little need for cash since the embedded chip could process transactions like today's swipe cards. Coding could be appended to the chip sending remote instructions to SmartSpaces for anything available online: information, communication, entertainment, food delivery and preparation, temperature control, whatever.

If we're always online, connections can be opened to an even greater range of services, including community support groups or health centres. The medical applications are clear. Once again, it's where we consign such issues in a socio-cultural sense that needs to be addressed along with any specific diagnostic online tools.

I suspect this will require a greater degree of adjustment for doctors, nurses and healthcare workers than for the public. Technology will allow us more responsibility in maintaining our own health as well as making preliminary diagnoses. The medical profession [and by implication the insurance industry] will have to release or at least share a degree of authority. And because we're unlikely to see significant changes in the predominance of a global capitalist imperative over the next century, such sector-wide adjustments will probably be as much a result of economic prudence as anything else.

Similarly, we'll adjust our political participation, possibly even redefine politics. A very large paradigm shift for the power seekers. We can't tell precisely, but there are bound to be new structures of cultural expression if people all over the world connect to explore synergies between the Arts and Technology. In a world of shared specialisms, we all become teachers. The evolving Net will help us carry the best of the past far into the future.

In the end the only solid prediction we can make about the Internet is that it will change. It's up to us to influence that change, and at last we have a technology which actually encourages our involvement. I may not know where the SuperHighway leads, but I'm proud to be part of it, and I want to stay onboard.

The going is the goal.

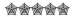

index

2

2001: *A Space Odyssey* 52, 98

A

Aardman Animation 113, 126, 190
Aaron [the drawing robot] 83
abacus 14
Ada 17
Addison, Ruth 115
Adorno, Theodor 130
Advanced Research Project Agency
[ARPA] 6, 32, 42
Advanced Telecommunications
Research Labs 87
Advisory Committee on Online
Access & Security, US 161
Aiken, Howard 33
Alexander, C. H. 15, 27
Allan, Alex 153-157
Allen, Paul 40
Allen, Woody 80, 98
alphabet 12, 80
Altair 8800 39, 40
Amazon.com 93
American Film Institute's OnLine
Cinema 109
Analytical Machine 16, 17
Andreesen, Marc 66
Apple 40
Apted, Michael 26
ARPAnet 45, 46, 47, 48, 133, 173
Arts and Technology 129
Arts, the 79, 80, 81, 83, 96, 102,
104, 115, 124, 179
Ascott, Roy 83-85, 108
Asimov, Isaac 81
AT&T 22, 35, 46, 67
Atanasoff, John 33
Atomic Bomb 23, 29
Automatic Sequence-Controlled
Calculator 33
avatar 107

B

Babbage, Charles 16, 17, 33
backbone servers 132
Baer, Adam 116
BAFTA 1128, 129
Baker-Cresswell, A. J. 26
Ballard, JG 89
bandwidth 110, 127, 129, 136, 140
Barlow, John Perry 171, 172
Barnett, Doug 103
Bayliss, Trevor 59, 164
BBC2 9, 68, 70, 77, 99, 100,
115, 137
Beatles, The 47
Beethoven, Ludwig von 116
Bell Laboratory 32
Berners-Lee, Tim 63, 64, 65, 66,
67, 69, 117, 141, 164, 170
Berry, Cliff 33
Bilas, Frances 32
BINAC 33
binary system 17
Bissaker, Robert 16
BKSTS [aka the Moving Image
Society] 99, 144
Black Chamber 19
Blackfoot 55
Blagrove, Edith Gordon
[Lady Brind] 23
Blair, Tony 140, 150, 153
Bletchley Park 22, 23, 24, 25, 26,
27, 28, 29, 30, 32, 34
Bluetooth 139
Bomba 21, 25
Bombe 25, 26
Boole, George 17

Boosting the Net Economy 2000
148, 152, 165
Bradley, Brian 108, 113
Bristol City Council 164
British Council, The 115

British Interactive Multi-media
Association, The 127
British Telecom [BT] 28, 36
Brodman, Dr Janice 148
Broom, Andrew 25
Browning, Robert 11, 13
BulletinBoard System [BBS] 136
Bush, Vannevar 18, 19, 30, 31, 32,
55, 90

C

Caesar, Julius 13
Cailliau, Robert 63
calculus 16
Canadian Broadcasting
Corporation
59
Capek, Karel 80
CD-ROM 70, 71, 83, 103, 114, 129
Centre for Advanced Inquiry in
Interactive Arts 83
Ceremony of Innocence 129
Cerf, Vincent 40, 44, 46, 171, 176
CERN 63, 64, 66, 67
Chaplin, Charles 98
Cheswick, Bill 170
Choctaw 20
Churchill, Winston 22, 23, 24, 27
circuit board 39
Clark, Jim 66
Clark, Wesley 43
Clinton, President William 26
COBOL 34
codes 19, 21, 22, 24, 26, 27, 29,
30, 46, 88, 97, 119, 145, 158
codetalkers 20
Coleman, Dr Stephen 149-152
Colossus 28, 29, 36
communication 9, 10, 12, 13, 31,
32, 44, 45, 47, 48, 56, 59, 63, 64,
77, 82, 83, 84, 86, 87, 132, 133,
135, 136, 137, 139, 147, 150,
159, 172, 178, 179
Communications Supplementary
Activity 23
computer 5, 6, 9, 13, 16, 17, 18,
23, 25, 30, 31, 32, 33, 34, 35, 36,
37, 38, 39, 40, 41, 42, 43, 46, 47,

48, 57, 58, 60, 63, 64, 69, 72, 73,
75, 76, 78, 80, 82, 84, 85, 86, 87,
88, 91, 92, 94, 97, 100, 101, 102,
104, 107, 108, 111, 115, 117,
118, 119, 122, 129, 134, 136,
138, 144, 146, 157, 158 159,
162, 163, 164, 165, 171, 174,
175, 176, 178
Conway, John 120
Countess of Lovelace 16
Cray, Seymour 38, 39
Crocker, Steve 46, 47
cryptanalysts 19
cryptography 19, 20, 29
cryptology 23
CSAW 23, 24, 26, 29, 30, 32,
37, 38
cybernetics 84
cyberspace 65, 72, 75, 134, 135,
157, 164

D

da Vinci, Leonardo 79, 81
Dali, Salvador 81
Darius 13
DARPA 42, 67, 173
Davenport, Gloria 88, 113
Davis, Les 39, 120
Day In Day Out [DIDO] 76
de Colmar, Charles 16
decoders 19, 23
decryption 21, 22, 24, 25, 26,
27, 29, 30, 35, 36
Deep Space Network [DSN] 176
Defense Research Committee 18
Deforest, Lee 18
Denniston, Alastair 22
designer 88, 106, 107, 111
differential analyser 18
Digital Arts Development Agency
[DA2] 126
DoCoMo 140
Dogmatic 113
Dollis Hill Research Station 28, 36
dotcom companies 141, 146
Draisin, Maya 128
Dream Machine, The 108, 113
Driscoll, Agnes 19

dumb terminal 84, 85
Dylan, Bob 41
Dyson, Esther 171

E

Eade, Justin 115
Earl of Stanhope 16
eBook 92
eBusiness 129
Eckert, John Presper 32, 33, 38
eCommerce 63, 141, 143, 151, 153, 158, 161, 169
eDemocracy 148, 149, 150, 151, 153, 165
EDSAC 34, 35
EDVAC 33, 34, 35
eEnvoy 153
eGovernment 150, 153
eInk 92
Electric December 113, 126
Electronic Commerce Consultation Forum 153
Electronic Frontier Foundation [EFF] 172
Eliot, George 49
ELSPA 105
eMail 6, 48, 62, 87, 113, 116, 122, 132, 133, 134, 135, 136, 140, 158, 161, 162, 164, 166, 167
encryption 19, 20, 22, 24, 27, 29, 34, 146, 151, 157, 158, 159, 161
Engelbart, Doug 65
English Electric Company 35
Engstrom, Howard 37, 38
ENIAC 32, 33, 34
Enigma 19, 20, 21, 22, 23, 24, 25, 26, 27, 29, 37
Eno, Brian 117-120, 175
European Commission's Advisory Group 165
Europrix 129
extranets 137
eye-candy 78, 104

F

Feiffer, Jules 42
Ferranti Ltd 37, 38, 63

Fibonacci, Leonardo 11, 36
File transfer protocol [FTP] 132, 136
Fischetti, Mark 65
Fish 22, 27, 29
Flash 113, 127
Fleming, Ian 26
Flowers, Tommy 28, 36, 158
Forrestal, James V. 38
Frankenfeld, Don 110
Friedlander, Larry 107
Friedman, William 19, 24

G

G-2 22, 24
Gabriel, Peter 129
Galactic Network 43
Galyean, Tinsley 113
Gamelan 88
games 61, 73, 75, 88, 90, 100, 102, 103, 104, 105, 106, 107, 108, 113, 118, 119, 136, 169, 174
Gates, Bill 34, 40, 75
GetWired 130
Gilgamesh Epic 12
glocal 148
Goldman, Lisa 128
Goodall, Jane 50
GPRS 140
Green, Tom 115
Griffiths, David 88
Grotowski, Jerzy 124
Gutenberg, Johann 72, 89

H

Haase, Ken 108
Hahn, Mathieus 16
Hair, Art 111
Halliday, Mark 108
Hammurabi 13
Hansard Society 149-152
Hartree, Douglas 37
Harvest Project 39
Hassabis, Demis 106, 107
Hawking, Dr Stephen 83
Heath Robinson 25, 27, 28
hieroglyphics 12
Hitchcock, Alfred 95

Hitler, Adolf 17, 21, 22, 24, 26, 28
Hodges, Andrew 18, 19, 34
Hogel, Georg 26
Hollerith, Herman 17
Hopper, Grace Murray 33, 34, 38
House of Lords 23
hypertext 5, 63, 64, 69, 70, 89,
 118, 127

I

IBM 17, 39, 44, 45, 46, 122
ICL 35
Infomedia 84, 85
Information Technology 6
Interactive Cinema Group 113
interactive fiction 90
Interactive Media Festival 128
interactivity 47, 86, 88, 93, 97,
 104, 105, 138, 140, 151, 152, 175
Intergalatic Network 43
International Business Machine
[IBM] 17
International Telecommunication
Union 60
Internet
+ accessibility 134, 164
+ Alan Turing 36
+ avatars 107
+ books 92
+ business 77, 153, 155
+ cinema 75, 110, 111
+ civil liberty 172
+ commerce 78
+ creative programming 86
+ cultural accountability 68
+ cyber-communities 167
+ data transmission 76, 133, 140
+ design 87
+ digital television 154, 155
+ eDemocracy 150
+ editorial comment 71
+ eMail 134
+ evolution of 172
+ Fish 22
+ free speech 69
+ gender disparity 166
+ government funding 141
+ government repression 62,

 163, 165
+ Grace Murray Hopper 33
+ information 71
+ interactivity 71, 88, 93, 141, 173
+ Leonard Kleinrock 44, 47
+ lifelong learning 166
+ local government 154
+ Mark Pesce 129
+ MIT 42, 45
+ monitoring 76
+ music(delivery) 114, 121
+ music(distribution) 114, 120
+ music(performing) 116, 121
+ openness 43, 47
+ Patrick Marber 122
+ pornography 76
+ preparing society 163
+ Project Gutenberg 73
+ publishing 92
+ security 157, 163
+ SFX 88
+ skills 145
+ socio-cultural adoption 53
+ space exploration 176
+ speed 43, 55, 127
+ stimulating creativity 125
+ story-telling 108
+ synthesis of Arts & Technology 79
+ take-up 58, 61, 62, 63
+ technology 57
+ technophobia 49, 58
+ terminology 6
+ the future 169, 177, 179
+ user agenda 170
+ Webby Awards 129
+ Webcast 115
+ World Wide Web 65, 67, 133
as a media leisure option 75
as a political tool 148, 149, 172
as an experience 5, 133, 138, 139,
 147, 168
as cyber-tool 63
as marketplace 78
as timesaver 83
attracting artists 93, 109, 117
compared with radio 59, 60
compared with telephone 60
component applications 6
components of 133

confusion with computers 5, 146
definition 5, 6, 11, 48
evolution of 12, 13, 18, 19, 20, 27,
 30, 40, 42, 43, 105, 169
focus of the book 5
fundamental concept of 9, 137, 177
general reference 5, 79
how vs why 8
labour force 77
online standards 171
relevance 6
SuperHighway 9
synthesis with Art & Technology 7
the medium as message 12
underlying construction 170
used in Closer 122, 123
user agenda 172
user ignorance 57
variety of use 156
wireless 139, 140
Internet Corporation of Assigned
Names and Numbers [ICANN] 171
Internet Relay Chat [IRC] 135
Internet Service Provider [ISP] 48,
 61, 62, 71, 78, 133, 134, 135
Internet Society, The [ISOC] 40, 171
intranet 137
IT 5, 6, 61, 77, 138, 146,
 153, 154, 164, 165, 166

J

J. Lyons & Company 35
Jacobson, Dr Joseph 91
Jacquard 17
Jade 29
JANET 48, 166
Java 88, 108, 121
Jennings, Betty Jean 32
Jet Propulsion Laboratory [JPL] 176
Jipguep, Jean 61, 62
Jobs , Steve 40
Johnson, President Lyndon 43,
 45, 98

K

Kelly, Kevin 117
Kelvin, Lord 16

Khan, Kublai 13
Khoi-San 54
Khrushchev, Premier Nikita 42
Kiefl, Barry 60
Kilby, Jack St. Clair 39
King, Augusta Ada 17
King, Dr Tim 61
King, Stephen 92, 125
Kleinrock, Dr Leonard 40, 44,
 45, 46, 47, 171, 173
Knockholt 23
Knox, Dillwyn 25
Kubrick, Stanley 52
Kucza, Reinhold 128

L

Lachman, Richard 107, 113
LaMaMa 96, 124
Lang, Fritz 80
Last Book, The 91
Lawrence, Peter 44, 115
Lemp, Fritz-Julius 26
LEO 35
Liberace, Lee 41
Lichterman, Ruth 32
Licklider, Dr Joseph 43, 44, 46,
 47, 64
Lincoln Lab 44, 45
Luddites 56
Luftwaffe 25, 27
Lutoslawski, Witold 116

M

MacArthur, Douglas 38, 63
Machiavelli, Niccolo 58
Madonna 114
Magritte, Réné 11
Manhattan Project 22, 23, 32
Marber, Patrick 122-124
Marconi, Guglielmo 19
marketing 77
Maryland Ballistics Research Lab 32
Masquerade 89
Massachusetts Institute of
Technology [MIT] 41
mathematical functions 16
Mauchly, John 32, 33, 38

Mauchly, Mary 32
McAuliff, Christa iv
McCartney, Sir Paul 114
McLuhan, Marshall 12
McNulty, Kathleen 32
Meliès, Georges 98
memex 31
Metois, Eric 120
MI5 22
MI6 22, 34
MI-8 19, 24
Micro Instrumentation Telemetry
Systems [MITS] 39
microprocessor 32, 39
Mignonneau, Laurent [& Christa
Sommerer] 87, 88
military 11, 16, 19, 20, 21, 22, 23,
24, 28, 29, 30, 31, 32, 33, 42, 43,
45, 46, 48, 59, 68, 70, 79, 132,
148, 159, 176
Military Intelligence 19, 20, 22
Mills, Louise 115
MilNet 48
Minsky, Marvin 121
MIT MediaLab 88, 91, 113,
120, 175
Mitchell, Mitch 99, 120
MITS 39
Moore School 24, 32, 35
Morgenroth, Lee 113
Moulthrop, Stuart 89
Mozart, Wolfgang Amadeus 81, 94
MP3 75, 114
Mueller, J. H. 16
Multi-media 128, 129
music 101, 114, 116, 117

N

NASA 39, 42, 44, 176
National Center for
Supercomputing Applications
[NCSA] 66
National Cryptologic Museum 22
National Physical Laboratory
[NPL]
34, 45
National Security Agency [NSA]
22, 39, 68

Navaho 20
NBC 99
Neanderthals 10
Nelson, Ted 65
Net, The
+ accessibility 62, 63
+ Alex Allan 154, 156
+ Arts(research) 126
+ as a political tool 152
+ availability 154, 156, 164, 165
+ business 143, 146
+ cinema(delivery) 74, 113
+ cinema(distribution) 110, 111, 113
+ cinema(production) 113
+ commerce 78
+ commercial potential of content 131
+ content 147
+ convergence technologies 133
+ data transmission 133, 136, 137
+ digital television 154
+ eDemocracy 147, 148, 151, 165
+ eMail 135
+ false impressions 78
+ gender disparity 165
+ government repression 164
+ interactivity 47, 138
+ investment 141
+ Leonard Kleinrock 44
+ lifelong learning 166
+ Madonna 115
+ music(composing) 119
+ music(performing) 114
+ music(promotion) 115
+ online trading 155
+ openness 46
+ preparing the public 163
+ security 159, 161, 163
+ SmartWear 175
+ social change 160
+ space exploration 176
+ speed 133
+ Stephen King 93
+ take-up 58, 61
+ technology convergence 173
+ technophobia 49, 58
+ the Arts 80
+ the creative process 94
+ the future 169, 172, 173, 175,
177, 178
+ Tom O'Horgan 125
+ user agenda 160
+ user ignorance 146
+ Webcast 115
+ You Don't Know Jack 74

access to 62, 134
as a political tool 148
as a research tool 48
as an experience 71, 78, 177
attraction to artists 117, 128
barriers to its potential 160
changing perception of 141
compared with telephone 61
components of 133
content 75
effect on language 136
evolution of 6, 7, 18, 30, 42,
 141, 144, 169, 172, 179
focus of the book 5, 8
fundatmental concept of 6
general reference 132
in a socio-cultural context 8
preparing the public 138
strength of 6
terminology 6
the unthinkable 178
underlying construction of 170
underlying structure of 172
wireless 139, 140
Newman, Max 25, 28, 36, 43, 131
Nimitz, Admiral Chester W 38
Nipkow, Paul 59
non-linear storytelling 85, 123, 128
Norris, William 37, 38, 39
Northwestern Aeronautical 38
Nostradamus
[Michel de Nostredame] 31
NUA 177

O

Office of Scientific Research and
Development 31
O'Horgan, Tom 124-125
Oliver, William 16, 120
Online Aquarium 126, 127
Online Man Computer
Communication
 43
Op-20-Q 24, 29, 30
Opera of the Future 121
Oppenheimer, J. Robert 27

P

PARC 126
Parker, John 38, 112
Party Girl 109
Pascal, Blaise 16
Pascaline 16
Pellow, Nicola 64
personal digital assistant [PDA] 175
Pesce, Mark 88, 128, 177
Picasso, Pablo 81
pigeons 12, 19
Pollermann, Bernd 64
Polo, Marco 13
Pony Express 13
processors 19, 23, 158
programmer 106
protocol 48, 65, 133, 136, 138, 140
punch-boards 17
Purple 29

Q

Quantum Project 110
quipu 14

R

radio 18, 59, 60, 70, 71, 73, 75,
 78, 111, 114, 141, 147, 164
Red Rooster Ltd 97
Regulation of Investigatory Powers
Act [RIP] 148, 161
Rejewski, Marian 21
relay systems 13
Remington Rand 38
Research and Development Board 31
Roosevelt, President Franklin D. 23,
 24, 27, 29, 30
Rosing, Boris 59

S

Safford, Laurance 19, 24, 29
Sale, Tony 29
Sargon, King of Akkad 12
Schickard, Wilhelm 16
Schluesselzusatz 22

Scholz & Volkmer 129

Schreyer, Helmut 20

Schuman, Howard 101

science fiction 80, 81, 99

Scottish Record Office 25

Search Engine 137

security 29, 36, 45, 93, 144, 151, 154, 157, 158, 159, 160, 161, 163, 178

semaphore 15

Sesostris I 13

Shareable Media Project 113

Shaw, Jeffrey 105

short messaging service [SMS] 138

Sigaba 29

SightSound.com 110, 111

Signal Intelligence Service 22

signals 9, 25, 27, 39

silicon chip 39

Singing Tree, The 120-122

SIS 22, 24, 30, 39

Six Million Dollar Man, The 178

slide rule 16, 17

small & medium enterprises [SMEs] 156

Small Business Service 157

SmartSpaces 179

smoke signals 15

Snail Mail 134

Snyder, Elizabeth [Holberton] 32, 34

social inclusion 149, 156

Sommerer, Christa [& Laurent Mignonneau] 87, 88

Soviet Union 22, 45

spammers 136

Sperry-Rand 38

Sputnik 42

steganography 159

Stein, Johann Andreas 81

Stepped Reckoner 16

Stewart, Ellen 124

Stillwell, Nick 112

Stone, Amy 95, 112

Stravinsky, Igor 80

Sturgis 2000: The Internet Movie 110

Sundance Festival 129

SuperHighway 9, 15, 177, 179

Sutherland, Ivan 44, 46, 124

syllabary system 12

symbols 10, 11, 12, 14, 34, 134

T

Taylor, Gordon Rattray 177

technology 8, 9, 27, 30, 31, 37, 42, 43, 46, 48, 50, 51, 53, 54, 55, 56, 57, 58, 60, 66, 67, 69, 75, 80, 81. 82, 85, 89, 90, 93, 94, 95, 98, 99, 100, 101, 105, 106, 107, 109, 110, 115, 117, 118, 122, 123, 124, 129, 130, 139, 140, 149, 150, 153, 159, 166, 171, 172, 173, 174, 179, 180

telegraph 15, 17, 57

telephone 15, 19, 21, 32, 36, 47, 60, 61, 62, 133, 140, 142, 164

Telephone Research Establishment 28

television 5, 7, 12, 23, 32, 41, 56, 59, 60, 66, 73, 75, 76, 78, 96, 97, 98, 99, 100, 101, 109, 111, 112, 124, 144, 154, 155, 172, 178

Texas Instruments 39, 84

Thames Television 101

The Museum of Web Art [MOWA] 95

The Plant 92, 93

Thirty Years War 16

Timms, Stephen 153

Tinguely, Jean 83

Toffler, Alvin 55

Tomlinson, Bob 48

Tractor 39

Traf-O-Data 40

transistors 15, 18, 39

triode 18

Truman, President Harry S 38

Trumbull, Douglas 98

Trumpington, Baroness 23, 24

Tunny 22, 27, 28, 29, 158

Turing, Dr Alan 18, 19, 25, 26, 27, 28, 30, 34, 35, 36, 45, 117, 158

Typex 29

U

U-Boat 26, 27

Ultra 22, 25, 27, 32
UNIFEM 164
Unisys 38
United Artists 98
UNIVAC 33, 34, 38
Universal Machine 18, 25, 117
University College London 142
US Education Development Center 148
US Marines 20
US Navy 18, 19, 33, 38, 176
US State Department 19
UseNet 48

V

V1 20
vacuum tubes 24, 28, 32
Vallée, Jacques 84
Vanguard 171
Venona 22
Vernam, Gilbert 22
Vesna, Victoria 82, 83
Victory Garden 89, 90
Viner, Norbert 83
Virtual Reality 44, 88
virtual reality markup language
[VRML] 88, 127, 128
virus 107, 162, 163
von Braun, Wernher 20
von Leibnitz, Gottfried 16
von Neumann, John 32, 34
von Schelling, Friedrich 6, 9
von Scherler Mayer, Daisy 109

W

Warner Brothers 98
Watershed Media Centre 126
Watson, Thomas Sr 17
Web, The
 + as a cyber-library 73
 + as an experience 7
 + Bangemann Awards 68
 + cinema attendance 74
 + commerce 77, 78
 + commercial potential 77
 + content 70
 + content reliability 69
 + design 87
 + effects on society 67
 + free speech 69
 + game sponsorship 75
 + information 71, 72
 + interactivity 67, 76
 + music compression 76
 + non-comercial display 129
 + Project Gutenberg 73
 + quality of content 68
 + reliability of content 68
 + Shockwave 112
 + Stephen King 92
 + technophobia 58
 + the Arts(future) 114
 + the British Museum 72
 + Tim Berners-Lee 64, 66, 67, 68
 + variety 69, 70
 as a cinema resource 75
 as a cyber-library 73
 as a research tool 48
 as an experience 70
 as display platform 75
 as entertainment platform 75
 as marketplace 77
 attraction to artists 94
 confusion with Net 6
 employment definitions 144
 Enquire as early model of 64
 evolution of 71, 141
false impression of 78
 growth-rate of 63
 language of 70
 legal aspects 69
 ownership dispute 66
 ownership of 66
 quintessence of 64
 relationship to the W3C 67
 searching 138
 wireless(restrictions) 140
Webby Awards 128
Webcast 114, 115
webhouses 143, 144, 145
Welchman, Gordon 25
Wescoff, Marilyn 32
wide area network [WAN] 45
Wilkes, Maurice 35
Williams, Kit 36, 89
Wilson, Robert 82, 109, 124
Wired 117, 130

wireless application protocol
[WAP]

138, 139, 140, 146
Wolff, Professor Heinz 174
Women Accepted for Volunteer
Emergency Service [WAVES] 26
Woocester Group 123
working conditions 144
World Wide Web
 + content 49, 70
 + MOWA [qv] 95
 + programme code 29
 + terminology 6
 + the economy 141
 + Tim Berners-Lee 64, 66
 as part of the Internet 6
 confusion with the Internet 133
 evolution of 6
 general reference 63,65, 68, 164,
 170, 171
World Wide Web Consortium
[W3C]
 64, 67, 68, 164, 170, 171
Worlds Away 107

Wozniak, Steve 40
WWI [World War I] 16, 18, 19,
 20, 22
WWII [World War II] 16, 19, 21,
 38, 40, 158, 159
Wynn-Williams 25

Y

Yardley, Herbert 19
Young, Margaret 25, 73

Z

Z1 20
zero 14, 17
ZKM Centre for Art and Media 105
Zuse, Konrad 20, 21, 29
Zworykin, Vladimir 59

About the Author

An independent Media Consultant, Beth is an Advisor to the Women's Forum of Bristol City Council, and a member of the Executive Committee of Network West Country for professional women. A member of The Internet Society, she co-founded and served for three years as Chair of the Board of SW Interactive Media, the regional trade association for the industry. For three years she has been a nominating judge for the International Digital Academy of Arts & Sciences.

Beth's clients have included Aardman Animation, BBC Online, Crocus.co.uk, Gloucester Business Link, Granada's World In Action, and the University of the West of England's MultiMedia in Europe Course. Before moving to Bristol, Beth was Senior Producer of corporate websites such as Radio 5Live, Boots The Chemists and the RSPCA at international award-winning webhouse Online Magic.

She served as Executive Producer of The Online Aquarium, a showcase for Bristol-based web and Arts talent, presented as a gift to Bristol Zoo Gardens. Beth has participated in all three sessions of *Boosting the UK Digital Economy*, an annual international online debate sponsored by Headstar, BT and Bull Technology Systems. She has lectured and conducted seminars for Shell International, Birkbeck College, the BKSTS, the University of Bristol, and The University of the West of England. Beth delivered the keynote speech at The Fuel MultiMedia Conference 2000 in Stockholm, and presented a paper on Art and Technology at the 1998 IST Conference in Vienna.

She contributes columns for Internet.works Magazine, has critiqued websites for Internet Magazine and researched and delivered the computer news for Radio 5Live's *The Big Byte*. She is a member of the BKSTS New Media Committee and also contributed to the DTI Innovation Unit Think Tank on Multi-Media.

Before becoming seduced by the Internet, Beth's previous media career includes writing, journalism, television drama production, and acting. A member of the original award-winning NY LaMaMa Theater Troupe, she co-founded and ran the Wherehouse LaMaMa London and was voted Most Promising Actress by the London Times. She featured on the West End with Albert Finney, and in many recorded dramas opposite Bob Hoskins, Tim Curry, Nigel Hawthorne, Frankie Howard, and Leonard Rossiter. Subsequently she co-starred as Kitty Schreiber in Thames TV's 1977 hit series *Rock Follies*, BBC1's *The Deep Concern*, and featured in films with Kirk Douglas, Woody Allen, Warren Beatty, and Barbra Streisand. She guest-starred in US TV episodes of *Kojak* and *Baretta*, as well as featuring in UK mini-series such as *The Men's Room, Hitch-hikers Guide to the Galaxy, Inspector Wexford*, and *Alan Bleasdale Presents*. Among extensive voice work, she played Roger Water's wife on his album, *The Pros and Cons of Hitchhiking*, and Ridley Scott asked her to re-voice Veronica Cartwright's death in *Alien*.

A lifetime member of BAFTA and the UK Critics Circle, for 10 years she was London Editor of *Film Journal International* as well as contributing reviews to BBC radio, BskyB TV, *The Independent*, and *The Times*. She has served as Development Executive of new Drama Series for BBC TV, and sat on the Board of Women in Film and Television. She produced television drama for the BBC and Channel 4. Radio 4 has broadcast her short stories and plays; her poetry has been published in US and UK anthologies.

Beth attended Hunter College of the City University of New York and New York University, studying English Literature, Drama, and Fine Art. Her avocation is primate ethology, and in 1976 she devised and carried out a six-month project in non-verbal interspecies communication with two infant orangutans for the Los Angeles Zoo Baby Animal Unit.